Editor:
Marcia Pointon, *University of Manchester*

Reviews Editor:
Kathleen Adler, *Birkbeck College, University of London*

Associate Editor:
Paul Binski, *University of Manchester*

Editorial Assistant:
Sarah Sears

Editorial Board:
Tim Benton, *The Open University*
Craig Clunas, *University of Sussex*
Thomas Crow, *University of Sussex*
Jaś Elsner, *Courtauld Institute of Art*
Briony Fer, *University College, London*
Robert Hillenbrand, *University of Edinburgh*
Paul Hills, *University of Warwick*
Ian Jenkins, *British Museum*
Susan Lambert, *Victoria and Albert Museum*
Neil McWilliam, *University of East Anglia*
Lynda Nead, *Birkbeck College, University of London*
Desmond Shawe-Taylor, *University of Nottingham*
John Styles, *Royal College of Art/Victoria and Albert Museum*
Gilane Tawadros, *INIVA, London*

Nigel Llewellyn, *Chair, Association of Art Historians*

International Advisory Board:
Svetlana Alpers, *Berkeley, California*; Hubert Damisch, *Paris*;
Klaus Herding, *Frankfurt am Main*; Lynn Hunt, *Philadelphia*;
Natalie Kampen, *New York*; Serafin Moralejo, *Harvard*; John Onians,
Norwich; Jessica Rawson, *Oxford*; Sigrid Schade, *Kassel*;
Pat Simons, *Ann Arbor*; John White, *London*

Blackwell Publishers
Oxford, UK and Cambridge, USA

ART HISTORY

Journal of the Association of Art Historians

Volume 18 Number 1 March 1995

Art History is published quarterly in March, June, September and December for the
Association of Art Historians by **Blackwell Publishers**, 108 Cowley Road, Oxford OX4 1JF
or 238 Main Street, Cambridge, MA 02142, USA. Registered charity no. 282579

Information for Subscribers: New orders and sample copy requests should be addressed to
the Journals Marketing Manager at the publisher's address above (or by email to
JNLSAMPLES @CIX. COMPULINK. CO. UK, quoting the name of the journal).
Renewals, claims and all other correspondence relating to subscriptions should be addressed
to the Journals Subscriptions Department, Marston Book Services. PO Box 87, Oxford OX2
0DT. Cheques should be made payable to Basil Blackwell Ltd. All subscriptions are supplied
on a calendar year basis (January to December).

SUBSCRIPTION PRICES 1995	UK/EUR	NA*	ROW
Institutions	£87.00	US$152.00	£98.00
Individuals	£52.00	US$ 98.00	£64.00
Single copies (Institutions)	£26.00	US$ 46.00	£29.00
Single copies (Individuals)	£16.00	US$ 29.00	£19.00

*Canadian customers/residents please add 7% for GST

US mailing: Second class postage paid at Rahway, New Jersey. Postmaster: send address
corrections to Art History, % Mercury Airfreight International Ltd Inc., 2323 E-F Randolph
Avenue, Avenel, NJ 07001, USA. (US Mailing Agent).

Advertising: For details please contact the Advertising Manager, Ludo Craddock, 15 Henry
Road, Oxford OX2 0DG, UK, tel/fax 01865 722964.

Articles for consideration to: Marcia Pointon, Editor, *Art History*, Department of History of
Art, University of Manchester, Manchester M13 9PL, England.

Articles/Books for review to: Kathleen Adler, Reviews Editor, *Art History*, Centre for
Extra-Mural Studies, Birkbeck College, University of London, 26 Russell Square, London
WC1B 5DQ, England.

Membership of the Association of Art Historians is open to individuals who are art or
design historians by profession or avocation and to those otherwise directly concerned in the
advancement of the study of the history of art and design. The annual subscription, due on
1 January each year, is £34.00 (UK); £39.00 (Europe, including the Republic of Ireland);
£45.00 or $80.00 (USA and Rest of the World), and includes four issues of both the journal
Art History and the *Bulletin*. Student rates (UK) are available on application. Applications
should be sent to Kate Woodhead, Dog and Partridge House, Byley, Cheshire CW10 9NJ.
Tel: 0606 835517.

Back Issues: Single issues from the current and previous three volumes are available from
Marston Book Services at the current single issue price. Earlier issues may be obtained from
Swets & Zeitlinger, Back Sets, Heereweg 347, PO Box 810, 2160 SZ Lisse, Holland

Microform: The journal is available on microfilm (16mm or 35mm) or 105mm microfiche
from the Serials Acquisitions Department, University Microfilms Inc, 300 North Zeeb Road,
Ann Arbor, MI 48106, USA.

Printed in Great Britain by Hobbs the Printers of Southampton
This journal is printed on acid-free paper

© Association of Art Historians 1995 ISBN 0-631-194-878 ISSN 0141-6790

Art History Vol. 18 No. 1 March 1995 ISSN 0141-6790

CONTENTS

NOTES FOR CONTRIBUTORS

Art History provides an international forum for original research relating to all aspects of the historical and theoretical study of painting, sculpture, design and other areas of visual imagery. The journal is committed to the publication of innovative, synthetic work which extends understanding of the visual within a well-developed interdisciplinary framework and raises significant issues of interest to those working both within the history of art and in related fields.

(1) *Two copies* of manuscripts should be submitted; the overall word length should not normally exceed 9,000 words. They should be clearly typewritten, *double spaced* with generous margins. The title page of the script should indicate the author's name, institution, address and telephone number, together with accurate estimates of text and footnote wordlengths; subsequent pages should be numbered and should carry an identifying running head. The author should retain an up-to-date copy of the typescript. Photocopies of illustrations should be included with initial submissions and originals supplied only on the editor's request.

(2) English spelling conventions should be followed in the text (e.g. colour, centre); foreign-language citations should be given in translation in the main text, with the original appearing in full in an accompanying footnote. All quotations within the text should be enclosed within *single* inverted commas. More extensive citations should be indented without quotation marks. All new paragraphs should be clearly indicated by indentation.

(3) Footnotes should follow the text and be double spaced. References should be kept to a practical minimum and should avoid unnecessary digression or redundant displays of erudition. Bibliographical references should correspond to the following examples:

> M. Baxandall, *The Limewood Sculptors of Renaissance Germany*, New Haven and London, 1980, pp. 20–1.
> P.F. Brown, 'Painting and History in Renaissance Venice', *Art History*, vol. 7, no. 3, September 1984, pp. 263–95.

Titles in French should follow the capitalisation conventions adopted by the Bibliothèque nationale, Paris, as in the following example:

> J.-C. Chamboredon, 'Production symbolique et formes sociales. De la sociologie de l'art et de la littérature à la sociologie de la culture', *Revue française de sociologie*, vol. 27, no. 3, July–September 1986, pp. 505–30.

(4) Illustrations should be used discriminatingly and should be confined to objects whose discussion forms a substantive part of the text. Good quality black-and-white plates should be provided upon acceptance of an article for publication. These must be clearly labelled and numbered, with accompanying typewritten captions on a separate sheet. Where indicated, measurements should be given in metric form; any details for reproduction from a larger image should be clearly indicated. Illustrations should be referred to as 'plate' in the text. All copyright clearance is the author's responsibility and full acknowledgement of sources should be included where appropriate.

(5) Corrections to accepted scripts should be kept to a strict minimum at proof stage. In view of the costs involved, the editor reserves the right to refuse any extensive alterations to authors' texts in proof. Prompt return of corrected proofs to the editor is essential.

(6) Manuscripts will not be returned to contributors.

Art History ISSN 0141-6790 Vol. 18 No. 1 March 1995 pp. 1–3

A Psychopath, a Mega-nerd and now Bambi

Steve Bell

The following article appeared in the *Guardian* on 21 July 1994, following Tony Blair's selection as Labour leader.

How does a cartoonist de-Follett Tony Blair? When I first saw him in the flesh at a Labour press conference I thought: 'That young man has spiky hair and too many teeth.' Then I saw him on TV. I can't remember what he was talking about, but I remember the smile. Dazzling, there's no other word for it. John Major has a nice smile, one of his few strengths; it switches on and says: 'I am Nice.' It's precisely one half of his armoury of facial expression. The other is his gormless but inscrutable look. Tony Blair's smile says: 'I have too many teeth. I am dazzling. I am dangerous.'

The next thing I remember Tony Blair for is a Labour Party conference speech. It was in the Kinnock years during the year-long run-up to the 1992 election. The words 'agenda'; 'values'; 'challenge'; 'freedom'; 'opportunity'; 'empowerment'; 'modernized'; 'issues'; 'democracy'; 'achievement' and 'change' featured prominently in a speech that hinted at meaning and sought to please without actually saying anything. There were a lot of speeches like that that year, but Blair's effort struck me as an archetype.

I thought no more about him apart from the famous 'Tough on crime; tough on the causes of crime' soundbite (which made me think: 'that sounds like a good soundbite') until John Smith's death, and suddenly there he was all over everything everywhere. I'm sure this wasn't entirely of his own volition but there has been a definite snowball effect. Now I know that he's two years younger than me, he's the first 'post-modern' Labour leader, he used to sing in a rock band, and somebody or other started calling him 'Bambi' — which of course is a gift to any self-respecting cartoonist.

Why 'Bambi'? Extreme youth? Forty-one is well on the way to middle age. He's definitely wide-eyed with big lashes. He's shortly to become king of the forest. He's also got enormous ears. Drawing Blair as Bambi does present problems, however, because even though they both have big eyes and big ears, they have completely differently shaped heads. Then there's the problem of teeth: Blair has loads, Bambi doesn't have any. Just splicing a human head on to an animal's body is rarely very satisfactory in a political cartoon (unless it's about vivisection).

The truth is that it's difficult to do anyone until you're fairly sure what sort of political animal he/she is. It took several years before I realized that Margaret

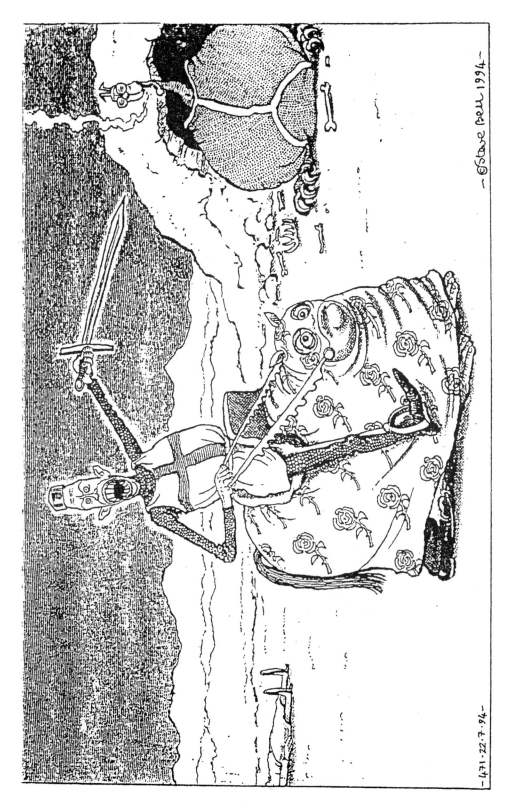

Thatcher was a psychopath. Conversely, it took less than a month to see that John Major was a mega-nerd. Margaret Thatcher definitely connived in her own depiction as the Iron Lady. It was an image she built for herself and played up to. She first impressed me as a small-minded and extremely right-wing hoarder of tinned food. The actual structure of her face took a long time to work out. It's largely to do with the angle of her nose in relation to her eyeballs, one of which is half-hooded, while the other swivels free. Once this is established, all else — the quiff, the neck, the pearls — falls into place.

While Major has never connived in his depiction as mega-nerd, he does play up to the image of plucky little ordinary chap, rather in the manner of Chaplin, or Hitler. He wears glasses, which for me always makes caricaturing easier because it's a ready-made structure on which you can build the likeness. (In life-drawing classes you're always told the likeness doesn't matter.) Above all, he has a unique upper lip structure, which, when I first drew him, tended to spread out in a duck-like manner until I saw a side view of him and realized that it swoops inwards and wraps itself around his front teeth. Add the weak chin poking out underneath and here you have him.

The underpants are simply a metaphor for uselessness. I stumbled on them when, just after his accession to the leadership, I was looking at his record in office hitherto. It was a sorry tale of non-achievement, ranging from the cold weather payments fiasco through to his ballsed-up entry into the ERM, so I drew him as a crap Superman. Superman wears sleek red briefs outside his tights; naturally John Major would wear aertex Y-fronts outside his trousers. Only later did I hear the vile rumour as to where he tucks his shirt-tails.

Kinnock I always found impossible, partly because he had the most difficult head, which seemed to change shape radically from every angle you looked at it. I wasn't helped by his lack of political definition and the strangulated foggy verbiage which characterized his journey rightwards.

Physically, Blair is more promising: teeth, ears, eyes and spiky hair are a sound basis for caricature. Politically, who knows? He's passionate about Europe; that's rather like being passionate about garden furniture. Along with everybody else on earth, apart from Margaret Thatcher, he believes in 'community' and 'the individual backed by the power of society', and he's a Christian. Some of my best friends are Christians. Maybe there's scope here for a few lion gags.

Will Bambi lead us to salvation? As the man on *News at Ten* used to say: 'Only time will tell.' Never mind Bambi, I'd vote for Goofy, Dumbo, Pinochio or even Digby the Biggest Dog in the World in order to consign this present bunch of clowns to the oblivion they so richly deserve.

Steve Bell
Brighton

Art History ISSN 0141-6790 Vol. 18 No. 1 March 1995 pp. 4–23

Carnal Satire and the Constitutional King: George III in James Gillray's *Monstrous Craws at a New Coalition Feast*

Lora Rempel

The Head of the State

On Tuesday, 29 May 1787, not far from the Palace of Westminster, a satirical print showing King George III as a feasting peasant woman appeared in the window of Samuel Fores's Piccadilly print shop, then one of the most popular commercial establishments of its kind in London.[1] Entitled *Monstrous Craws at a New Coalition Feast* (plate 1), it depicted king, queen and prince, with soup ladle in each hand, eating from a shared pot. Surprisingly enough, the name and address of this publisher and seller of prints were engraved below the satirical image. As Fores had Tory leanings, and the Tories were the traditional parliamentary defenders of the king,[2] it seems odd that he chose to publish and sell a print which vividly mocked the monarchy. Was there not a contradiction between supporting the values of kingship and distributing graphic satires that undermined the reigning George? If there was a contradiction, presumably it was not a serious one. This apparent political schizophrenia in his allegiance to the king was not Fores's alone. Graphic regal satire of the late eighteenth century is overwhelmingly Janus-faced: it mocks the man who is the reigning monarch while leaving curiously unscathed the quasi-divine institution of kingship that he personifies.

As the monarch who held the throne during military victories and Britain's greatest colonial loss to date — the United States of America — George III was apotheosized at one turn and held responsible for national burdens of defeat at another. And though he shared the Protestant faith of his nation, his Germanic roots and continued foreign political connections as the Elector of Hanover made him an outsider and a suspect in his own kingdom.[3] Not only was George III of foreign descent, he was also a stutterer, a hobby farmer and a victim of bouts of 'madness', bad eyesight and impaired hearing. He thus possessed a set of characteristics which provided satirists with a cornucopia of virtues, vices, flaws and curiosities upon which to draw in their representations of the king. For these reasons and others, political satirists and critics alike found both the timber of larger political causes and the kindling of individual eccentricities with which to build a roaring fire around King George III.

In contrast to satirical prints produced in Britain before the 1780s, and to most of those published contemporaneously with Gillray's copperplate engraving,

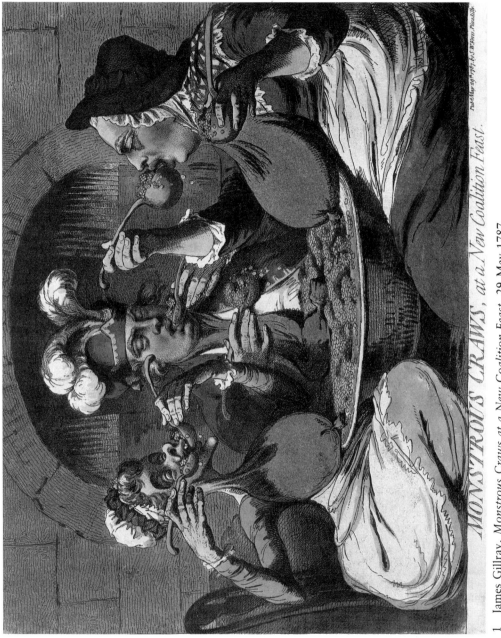

1 James Gillray, *Monstrous Craws at a New Coalition Feast*, 29 May 1787.

Monstrous Craws stands out through its radically provocative application of facial and body caricature to the portraits of King George III, Queen Charlotte Sophia and George IV, the Prince of Wales. Various degrees of caricaturistic distortion and exaggeration are observable in the three figures. But it is the figure of the king that is the most visually 'charged'. Befitting his role as the embodiment of national identity, the king also carries the heaviest load of narrative, iconographic and political meanings, and satirical twists. As the living symbol of the nation,[4] it is in his person that the tradition, myth and legally sanctioned privilege of kingship is revived again for another reign, and regal satire participates in this incarnation.

The tension between sharp satirical criticism and the maintenance of royal authority is particularly intricate in the body imagery and political references of *Monstrous Craws*. Despite the degree of caricature inflicted upon the representation of George III, his profile is detailed and individualized to render the identity of the figure immediately recognizable to contemporary viewers. Furthermore, the subject matter of the print is clearly political. The 'New Coalition' between king and prince recalls the public announcement of their reconciliation made a few days earlier, which was interpreted as ending a period of estrangement between the monarch and the heir. And, despite the attention paid to satirizing physical 'attributes', *Monstrous Craws* does not sacrifice this opportunity for political commentary.

The union of portrait caricature and political content that *Monstrous Craws* holds in balance leads to two key problems which will be investigated here. The first considers to what extent lampooning the body of George III in *Monstrous Craws* provokes a critique of the king and his role as the head of the State. The second analyses the joint venture between the trade of graphic political satire and the business of out-of-doors political opinion-shaping within the frame of Britain's Constitutional Monarchy in the late eighteenth century. To address these queries, two related issues are examined: shifts in notions of kingship in seventeenth- and eighteenth-century Britain and the measure of subversive political content permitted in satirical images of George III.

Often designated the 'Golden Age of Political Caricature' by historians of political prints, the late eighteenth century was an historical era of European nations in political crisis. In France, to cite only one example, political turmoil led to the revolutionary restructuring of governmental bodies after the destruction of the Bastille. In Britain, however, there was no parallel revolution, not even a widespread political storm.[5] Yet Britain was far from immune from domestic strife, and the debt owed by graphic satirists of the period to the political tensions of their age is often discussed by historians who examine the political import of print culture.[6] But historians have seldom asked what debt the apparent political stability of eighteenth-century Britain owed to political satire for helping to give visual articulation and practical example to the notion of the British nation as a formidable fortress of freedom?

The development of graphic political satire in the late eighteenth century corresponds to the maturation of the first western, early-modern structure of government that is frequently discussed under the rubric of representational parliamentary democracy.[7] Great Britain was the exemplary parent of nations

which followed its parliamentary model of centralized government. Certain elements and premises of the parental model were, however, reworked or rejected: neither the newly independent nation of the United States nor the renewed post-Revolutionary French state included, in their versions of parliamentary government, the monarchical components which to this day crown Britain's Constitutional Monarchy.[8]

Framing Prints

George III is shown dressed in women's clothes: the frock, apron and shawl of a peasant woman. On his head he wears a hat and bonnet which is tied under his fleshy chin. An immense appendage hangs heavily from his throat and rests on the rim of the circular cauldron from which he feasts. A heaping soup ladle is delicately held in each hand, and, even though the expanded member under his chin reveals that his hunger should already be satisfied, his mouth is open wide, and his head is slightly tipped back, in order that he may continue to stuff his exposed, monstrous, stomach-like sack. His profile concedes a full white brow beneath large deep-set eyes, full lips, and an almost too fine and noble nose for so round and globe-like a head. Opposite him, also in the guise of a peasant, is a representation of a woman partaking in the seemingly simple meal with equal two-handed enthusiasm. Though her body appears almost gaunt, her fingers gnarled and her arms spindly, her craw too is hefty and full. Directly across from the space left vacant for us to view this plentiful peasants' feast is a third figure. His large, heavy-lidded eyes underneath thick, light-coloured brows, and his long, sculpted nose that does not quite match his plump face, reveal a facial likeness to the figure to his left. But his utensils, which he holds with almost affected delicacy, are shallower than those of his companions. With the palm of his right hand close to his chest, he seems well aware that his craw is not inflated but flaccid and empty; the central focus, it hangs like a long, limp sack for all to see. He has arrived at the table wearing an elegant hat decorated with extravagant plumage — a costume appropriate for a royal prince. Indeed, the well-dressed central figure is a satirical rendition of George IV, the heir apparent. Framed beneath the arch of the Treasury, this feasting royal trinity of the king, queen and their eldest son eat communally from the cauldron labelled 'John Bull's Blood' — the blood of the English 'Everyman', whose labour is the sustenance and wealth of the nation.[9] King George III, the father of the nation,[10] is shown wearing peasant women's clothes, a cannibal devouring the body of his most loyal imaginary subject. How weak, or perhaps how strong, must the symbolic pyramid of power be in order to allow, or indeed to survive, such travesties as the image displays?

The description above responds to James Gillray's *Monstrous Craws at a New Coalition Feast*. The ostensible subject of the print is a notorious rift between the king and the heir, which stemmed from the prince's princely spending, mended only days before the print's publication. After prolonged parliamentary pressure had been exerted on him to deal with the prince's ever-growing debts, the king conceded to alleviate his son's financial burden with funds from his own Civil

List. The topical political import of *Monstrous Craws* is imprinted on the prince's ladles (labelled £60,000 and £10,000, the sum of his allowance and the amount by which it was to be increased), and in the craws — or money-bags — of the king and queen, which are being stuffed with John Bull's blood, turned into royal feast, turned into golden coins. Since the issue of the prince's astronomical debts was a familiar theme in Parliament, the press and satirical prints, it was common knowledge that the prince had spent all his nuggets in the process of long feasting, while the king had been saving his.[11] The 'New Coalition' received wide coverage in the press, was celebrated in pro-government newspapers, and was publicly commemorated by illuminating a representation of the king's crown and the prince's crest the evening after the decision was announced in the House of Commons.[12]

A print of *Monstrous Craws* could be purchased for about half-a-crown coloured and one shilling plain, which was the going price in London at the time for broadsheet prints — a purchase price beyond the reach of a large portion of the urban public. While many Londoners were without the means to own the latest graphic satire, the bawdy mockery and political messages communicated by the pictorial language of satire were still accessible to them (plate 2). Prints were generally published and sold from the premises of print shops, where political prints were displayed and sold alongside so-called 'fancy prints', engravings after history paintings, maps and official portraits of the same individuals who were often satirized in political prints. Ale houses, taverns and coffee houses also provided alternative environments for the viewing and reading of satirized versions of history in the making.[13] There political prints were displayed alongside satirical ballads, complete with melodies and lyrics for participatory entertainment, as well as newspapers for communal use. Posted on tavern walls, and exhibited in the street-facing windows of London's print shops, the art of graphic satire was an integral part of the city's public houses and street culture. These satirical pictures told the tales of the latest events and curiosities and reached a broad spectrum of the public for the price of a glance.[14]

A number of contemporary visitors from the Continent and from the United States commented on the unfamiliar profusion of prints in public spaces and the brazenness of their pictorial content (plates 2 and 3). Reporting on caricatures available in London, Louis Simond, a French-born visitor from the United States, wrote that 'It must be owned . . . that the English do not spare themselves, their princes, their statesmen, and their churchmen, [who are all] thus exhibited and hung up to ridicule, often with cleverness and humour, and of course a sort of wit.'[15] One cannot say which came first, the expectation that the liberties ensured by the British political system should allow the free trade of political satire, or that the noted abundance and harsh humour of satirical prints proved that free expression of political opinion did exist among Britons. What one can surmise from such comments, however, is that the British situation with regards to political satire was utterly unique and foreign to the experience at home.[16] Less surprised than irritated by the accessibility of satirical prints and their content was an anonymous commentator for the *Briton*, a conservative newspaper, who in 1762 lamented that 'the most indecent prints which obscenity and impudence can contrive were available to any passerby in London.'[17]

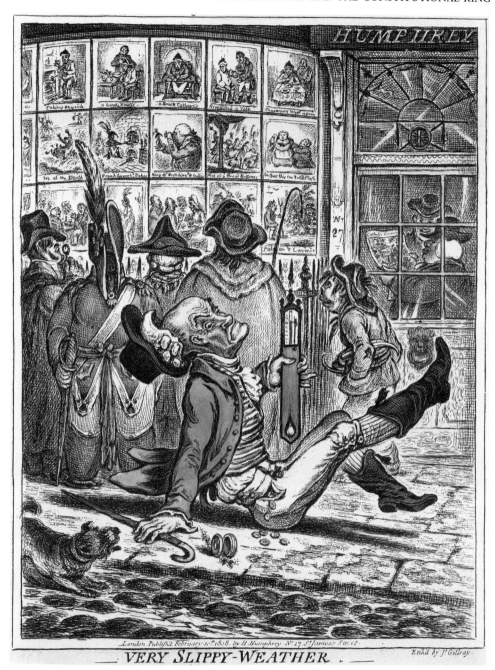

2 James Gillray, *Very Slippy Weather*, 10 February 1808.

Nevertheless, numerous innovations in engraving techniques throughout the eighteenth century gave prints a new face and a more reputable place in the hierarchy of the visual arts.[18] In addition, experimentation with earlier print-making methods multiplied the visual effects that could potentially be produced

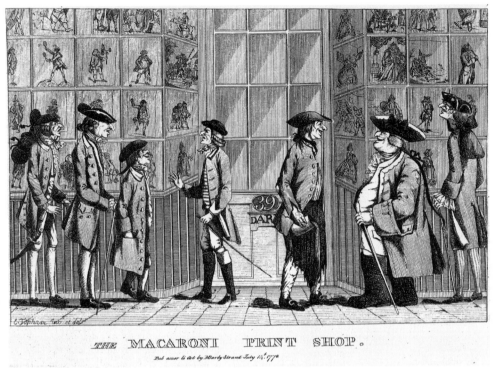

THE MACARONI PRINT SHOP.

3 Edward Topham, *The Macaroni Print Shop*, 14 July 1772.

through the print medium, thereby sparking the interest of connoisseurs.[19] And satirical political prints clearly benefited from innovations in the print medium at large. However, the collecting of prints, including political satires, among connoisseur-collectors, can be seen as affirming rather than challenging the aesthetic prejudice against the informal (read inferior) graphic medium.[20] Although framed prints often functioned as affordable substitutes for oil paintings, the code for the 'proper' manner of displaying, contemplating, collecting and sharing art works was a strict one among those of wealth and 'taste' in eighteenth-century Britain.[21] For members of this elite, codes of aesthetic taste which dictated where particular works of art should be placed in the private home were based on hierarchies of both genre and medium. Prints were generally not to be hung on walls but rather carefully compiled into folios which were brought out for the specific purpose of viewing them in private or in intimate groups. As the appreciation for prints as art increased, so did their framed and hung 'visibility' in collectors' private homes.[22] Additionally, the short-lived fashion of pasting prints directly onto walls as part of interior design programmes also reveals how an accessible and relatively inexpensive form of visual culture could, in fact, function as a kind of symbolic possession of cultural taste and social distinction.[23]

But the spectrum of viewing contexts for political satires in late eighteenth-century Britain was more multifarious and extensive than the dichotomy between private ownership and public sharing suggests.[24] For example, some print shop

10

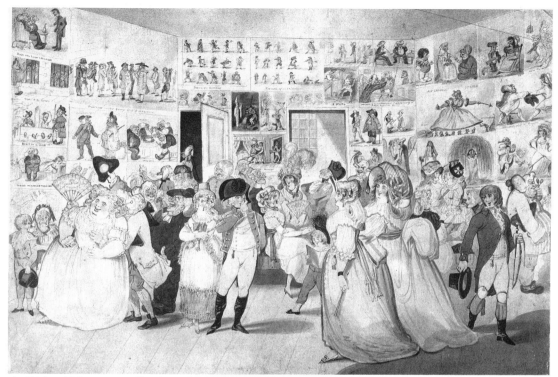

4 Richard Newton, *Holland's Exhibition Room*, 29 May 1772.

entrepreneurs provided rental services which hired out folios of political prints for the evening.[25] In the late 1780s one could also visit exhibitions of 'Entire Caricature Histories' for the admission fee of one shilling (plate 4). Political prints were of interest to royalty as well, and George III, when away from London, had the latest Gillray print sent to him.[26]

Censorship, or the lack thereof, played an important role in the content and circulation of political ideas in the press as well as in prints throughout the eighteenth century.[27] Whereas the printing of each and every over-the-counter book, leaflet and print was scrutinized under France's absolute monarchy, pre-publication censorship of the press had ceased to operate in Britain when the licensing act expired in 1695.[28] In Britain the machine of censorship was put into motion only after printed items had already hit the streets and shops, making the policing of 'libellous' or 'seditious' material much more difficult and far from thorough.[29] The trend in Britain throughout the century was toward more liberties of the press, and toward greater freedom to express in published form criticism of political means, measures and individuals.[30]

Gillray's representation of the eating peasant-king in *Monstrous Craws* is part of the eighteenth-century phenomenon which attests to the increasing circulation of political information and debates through numerous popular forms including newspapers, pamphlets, ballads and prints.[31] But in the visual language of satire, individuals with political power, authority and privilege

received a larger share of 'exposure' than the Executive, the House of Lords and the House of Commons.[32] The distortion of caricature lends itself much better to the depiction of individuals than to representations of bodiless principles or faceless parliamentary edifices; George III the man was favoured over the institution he represents as a target among graphic satirists. And *Monstrous Craws* is clearly an example of satire writ large on the body of the man who is king. Yet the occasions on which engravers directed their sharpest needles specifically toward the identifiable, mortal body of the king are relatively few in contrast to the wealth of satire produced in Britain in the eighteenth century. The degree to which the 'divine' headcovering insidiously prevented graphic satirists from traversing the bounds of acceptable ridicule is difficult to assess since no prosecutions were brought against engravers for satires of the king during George III's reign — not even during the hyper-paranoia that accompanied Britain's war with France, when the Treasonable Practices and Seditious Meetings Bills of 1795 loomed.[33] Ironically, both Bills were satirized in prints.

The benefit of lax printing restrictions for engravers, publishers, viewers of political caricature and readers of texts critical of the State is clear; the benefit of permitting such liberties for the Crown and the Constitution, however, is less so. The lack of governmental censorship, a phenomenon unique to Britain at the time, must be factored into the maze of overlapping contradictions in the relationship between print culture and the 'enlightened' politics of a constitutional monarchy on the changing field of socio-political experience. When twentieth-century historians argue that the profusion of circulating political critique, in the form of daily, weekly and bi-monthly newspapers, as well as pamphlets, ballads and, of course, satirical prints, reveals the emergence in the eighteenth century of a politically conscious public, they are in fact echoing claims that were made in that period by conservatives, liberals and radicals alike.[34] They are again reiterating eighteenth-century rationale when they claim that the free press played an integral role as an extra-parliamentary tribunal which kept checks on the deeds of public and political persons. With regards to eighteenth-century attitudes toward the censorship of the press, the view of Sir William Blackstone, the most famous legal writer of the period, was that:

> The liberty of the press is indeed essential to the nature of a free state: but this consists in laying no previous restraints upon publications and not in freedom from censure for criminal matter when published. Every free man has an undoubted right to lay what sentiments he pleases before the public: to forbid this, is to destroy the freedom of the press.[35]

An associated concept was that the freedom of the press was an indication of British liberties in general.[36] For example, holding up the freedom of the press as a 'peculiar privilege of the British subject', Edward W. Montague wrote in 1759 that

> Freedom of thought, or the liberty of the mind, arises naturally from the very essence of our constitution; and the liberty of the press, that

peculiar privilege of the British subject, gives every man a constitutional opportunity of laying his sentiments before the publick.[37]

With the greatest of admiration, adherents to the full political spectrum invariably praised the freedom of the press as the exemplary, cherished liberty guaranteed under the British Constitution in the Georgian era. Given this great pride in the liberty of the press in Britain, the 'arch libellers' of satire may not have been so defamatory after all.[38]

Siding with the King

Monstrous Craws is an example of visual satire at its most basic and farcical. Easily recognizable to contemporary viewers as a likeness of George III, yet toppling him from his position at the pinnacle of the social and political hierarchy: such are the fundamental visual puns of satire that could engage a broad audience in the sport of royal ridicule — a sport played in Britain with national pride.[39] *Monstrous Craws* does not, however, represent the *regression* of George III to peasant and to political impotence (the condition of virtually all the nation's peasantry at the time). The image shows rather a visual transformation of the king so utterly complete that it is unequivocally a reversal of the status, power and gender of the king. But is it even simply that? Instead of emphasizing the gulf between the king and the peasantry, the image of the peasant—king may also suggest that there is no gulf at all; for the apparent contradiction of the peasant—king is not only a vividly farcical motif, but also a relic of an old partnership.

Picturing the social hierarchy turned entirely upside down, the social contrast between the king and the peasantry is a reminder of the moral and legal contract between he who looks down from the very top of the constitutional pyramid and those toiling at the very bottom. The tradition of reciprocal responsibility between the monarch and the poorest subjects of the Crown stretches back to Queen Elizabeth I, who codified a set of emergency measures, commonly described by the term the 'Paternal Model', to ensure that the poor would have their share to eat.[40] Interestingly, those whom the queen and her council held culpable for undue hardships were of the same economic group that the poor blamed: the wealthy. The Paternal Model made clear the Crown's view that it was the 'greedy desier' of those who 'bee not content w[i]th anie moderate gayne, but seeke & devise waies to kepe up the prices to the manifest oppression of the poorest sort'.[41] A number of incidents during the eighteenth century reveal that the Paternal Model continued to have force in the minds of disenfranchised Britons two centuries after Elizabeth. That the rich continued to be blamed for hard times is demonstrated by an anonymous letter sent to the Bailiffs of Whitney in 1767, in which the enemies of the poor are described as 'damned wheesing fat gutted Rogues' who 'Starve the Poor by such Hellish Ways on purpose that they may follow hunting, horse-racing etc. and to maintain their families in Pride and extravagance'.[42] In such attacks on the wealthy, the king was often called up as the ally of the common people rather than a friend of the monied and

privileged classes whose interests George III, a wealthy landowner himself, shared. The king as ally of the people — a profound myth indeed.[43] Nevertheless, it was an ideal of kingship that supported notions of the kingdom as an organic body with the king at the top: the head of the State.

An anonymous copper-plate engraving entitled *England's Firm Pyramid* (plate 5) draws on the motif of Parliament as a pyramidal edifice which gives human form only to a youthful George III, dressed in the full regalia of his station, and to the workers of the land. All remaining components of the social and political body are excluded or merely implied by inscription on the slanting sides of the structure from which the man who heads the State overlooks those who work the plough. Beneath the illustration is written:

> Behold England's Pyramid gracefully peering.
> O'er a beautiful Campaign — Fields reaping — sheep shearing.
> The people all joyous, peaceful and prosperous.[44]

Nothing obscures the view of the 'joyous, peaceful and prosperous' from the crowned king firmly placed at the apex of the constitutional pyramid and 'gracefully peering' from above: timeless pastoral tranquillity ensured by the grace of the royal overseer. This print, which appeared in a pamphlet published near the end of George III's life, relies on the leitmotif of the monarch as the omniscient, benevolent guardian of the people: an unlikely bond between social, political and economic extremes. Adapted to the erroneous representation of George III as an aproned labourer of the land in *Monstrous Craws*, the traditional link between the king and the peasantry is an important sub-text of Gillray's satirical print.

The peasant—king in *Monstrous Craws* recalls the legal bond between the monarch and the poor, but with an added ironic twist. The representation of the peasant—king appears to close by inversion the social and political fracture between class extremes. But the single food staple of the royal peasants' feast is the blood of the polity — John Bull's Blood. Royal generosity or voracious cannibalistic greed? Who, in fact, is being sacrificed for this feast of plenty?

The Royal Sport of Satire

The peasant—king in *Monstrous Craws* recalls the tradition of the mocked or 'carnivalesqued' king, a theme which had been treated for centuries in popular culture. But its subject, George III, brings that theme into a contemporary frame of reference; into an historical frame in which the signifying potential of the 'carnivalesqued king', animal—man, and cross-dressed man, has shifted.[45] Peter Burke, in his study of popular culture in early modern Europe, discusses food (especially meat, unsurprisingly given the root 'carne'), sex and violence — often in the form of animal 'sports' or torture — as key ingredients of Carnival.[46] These three elements could be expressed in ways that reflected regional and political specificity, but they were always conspicuous during carnival by a license and an excess which everyday life did not allow.[47] In *Monstrous Craws*, the

14

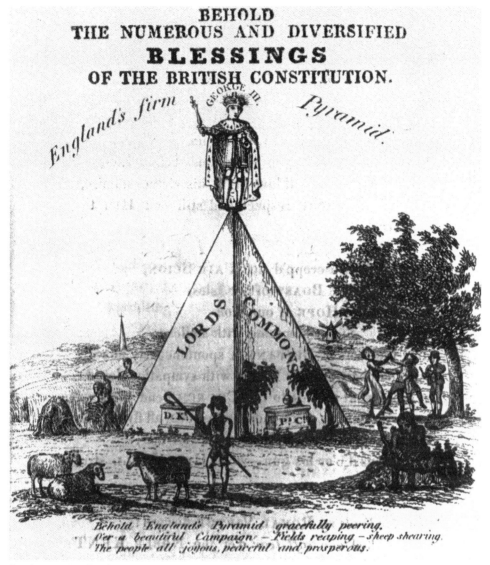

5 Anon., *England's Firm Pyramid*, n.d.

cross-dressing of the king, the abundant 'feast', and the violence against the living implied by cannibalism are all remnants of the popular ritual which permitted the world, for a designated time, to be turned upside down. Although travesties are the prerogative of the carnival rite, participation in the transgressing of codes is contained by and within the subversive event which is itself contained within the normative framework of the everyday.[48] The print *Monstrous Craws*, however, is a fixed object which presents the king as a physical likeness and as an aberration of that likeness: the empirical 'truth' of seeing juxtaposed with the fantastic. Is the laughter at the print's carnivalesque imagery 'contained' by dominant, normative cultural codes in a way that parallels the containing of

popular ritual within everyday propriety? Or, because the print is an object which exists over time, rather than an act which lasts merely for the duration of rite, is it in fact more integral to, and more integrated within, the everyday, as a thread weaving in and out of the fabric of kingship, thereby adding weight, texture and strength to the discourse of authority?

Facial and physical hyperbole, and preposterous settings and juxtapositions, are the keystones of graphic satire. Unlike the persuasive force of a text which presents itself as 'truth', or as simply the way things are, the basic syntactic absurdities of visual satire add humour to the political content of satirical prints without imposing a political way of seeing on the viewer—reader. 'Truth' and empirical validity are, after all, diametrically opposed to rudimentary pictorial devices of satire such as obvious exaggeration and distortion. Paradoxically, graphic political satires might also insidiously darken the lines which the printed word renders as factual contours.

Between encouraging a 'collective' political critique and provoking a subjective humorous response is a plethora of possibilities of how a satirical image of the king can be broadly functional in a political manner, and how it can be singularly interpreted. Because, in *Monstrous Craws*, this whole spectrum is confounded within the representation of the body of George III and the animistic member growing beneath his chin, political commentary and carnivalesque comedy become two halves of one body: two distinct yet inseparable halves. One half is the living body of George III. The other is the symbolic corpus of kingship which osmotically procreates the myth of royal right and privilege in the living mortal body of he who is king. It is the latter, the symbolic half, that makes George III, or any man, 'King'. Without the symbolic half he is but a man, nothing more.

Can the body of the sacred, immortal king be severed from the mortal being — the living embodiment — in an ideological and political system which incorporates a king who both reigns and rules? The sacred core pumps life through the symbolic body — the essence — of kingship; it can be taken from one living body and transplanted into another, and can survive each monarch's death. It exists at the same time within and without the living, empirical body of the monarch.[49] The beheading of Charles I in 1649 did not cause the death of the myth of kingship in Britain; it only caused it to withdraw into a state of dormancy. With another living cipher, the royal myth was brought back to life. And the sturdiest sutures to keep the man joined to the myth are representations that show that the miracle has been performed.

Satirical representations of George III which directly mock his physical body are not divorced from the dominant discourse of kingship. They cannot be. Nor are they disengaged from official forms of regal representation. For they all occupy a space within the complex network of defining and supporting texts which are in and of themselves the link that ensures the life of the symbolic body of kingship. Although they may appear to be depraved blasphemies of the semi-sacred institution of kingship, regal satires respond to the discourse of kingship, and are informed by its legend. As the living, reigning king is the embodiment of national identity in whose body an era is distilled, mocking the man who is king brings the institution of kingship and all it connotes into the joke. The punch-

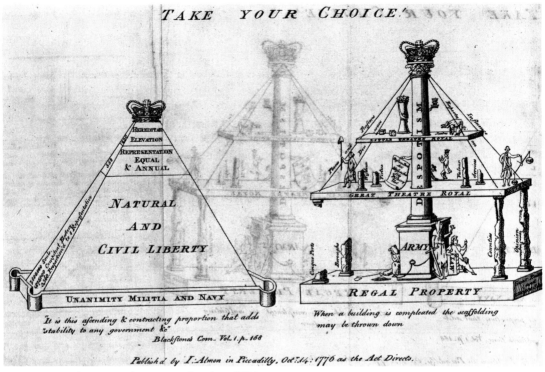

6 Anon., *Take Your Choice!*, 14 October 1776.

line would be impotent, meaningless, without the reference to kingship, and satires of George would be aristocratic caricatures, not political satires.

Before the legal and parliamentary challenges to notions of divine right peeled away some of the mystical, quasi-religious casing which had rendered the power of the king absolute, there was virtually no graphic tradition of regal satire in Britain.[50] But after 1649, with the example of Charles I, the king could be held accountable, could be criticized, punished and ridiculed.[51] Free of the prohibition of royal ridicule, graphic satires of the king began to appear in Britain more than a century before George III took the throne, their numbers increasing after the Glorious Revolution. Multiplying throughout the Georgian era, graphic satire reached peak production during the reign of George III. Consequently, when *Monstrous Craws* appeared in London in 1787, images which mocked the British king would no longer have struck Britons as equivocal.

Implicit abstract emblems prior to the 1780s provided the satirist with a guarding shield while the lingering taboo of regal satire remained a spectre of self-censorship.[52] Allegory is an iconographic mode among political satirists used when portrait caricature begins to come to the fore in the 1770s. The frontispiece for a political pamphlet entitled *Take Your Choice!* of 1776 (plate 6), for instance, lends visual force to the political views discussed in the text by Major John Cartwright, a radical reformer and founder of the Society for Constitutional Information.[53] The print, which, like the aforementioned *England's Firm Pyramid*, draws on the structural motif of parliament as a

pyramid, is an example of the power of images to convey concisely and with pictorial economy prevalent notions regarding the workings of government. The pictorial rudiments of the image are two pyramidal forms which are filled with emblematic references and labels alluding to Blackstone's *Commentaries* of 1765. The pyramid on the left represents a government which adheres to the principles of constitutional monarchy, and that on the right depicts a government in an advanced stage of decay; only the Corinthian column on which the crown is perched remains unscathed by corruption. George III, identified by his crown, is shown on the second tier of the shell-less structure, on the level labelled 'Great Theatre Royal'. But the figure of the crowned man is distanced from the symbolic crown which looms above. Severed from his responsibilities as the head of the State, the health of the political body headed by George III is endangered. Because of the manner in which political concepts and assumptions are rendered as geometric structures embellished with impersonalized figures and abstract emblems, the engraving belongs to the visual tradition of emblematics: the body politic is represented without 'animate' features — without the human organs — on which caricature feeds. It is thus a political print, but it is not a caricature.

Monstrous Craws belongs to a different sub-category of prints and graphic satire: portrait caricature, in which the identifiable body of the living king is neither avoided nor generalized, but rather amplified, particularized and mocked. In Gillray's satirical narrative, the body becomes the chief carrier of comedy and critique. Yet, if direct ridicule of the king's body remained for so long disguised beneath abstract allusions for a political reason, then the reasons for lifting this taboo of regal representation must also have a political foundation.

Celebrating the King

If there was a marriage between graphic political satire and George III, it was surprisingly untroubled. Indeed, this liaison was remarkably functional. But how (to return to my opening question) could the irreverent attacks of satire not harm the status of the person at whom they were directed? Were not the implications of showing the royal family voraciously devouring the symbolic body of the British polity stretching satire to the border of treason. Obviously not. *Monstrous Craws at a New Coalition Feast* was not censored. The boundary between humour and unacceptable insult was not transgressed by an image in which the king was represented as a greedy, cannibalistic peasant.

The political events and intrigues surrounding George III's royal predecessors undoubtedly resulted in a slow but steady rethinking of the king's power, which went hand in hand with the inculcation of a different notion of the king's role as crowning cap of the constitution and father of the nation. Political theorists throughout the eighteenth century argued that the power of the king was to be balanced and checked by that of the two Houses of Parliament: this was the legal outcome of seventeenth-century parliamentary discord. But how would changes in parliamentary law impact on extra-parliamentary notions of the monarch's role, function and royal prerogative? Contrasting British and French monarchs in the eighteenth century reveals a striking difference between the

Protestant British king of foreign descent, and the Catholic French king, who ruled at the end of an almost three-century-long unbroken lineage of Bourbons. When the Hanoverians were given the throne in 1714, their accession could only be founded on divine right with the greatest of faith. The symbolic link to the divine was yet to be severed in France whereas it had been severed and resurrected by Parliament in Britain a century earlier. No doubt some of the 'magic' of the divine ruler had waned in the process. Yet much of it remained in the minds of the monarch's subjects (as indeed it does to this day). The outbreak of the French Revolution in 1789 necessitated the construction of defensive fortifications around the discourse on British freedom and indeed the British monarchy — both of which appeared ancient in contrast to the demands and ideals of French Republicans. In all but the most radical circles, the British king was an accepted component within the constitutional machine.[54] But acceptance did not rule out criticism and political caricature participated in the playing field of out-of-doors political criticism. The same is true of the viewers of satire, which included both those who had political clout and those whose participation in politics was restricted to symbolically clouting power, ridicule being among the repertoire of equipment to employ in their criticism of misrule.

Was satire a safety valve that ensured that any displeasure with the political state of things would dissipate into harmless laughter before it could solidify into mass dissent? Or was political satire a demonstration that parliamentary checks and balances extended to include all social concentric circles of allegiance? Ironically, it was both. An image of George III eating John Bull's blood hit home the fact that much British blood had been spent since the third George had taken the throne, and pointed directly at the abuses of the king. But this criticism could be absorbed, dissipated and turned into palatable humour.[55] At times, however, criticism of ruling bodies could not — and cannot — be robbed of its anti-authority sting. Indeed, the topical import of *Monstrous Craws* points an unabashed finger at an abuse of the Crown — the prince's extravagance. But if the print satirizes the prince's spending, then it also converts criticism of the royal extravagance in general into a kingly coup for George.[56] On 24 May it was announced in the House of Lords that

> an additional allowance [would be allotted] to his Royal Highness the Prince of Wales, out of his Majesty's Civil List, in order to remove every possible doubt of the sufficiency of his Royal Highness's income to support amply the dignity of his situation, without occasioning any increase to the annual expense of the Public.[57]

The royal reconciliation received wide coverage in all shades of the popular press. Gillray's print is a satirical 'celebration' of the corresponding royal occasion. But unlike government newspapers, which reported the event in terms of the great magnanimity of the king both towards his son and his subjects, Gillray's image of 'a New Coalition Feast' uses an entirely different trope. Taking into account the well-publicized blemishes on the relationship between father and son, the artist tints the irony of his image of George III with judgement — the king who shares his feast but at the same time stashes reserves in his craw. In the terms of the reconciliation, George III demonstrates his dedication to the

well-being of his subjects as well as a fatherly compassion for his son. The public announcement emphasizes the domestic and public responsibility of the patriarch and king. In some newspaper reports of the prince's debts, criticisms of him are only thinly disguised. The contrast between the extravagance and impudence of the prince and the paternal generosity and public responsibility of his father is writ large in the public announcement of the outcome of the financial conflict and in the moralizing sub-text of *Monstrous Craws at a New Coalition Feast*. It is no great leap to suggest that George III's paternal generosity as the male head of his family could have implications for his role as symbolic father of his subjects. But, dressed as a woman and a peasant, he appears quite ineffectual both as father and king. The public and political rift between king and prince spill over onto Gillray's image of the domestic coalition around the royal dining table. Gillray makes the contrast between king and prince stark and obvious: their costumes, manners and appetites for the golden nuggets are the product of more than a generation gap. But there is also great political import in the comical dichotomy embodied in their differing physical constitutions which makes the joke of the feasting trio suddenly more sober. Recognizing that their feast consists of the life-blood of the polity, and that their craws appear like money bags, the obligation George III has to the social contract between himself and his subjects becomes highly questionable.

Rumblings within the 'excellent constitution' surface in the mocking of the mortal body of the king in *Monstrous Craws*. While the different spending habits of the king and the prince provide the 'topic' of *Monstrous Craws*, the historical thesis is beyond that which meets the eye. Indeed, what is significant in the graphic irony of the feasting king is that only the abuses of the man are exposed. And by engaging in laughter over ridiculous George III the privileges of class power are made momentarily tolerable, and the abuses of power perhaps even forgiven. Laughter: the great ameliorant. Autocratic monarchs might not allow their subjects the sight of graphic royal derision and the fantasy of levelling. That Britons possessed the liberty to laugh at the king is inseparable from the collective nod of approval; a nod that pays homage to the head of the British Constitution and supports the political system that values stability and 'balance' in its hierarchical order. Ridicule of the mortal man does not impede the resurrection of the regal body of the king who must never die. Rather, satire acts here as a mischievous Puck guiding monarchs through the kingly passage from one era to the next.

Although laughter recognizes undemocratic privileges and the abuses of power, it does not necessarily call for their destruction. Stripped of the emblems of his rank, George III in *Monstrous Craws* is, ironically, still represented as a disciplining and benevolent father of his son, and, by extension, of the nation. By satirizing the king, the abuses of power and public funds are put into visual form, but there is no suggestion that the political fabric should be ripped, torn, or refashioned. The regal body of the king remains solidly placed at the pinnacle of the pyramid that is the British Constitution, with the crown its capping lantern, while the sound of laughter at the sight of George echoes off the walls of the vast political order.

<div align="right">

Lora Rempel
City University of New York

</div>

Notes

This article derives from a project begun in 1992 at the University of British Columbia, Vancouver. The first version of this paper benefited greatly from Maureen Ryan's many helpful criticisms, theoretical insights and encouraging suggestions. I am indebted to John O'Brian and Sandra Gillespie who both read early drafts and offered invaluable comments. I wish also to thank the Editor for bringing to my attention a number of relevant citations.

1 J. Wardroper, *Kings, Lords, and Wicked Libellers: Satire and Protest, 1760–1837*, London, 1973, p. 8.

2 J.A. Downie, *Robert Harley and the Press: Propaganda and Public Opinion in the Age of Swift and Defoe*, Cambridge, 1979, pp. 7–8.

3 On the Hanoverian dynasty's continued connections with their kingdom on the Continent, see J. Godechot, *The Counter-Revolution: Doctrine and Action 1789–1804*, trans. S. Attanasio, Princeton, 1971, p. 109.

4 I found L. Colley's work on George III as a national symbol very helpful on this point. 'The Apotheosis of George III: Loyalty, Royalty and the British Nation 1760–1820', *Past and Present*, February 1984, pp. 94–129.

5 Discussed by J. Brewer in ' "This Monstrous Tragi-comic scene": British Reactions to the French Revolution', in D. Bindman (ed.), *The Shadow of the Guillotine: Britain and the French Revolution*, London, 1989, pp. 11–25.

6 W. Feaver's statement is exemplary: 'Caricature is always Us against Them. The joke is shared; so is the hate,' A. Gould (ed.), *Masters of Caricature: From Hogarth and Gillray to Scarfe and Levin*, New York, 1981, p. 9.

7 A.H. Birch, *Representation*, London, 1971, p. 30.

8 See W.D. Jordan, 'Familial Politics: Thomas Paine and the Killing of the King, 1776', *Journal of American History*, vol. 60, September 1973, pp. 294–308, for an intriguing analysis of ideas of kingship within a new republic.

9 Shifts in the legend and iconography of John Bull are the focus of J. Surel, 'John Bull', in R. Samuel (ed.), *Patriotism: The Making and Unmaking of British National Identity, National Fictions*, vol. 3, London, 1989, pp. 3–25.

10 On the metaphor of the king as father of the country, see J. Daly, *Sir Robert Filmer and English Political Thought*, Toronto, 1979, pp. 57–81. The politico-theological notion of the father–king is discussed by V. Carretta, *George III and the Satirists from Hogarth to Byron*, Athens, 1990, p. 152.

11 The long story about the prince's debts is told in detail by J.H. Plumb, *The First Four Georges*, London, 1956, pp. 134–9.

12 Reported in the *Morning Chronicle and London Advertiser*, 25 May 1787; and the *London Chronicle*, 12 May 1787.

13 For detailed accounts of these points see M.D. George, *Hogarth to Cruikshank: Social Change in Graphic Satire*, London, 1967, p. 17; P. Burke, *Popular Culture in Early Modern Europe*, London, 1978, p. 109; D. Marshall, *Dr Johnson's London*, New York, 1968, pp. 132–3; P. Anderson, *The Printed Image and the Transformation of Popular Culture 1790–1860*, Oxford, 1991, p. 36; and M. Harris, 'Print and Politics in the Age of Walpole', in J. Black (ed.), *Britain in the Age of Walpole*, London, 1984, p. 8.

14 This is argued in a provocative way by D. Donald in ' "Character and Caricatures": The Satirical View', in N. Penny (ed.), *Reynolds*, New York, 1986, pp. 355–63.

15 L. Simond, *An American in Regency England*, C. Hibbert (ed.), London, 1968, p. 28.

16 See, for example, J.W. Archenholtz's comments on the broad interest in politics in England. *A Picture of London . . .* , London, 1797, p. 63. For the response to the 'licence permitted to the people' and the widespread interest in politics in Georgian England, see R. Porter, *English Society in the Eighteenth Century*, London, 1982, pp. 103–104.

17 *Briton*, 11 September 1762.

18 D. Hill, *James Gillray 1756–1815: Drawings and Caricatures*, London, 1967, p. 7.

19 See R.T. Godfrey, *Printmaking in Britain: A General History from its Beginnings to the Present Day*, New York, 1978, p. 43.

20 On cultural capital as a mark of social distinction, and how the modes of artistic consumption define and legitimate social differences, see P. Bourdieu, *Distinction: A Social Critique of the Judgement of Taste*, trans. R. Nice, Cambridge, Mass., 1984.

21 J. Barrell, 'The Private Comedy of Thomas Rowlandson', *Art History*, vol. 6, no. 4, December 1983, pp. 431–3.

22 Although the most prized examples of a gentleman's collection of works on paper would have been displayed. See S. Lambert, *The Image Multiplied: Five Centuries of Printed Reproductions of Paintings and Drawings*, London, 1987, p. 176.

23 Lambert elaborates on the Paris-born fashion of wall papering with prints which was practised for a short time in England by a wide range of society. Ibid., p. 183.

24 R. Cartier's work on reading practices and the development of 'a hierarchy among plural uses

of the same material' has been of great value to my analysis of audiences of political prints. *The Cultural Uses of Print in Early Modern France*, trans. L.G. Cochrane, Princeton, 1987.

25 As did Fores and other print-sellers. D. Kunzle, *The Early Comic Strip: Narrative Strips and Picture Stories in the European Broadsheet from c. 1450 to 1825*, Berkeley, 1973, p. 176.

26 M.W. Jones, *A Cartoon History of the Monarchy*, London, 1978, p. 40.

27 S. Kadison, 'The Politics of Censorship', *The Charged Image: French Lithographic Caricature 1816–1848*, Santa Barbara, 1989, pp. 23–7, discusses the post-Revolutionary history of censorship of political prints in France, contrasting the French situation with Britain's tradition of press freedoms.

28 Downie, op. cit. (note 2), p. 1.

29 For a relevant discussion of this issue, though focused on the context of France in the nineteenth century, see R.J. Goldstein, *Censorship of Political Culture in Nineteenth-Century France*, Kent, Ohio, 1989, p. 3.

30 On the Stamp Act (proposed in 1704 but not adopted until August 1712) as functioning as a substitute for censorship, see F.P. Lock, *Swift's Tory Politics*, London, 1983, pp. 2–12.

31 A major reference point for analysing popular forms of political debate in print is E. Hellmuth, ' "The palladium of all other English liberties": Reflections on the Liberty of the Press in England during the 1760s and 1770s', *The Transformation of Political Culture: England and Germany in the Late Eighteenth Century*, Oxford, 1990, pp. 467–501.

32 See H.T. Dickinson, *Caricatures and the Constitution, 1760–1832*, Teaneck, New Jersey, 1986, p. 31.

33 P.D.G. Thomas, *The American Revolution*, Cambridge, 1986, p. 12; and M.D. George, *English Political Caricature 1793–1832: A Study of Opinion and Propaganda*, Oxford, 1959, pp. 18 & 122.

34 Even critics who denounced the press' representation of people or events as 'irresponsible' or 'immoral' were ultimately in favour of a free press. See E. Hellmuth, op. cit. (note 31), pp. 467–501, where he examines the debate over the freedom of the press in eighteenth-century England.

35 W. Blackstone, *Commentaries on the Law of England*, London, 1769, p. 151.

36 On the contemporary notion of the free circulation of ideas in Britain, see J.P. Klancher, *The Making of English Reading Audiences, 1790–1932*, Madison, 1987, pp. 29–32.

37 E.W. Montague, *Reflections on the Rise and Fall of the Ancient Republics*, London, 1759, p. 4 (quoted in Hellmuth, op. cit. [note 31], pp. 478–9).

38 I borrow the term 'arch libeller' from a comment in the *Public Advertiser*, 5 June 1765, by George Bout-de-ville (a pseudonym, no doubt), which reads:

> Every window of every printshop is in a manner glazed, and the shop itself papered, with libels One arch-libeller in particular has rendered himself more than a hundred times liable to prosecution He has dealt his grotesque cards from house to house and circulated his defamatory pictures from *Town's end* to *Town's end*.' (The reference is to George Townshend.)

39 On the 'liberty of abusing their betters, the boast of the English', see T. Wright (ed.), *The Works of James Gillray . . .* , London, n.d., p. 12.

40 E.P. Thompson, 'The Moral Economy of the English Crowd in the Eighteenth Century', *Past and Present*, no. 50, 1971, pp. 76–136.

41 'A Coppie of the Councells her[e] for graine delyvrd at Bobmyn the xith of May 1586' (quoted in ibid., p. 108).

42 Quoted in ibid., p. 127.

43 For a detailed and provocative critique of popular myths of the British monarchy see E. Wilson, *The Myth of British Monarchy*, London, 1989.

44 *England's Firm Pyramid* (BMC 13558), anon., n.d., reproduced in Carretta, op. cit. (note 10), p. 345.

45 A topical reference for the image of craw-bearing George III in *Monstrous Craws* was a popular contemporary 'amusement' in London from which the title of the print in part derives. An advertisement in the *Morning Chronicle and London Advertiser*, 29 May 1787, announces the exhibition of 'Monstrous Craws, Wild Human Beings' and claims that the three living 'spectacles' of the exhibition, two female and one male, eat from ten in the morning until ten at night. In fact, the three 'wonderful phenomena' were sufferers of goitre, and had large growths under their throats which moved when stimulated by eating, speaking, or laughing. No doubt the overgrown glands and the apparently insatiable appetites which attracted the curiosity of the public provided the satirical iconography of the bizarre added body parts for the royal three.

46 On Carnival see Burke, op. cit. (note 13), pp. 178–89.

47 This point is elaborated in M. Bakhtin, *Rabelais and His World*, trans. H. Iswolsky, Bloomington, 1984, p. 219.

48 For a critique of the 'carnival spirit' in nineteenth-century England, see R. Sales, *English Literature in History 1780–1820:*

Pastoral and Politics, New York, 1983, p. 169.

49 The concept of the sacred body of the king as distinct from the mortal person who is the king is theorized in the following texts to which I am indebted: L. Marin, *Portrait of the King*, Minneapolis, 1988; E.H. Kantornowicz, *The King's Two Bodies: A Study in Medieval Political Theology*, Princeton, 1957; and S. Zizek, 'The King is a Thing', *New Formations*, vol. 13, Spring 1991, pp. 19–37.

50 Carretta's thorough analysis of the relationship between satirists and George III was tremendously helpful on this and many other issues, op. cit. (note 10), p. 1.

51 On the changing faith in divine right in England, see H.T. Dickinson, *Liberty and Property: Political Ideology in Eighteenth-Century Britain*, London, 1977, pp. 13–18; and, as revealed by the termination of the practice of the hereditary miracle of royal 'touching' under the Hanoverians, see M. Bloch, *The Royal Touch: Sacred Monarchy and Scrofula in England and France*, trans. J.E. Anderson, Montreal, 1973 (esp. pp. 218–23).

52 See Burke, op. cit. (note 13), pp. 154–5.

53 In her discussion of this print, L. Colley, 'Radical Patriotism in Eighteenth-century England', in R. Samuel (ed.), *Patriotism: The Making and Unmaking of British National Identity*, vol. 1, London, 1989, pp. 169–87, brings out the tensions inherent in the patriotic discourse of radicalism in England after the American Revolution.

54 A. Goodwin, *The Friends of Liberty: The English Democratic Movement in the Age of the French Revolution*, Cambridge, Mass., 1979, pp. 24–5.

55 In fact, the decade of the 1780s saw a gradual rise in the popularity of the king, which continued to climb in the 1790s. W. Hunt, *The History of England From the Accession of George III to the Close of Pitt's First Administration (1760–1801)*, London, 1905, p. 307.

56 The dissolute public conduct and lavish spending of the heir immediately upon entering public life in 1783, gave a varnish of respect and admiration to the more temperate king. Colley, op. cit. (note 4), p. 104.

57 *London Chronicle*, 24–26 May 1787, p. 497.

Art History ISSN 0141-6790 Vol. 18 No. 1 March 1995 pp. 24–36

'In Betweening':[1]
An Interview with Irene Kotlarz

Barry Curtis

Irene, you have been interested in animation for a long time and have approached it as a teacher, a writer, a programmer and a producer. I know that it's difficult to think of animation as any one thing and that most accounts of it have been reductive of its range of practices, contexts and forms; but what, for you, are its key characteristics?

I feel that animation is difficult to define, and as you say it covers a wide range of ways of working and visual forms. I think of it as a marginal activity, something that has rarely been taken seriously either institutionally or by audiences. It is interstitial in the way that it is marketed and experienced, although it is increasingly consumed in bulk, and whole satellite and cable channels are devoted to it. It is taken most seriously in the case of full-length animation features. Animation used to be conceived largely as a special effect or a filler to provide moments of relaxation and mayhem between 'real' films. It is often conceived of as a form and an experience that is particularly suitable for young people — appropriate for a lowered level of emotional and intellectual involvement — as pure entertainment. It's hard to say, of course, how most people think of animation, but probably the first thing that would come to mind is 'funny cartoons'. More recently there have been significantly popular animation programmes on television. I would say that the popularity of *Creature Comforts*, *The Simpsons* and *Beavis and Butthead* in America — both of which are centrally concerned with youthful transgression — have had quite an impact.

How do you think that animation, as it has been practised over the last fifty years relates to the wider category of illustration, to, say, satirical cartoons or the comic strip?

I think it's hard to ignore the peculiar nature of creation and the mode of production as well as the fact that animation is concerned with narrative in time in a way that other forms of illustration aren't. Animation is a very difficult and painstaking medium. It requires extreme patience and is often associated with a degree of obsession which promotes a particular relation to it on the part of producers and consumers. It creates aficionados and is steeped in a very self-

aware attitude. People who make animated films tend to be really dedicated. There is an obsessive and almost childlike interest in making things move — which often starts in early childhood. It is essentially different from other media in that respect. Like film, it develops narratives, but unlike it, doesn't mistake the photographic for the real. It creates characters that move and often the characters participate in producing or disturbing the illusions which create them. The first animators, people like Emile Cohl, were clearly developing in relation to, and out of, cartoons and grotesque and satirical drawings, and incorporating all those elements of exaggeration and selective distortion.

Would you say that those origins in comic and satirical drawing predisposed animation in a comic mode?

Well, yes it had strong links with comic strips, which are, of course, already concerned with narrative, but it's important to recognize the influence of vaudeville and early film. Many of the first animators like Cohl in France, or Winsor McCay in the United States, or Lancelot Speed in Britain were also comic-strip artists of political cartoons. Others, like the American Stuart Blackton, were vaudeville performers. Blackton did 'chalk talks' — a live act illustrated with blackboard drawings. He, and others like Winsor McCay, went on to use projected animated films as part of their act. In some cases clever timing made it possible for them to interact with their cartoon characters by tossing balls to them, or becoming incorporated into the two-dimensional image as drawn versions of themselves. People like Cohl were very aware of what was going on in cinema at the time; he also had links with painters. There has always been close attention within the animation community and industry to what's been going on in contemporary painting and illustration.

Has the association with children always been present; has animation always been regarded as somehow juvenile and essentially ludic?

I would say that there is an inevitable link with the childlike because so many of the concerns of animation have been with the unfilmable, or with aspects of the imagination which are hard to represent in other media. Movement itself can be rendered in evocative ways, objects and people can be deformed, metamorphosed and dismembered. So many of its themes have come from fables or folklore or magic. Maybe there is something too about the close attention to detail — an aspect of the process of production which promotes a kind of 'innocent' encounter with the world.

But the links with children were not so strong in early animation when the excesses of slapstick comedy were more central to mainstream film. In the early days it was closely linked with celebrations of the illusionary contrivances and power of editing. It foregrounded the means of producing illusion by montage, perspective and juxtaposition. There was a strand in early cinema which used animation and other tricks, which in more sophisticated form is what we would

now call 'special effects'. Eventually, the characteristic generic and stylistic conventions emerged. There is an argument that animation had such volatile and transgressively deconstruction potential that it had to be carefully packaged within the Hollywood system — that it had to be contained within conventional narratives — subject to a 'star system' which depended on the development of well-known characters and stereotypes, and that it had to be restricted to the characteristic 'seven-minute' running time.[2]

You said earlier that understanding the mode of production is crucial to understanding other aspects of animation. How much do you think that the process and relations of production determine meaning in the animated film?

I would say that it's very important to understand not only the way that animation is produced but something of the culture it is produced in. Obviously, commercial animation involves a high degree of organization and a complex division of labour.

It is, effectively, industrialized drawing. Certain directors, or 'key' animators, who do all the character development and the key concept drawings, have enjoyed cult status, but a lot of other people and skills are involved. In some respects, animation is the epitome of industrial production; in others it resembles the procedures which enabled large collaborative paintings or frescoes to be produced in the workshops of Renaissance artists.

Peter Wollen gave a lecture at an Association of Art Historians Conference in which he explained a similar division of labour on large-scale subway graffiti projects in New York.

Yes, it is, in a way, characteristic of all large-scale graffiti projects which have to be completed to strict deadlines — one night in the case of the example you mention. The Author becomes something like an inspirer and manager of the project.

Another characteristic of animators and animation is an acute and expert awareness of the archive. Animation studios tend to keep libraries of diverse material for reference. Some studios are well known for developing consistent and recognizable style. Others, like Speedy, are highly adaptive and get work on the strength of versatility and an ability to respond to needs. One of the tasks of commercial animation is to animate ideas which often start out as highly subjective and personal — finding a kind of identikit for vague perceptions and propositions. This is often an aspect of the development of character which can incorporate aspects of existing cartoon characters or real people; the history of animation is full of anecdotes of the incorporation and transformation of people into cartoons. It can also involve lengthy deliberations with agents, witnesses, or self over how some imaginary entity looked or moved.

I have been interested, though not convinced, by the way that attempts have

been made to claim Animation for postmodern theory — the sense of it being concerned with topologies, being so demonstrably intertextual and willing to bare the device, so disruptive of time and space . . . so much the logic of the supplement and so on. . . . In production terms it is certainly an interesting mixture of industrial, craft and electronic techniques.

Those claims were certainly in evidence at a conference I attended in Australia a few years ago.[3] The main thrust was Baudrillard and his notion of the 'simulacrum'. Unfortunately, most of the speakers knew more about Baudrillard than they did about animation, so this remains an under-developed but, perhaps, promising area of animation theory. The irony is that the mode of production has normally been very low-tech, until quite recently very artisanal and workshop-based, using traditional techniques and materials. It has been suggested, with some justice, that the Warner Brothers' cartoons, which are probably the most celebrated by theorists writing about animation, are — in their urbanity, their interest in speed, pragmatism and mechanics — pre-eminently modernist. I often feel that people who have been involved in producing animated films, had they been born a thousand years ago, might well have been scribes or manuscript illuminators; they have a similar meticulousness and usually share a similar anonymity.

Do you find that part of the appeal of animation is the way in which the persistence and the fatalism of the production process is carried over into the characterization and the narratives: *Roadrunner* (plate 7), for instance, which has often been sited as the acme of animation perfection and compared with everything from *Last Year at Marienbad* and Piet Mondrian, to the Myth of Sisyphus?[4]

I suppose it's inevitable that animators will be interested in processes and the minutiae of movement, as that is inherent in the project. One of the persistent gags is the distortion or separation of parts of the body: the infinite malleability that is implied in the conventions of 'stretch and squash' — in which bodies and things react excessively to contact, pressure and tension. It's interesting that animation is a process of bringing together individual moments in time, backgrounds and foregrounds and the work of specialized individuals. Perhaps the incessant sundering which is a feature of the films is a reaction to this determined synthesis.

Maybe part of the appeal to children is the sense that there is no underlying, predetermined structure, that anything can take on the shape of anything else, that roles can be reversed and signifiers and signifieds can merge.

For animators these visual gags are often the result of 'in jokes'. The professional discourse is full of anecdotes which are often subversive. I suppose that there is always a relation with the grotesque and horrific, because animation or re-

7 'Power to the Powerless?': Resnais, Mondrian, Sisyphus ... at the Acme of Animation: Roadrunner and Wile E. Coyote, created by Chuck Jones. © Warner Brothers; all rights reserved.

animation as a metaphor for bringing something alive is also part of the vocabulary of horror. Animation is often concerned with the abject. I am interested at the moment in an American MTV series called *Beavis and Butthead*[5] which is hugely popular but which has caused a lot of controversy in America. A bit like *Ren and Stimpy* on the BBC, its humour is unpleasant, anarchistic and socially disruptive. *Beavis and Butthead* is very low-budget, limited animation with minimal movement and long holds. It's about the unacceptable face of adolescence. I suppose that animation can carry the logic of violence or even apathy to a more excessive degree than live action. There is a long tradition too, of pornographic animation, often parodic and circulated clandestinely, sometimes as a parody of commercial work. There is also a tradition of inserting single pornographic frames or incorporating obscene reference which would be noticed by the trained eyes of other animators. Since the widespread ownership of video machines with stop-frame facilities, this has become risky, but the general principle of hiding things in the margin or in the background seems to be part of the illicit project of the medium.

So, do you think that animation can usefully be considered as an extension of older traditions of caricature and satire in illustration?

8 'Transgression Incanardate — the Deconstructive Duck': Daffy Duck, created by Chuck Jones. © Warner Brothers; all rights reserved.

Certainly there are a lot of instances of characters being developed with reference to known film stars, usually with clear satiric intent. Pepe le Pew is said to be based on Charles Boyer, and there is often a specifically critical attitude and awareness of the potential for parody in relation to what was popular in mainstream cinema. In this respect animation functioned as a sort of ribald annotation in the margin. Remember that they would normally have been viewed as an insert between the main features. I suppose 'marginal' is a good way of thinking of the relation of the animated cartoon to the mainstream Hollywood text. There are many occasions in the anecdotal history where the attributes of figures of authority are memorialized in animation with an irreverence comparable to that of the medieval craftsman. Daffy Duck (plate 8), for instance, is said to have the voice of the much-disliked producer and animation studio boss at Warner Brothers, Leon Schlesinger. In Eastern Europe under the repressive Marxist-Leninist regimes when film was heavily censored, animators like Jan Lenica and Jan Svankmajer used allegory and visual metaphor to convey hidden political meanings in their animated films.

Do you think that the appeal for children, even very young children, is that animation is marked as a safe space where absence, violence, even death can

9 'A Quality of Indestructibility': Tom and Jerry, 1994 Turner Ent. Co. All rights reserved, licensed by C.P.L.

be rehearsed over and over — that it has a sort of 'fort . . . da' structuring of aggression, where there is never any irreversible damage?

Children do seem to respond to animation in ways that are different from live action, and this is a dimension which critics of violence who often target examples like *Tom and Jerry* (plate 9) miss. *Roger Rabbit*, despite the synethetic and rather shallow nature of its character, does explore this a bit; it does mix the terms of animation and live action to produce a worrying world in which cartoon characters can be eliminated (by the use of solvent). Animation can be seen as a sort of permanent condition of the Carnivalesque which often offers power to the powerless — Tweety Pie or Jerry are persistent examples — and makes spectacular acts of natural justice and revenge possible. I suppose that some of the arguments that have been developed around the 'horror' genre in film can be developed in relation to animation. There is certainly a preoccupation with things that can go wrong with the body, although they are bracketed in a kind of metaphorical realm. I suppose that the appeal might be stronger to young children, who are intensely curious and aware of the mysteries of the body, and to adolescents, who are in the process of dealing with disturbing physical transformations which might seem to have a life of their own — be animated by some outside agency. I suppose you could say that an interest in using drugs

30

is an attempt to be animated and it has certainly been the case in the history of animation that some films have had a particular appeal to the drugged — *Fantasia* for one. One development, which strictly speaking lies outside the concern of animation, is the extent to which the effects which animation has made possible have been taken up and developed by live action cinema.

I suppose there has always been that link in comedy films with people like Frank Tashlin transforming timing and visual gags that have appeared in animation into live action. It has been suggested that 'special effects' is a kind of animation which has become acceptable to adults and it certainly fulfils a similar function in attracting attention to the spectacular contrivances of cinema.

The closer you look, the more connections there seem to be: David Lynch made animated films at college and even the well-known story-boarding of Spielberg's films may be relevant. It does seem that cinema has become more 'animated' — there are recognizable elements of timing and excess, and not only in comedy but particularly in 'action' films. Although I suppose there has always been an improbable quality of indestructibility about heroes and occasionally heroines.

What is it, then, that makes animation funny? How much is due to the characterization?

Often it's the skill that produces a good character. In most classic animation the character development took a long time and it was a collaborative effort, so that characters like Bugs Bunny evolved and became very layered and ambiguous. In others, like the *Roadrunner* cartoons, it's a comedy of situation and repetition. There are so many theories of comedy. I suppose the Bergsonian notion of people behaving like machines is quite obvious in its application to animation, but in animation it's often the other way round as well. It's very noticeable, perhaps inevitable considering the way they work, that animators incorporate a lot of themselves into their drawings — that is to say, the drawings often embody recognizable physical characteristics. Maybe other, more hidden characteristics are there too, possibly a kind of 'acting out'. A lot of comedy is to do with timing and the manipulation of screen space and off-screen space and so on.

Why is the use of anthropomorphic animals so central? I suppose there is always an element of the grotesque involved in animals getting up on their hind legs and there is a long tradition of animals as philosophical models for contemplating human behaviour.

I asked Steve Bell that once and he couldn't tell me — it seems an instinctual choice. Obviously, you can get away with more using animals. Children don't identify so closely, and the damage that is done to them is not so frightening.

On the other hand it may be easier to introduce pathos in ways that are not so immediately threatening. Perhaps too, it's a way of exploring 'natural' antagonisms and desires and impulses in the 'raw' — animals are signs for compulsive and libidinal behaviour. There is a long tradition of using animals as metaphors. At a simple level, they are so various and enjoyable to draw and there is always a potential for comic surprise in the way that animals behave outside the normal limits of expectation. Animation makes a lot of use of transformations from animal to human for comic effect, whereas, of course, in the horror genre hybrid creatures like werewolves are frightening. So maybe in that respect, animation is a sort of antidote to horror. In more recent tough American cartoons, like *Ren and Stimpy* and *Beavis and Butthead*, there is a persistent theme of boys acting in bestial and disturbing ways, and, although animation can be conceived as a 'safe place', considerable anxiety has arisen as a result of some assumed 'copy cat' cases.

Clearly, as you said before, there is a massive range of animation and we are mostly concerning ourselves here with the most popular and probably the most celebrated and analysed work. Do you think it's true to say that the transgressive and deconstructive potential of animation was so strong that the Hollywood system had to constrain it by imposing restrictive narrative and generic conventions?

Early Disney, especially Mickey Mouse films like *Steamboat Willie*, fell foul of the Hays Office in the early 1930s, as did *Betty Boop*. In both cases the studios responded without a fight, and cleaned up their act. These are the only examples of direct intervention I know of, although Tex Avery's sexy showgirl and wolf films like *Red Hot Riding Hood* also caused moral concern in the 1940s. The interest in transgressive *auteurs* like Chuck Jones and Tex Avery was the product of a time when American and French critics were looking for creative artists who subverted systematic regimes of representation. It is important to remember that their 'transgressive' work represents only a tiny output of the studios. It's hard to find much that's transgressive in the work of Walter Lanz or in *Terrytoons*. Certainly the development of the 'cel' system,[6] which massively increased the productivity of animation and made it possible to build layers of characters and backgrounds, implied mass production and the division of labour. Many 'independent' or 'arty' animators refused to use it because they thought that it necessarily implied a loss of 'life' and spontaneity. Most 'art' animators who gave priority to complete control over the process used more direct techniques, like drawing onto the film, or working with cut-outs, silhouettes or models. There was a significant change in the 1950s, when some of the money went out of the animation industry. Competition with television was a significant factor, along with the decline of the 'double bill' in cinema. When television did buy animation it wanted cheaper material. It was at this point that 'cartoons' became most definitely identified with children as an audience, but consequently this was also the moment that concern with cartoon violence began to be expressed.

There does seem to be a significant change in style and quality in the early 1950s — less movement, less aggression and a general entropy of inventiveness.

That is the time when the major studios closed down their animation units. Some animation, like the *Tom and Jerry* series, was sent to Eastern Europe and animators, notably Tex Avery, lost their jobs — they certainly don't have many kind words for the effect of television at that time. U.P.A. (United Productions of America) introduced a different aesthetic which was partly determined by economic considerations, but it was also partly conceived as an alternative to Disney and it was a style more suited to television. The animators concerned were mostly 'lefties' who had lost their jobs in the McCarthy era — particularly as a result of union activism during a strike at Disney Studios. If you look at *Snow White* made by Disney in the 1930s, which shows the perfection attainable by the use of the multi-plane camera — a virtual three-dimensional effect with complex spatial relations, combined with an extraordinarily lavish ensemble play of characters — you can seen how different U.P.A. style is. It is driven by an aesthetic imperative led by trends in painting and illustration — notably the work of Steinberg in the *New Yorker* — the effect is much less naturalistic and more schematic than Disney. Some commentaries at the time suggested that it was more true to the fundamentals of animation in the way that it embraced flatness and colour as opposed to illusionism — analogous to the sorts of imperative that Greenberg was laying down for modernist art at the time.

I have heard it suggested that the classic moment of transgressive commercial animation coincided with the 'moment' of Abstract Expressionism and that they share some of the same concerns with speed, violence and facture. U.P.A. looks more like Continental modernism, more like Dufy or Buffet.

U.P.A. was still essentially popular entertainment, embracing an idea of 'Art'. I think they are part of a more general fascination with European art and its environment that appears at the same time in films like *An American in Paris* (M.G.M. 1951, directed by Vincent Minelli). It was an interesting historical episode, because at the same time attention was directed to the possible harmful effects of violence on children in horror comics in books like Frederick Wetham's *Seduction of the Innocents* (1953).[7]

What do you see as the most significant developments in animation in recent times?

I find animation interesting because it is so self-aware and because it is constantly drawing on developments in other areas — particularly comic-book art, which has been so diverse and experimental recently. It is a very knowing culture, far from the idea of isolated artists developing their own styles in private. Parallel to the Hollywood industry, there has always been an avant-garde counter culture which has taken on new energy in the last ten years or so, partly because of

funding from Channel 4. Until recently, unless the work had a direct commercial application, the only hope of support came from rare instances of Arts Council funding or grants from the British Film Institute. The first Animation Festival was held as recently as 1960. Festivals were started to create a culture of animation beyond what could easily be seen at the cinema. They were also tremendously influential in helping to restore a lost history and establishing a canon. Channel 4 has had a significant influence by screening a lot of films. It has helped to put a lot of work into production and to make it more widely available. Perhaps one of the most important aspects of this wider availability is the way that it has raised the awareness and expectations of advertising agencies and programmers — it has promoted more interesting and ambitious commissions. This awareness has, perhaps, reached a plateau for the moment.

What effects has this had on the industry and the people who work for it?

Well, the popularity of *Creature Comforts* has caused a lot of young people to want to be animators. Courses at colleges have taken more students so that the number of trained animators has grown dramatically — but there is very little work. The courses don't seem to teach them what they need to know to survive in the industry, where there is usually something like twelve weeks available to make a commercial and it is difficult to accommodate anyone who doesn't know what they are doing. Aardman[8] have produced bestselling video tapes and their work has been very successful at tapping into a familiar brand of British humour which is a sort of Mike Leigh/Alan Bennet genre of closely observed people — very different from the excessive and zany humour usually associated with cartoons.

What effects are new technologies having on animation? How close is the long-anticipated displacement of traditional skills by the computer?

In the 1980s there was a lot of interest in experimental and low-tech work — the Brothers Quay were doing advertisements for computers and cameras. A lot of art companies that were set up in the 1980s are struggling now, whereas computer and facility houses are doing very well. It's most likely that a blend of hand-made and computer animation will be the order of things. Perhaps most significant are new ways of using computers to do the painting work. I wouldn't advise any young people to take up 'paint and trace' now, which is particularly bad news for fine artists who used to freelance in that area. The world market is opening up too, and the effect of the E.E.C. is that work is circulating throughout Europe. For artistic and economic reasons, the industry in Britain is breaking up. A lot of American work, including the *Simpsons*, is planned in the U.S.A. but executed in the Far East. It's important to recognize as well that a lot of people are using the capacity of P.C.s like the Apple Mac which enables them to do their own animation. There is a growing industry too in producing animation for video games.

What has been the effect of the entry of women into animation?

It was always hard at festivals to find a significant quantity of feminist work — it was necessary in compensation to cover long historical and wide geographical areas. It's good that there is now more potential for women to become Hollywood directors in an essentially male ethos. Women are significantly more active as producers, but there are still very few female animators who have made a significant impact on the industry. It is funny for me now, seeing things from the other side — from within the industry. I do find myself falling into stereotypical patterns. It's hard to create interesting female characters, partly because you can't do the same things to them. Certainly the levels of violence and distress that are normal to animation would be more worrying if women were on the receiving end.

Do you think that animation is condemned to pastiche or does it still have a capacity to be exciting, funny or disturbing?

I do think that it still has a disturbing role. There are a lot of exciting graphics in comics like *RAW* which influence animators. Early animation, in retrospect, had something very visceral involved, particularly in the way that animals were treated — broken down and dis-assembled. Early Disney had very macabre elements, particularly in *Steamboat Wille* and *Silly Symphonies*, a kind of Gothic sensibility. I think too that in some ways the acceptable face of animation has never been so omnipresent and widely seen, and that there will inevitably be an opposition and a tendency to push against and subvert the constraints of taste and technique.

Barry Curtis is Head of the School of History and Theory of Visual Culture, Middlesex University.

Irene Kotlarz has taught and written on Animation History and Theory. She was the organizer of the Bristol and Cardiff Animation Conferences and is now working for Speedy Animation.

Notes

1 'In Betweening' is filling in the stages between two 'key' drawings.

2 See *7 Minutes: The Life and Death of the American Animated Cartoon* by Norman M. Klein (Verso: London 1993).

3 The proceedings of which became the publication: *The Illusion of Life: Essays on Animation*, edited by Alan Colodenko (Power Publication, Sydney 1991).

4 All these claims are made in *Meep Meep* by Richard Thompson, first published in *December*, vol. 13, no. 2, and reprinted in: *Movies and Methods*, edited by Bill Nichols

(University of California Press, Berkeley, 1976).

5 Since the interview, which took place in March 1994, Channel 4 have televised this series.

6 Cel animation involves separating components of a drawing onto different layers of clear celluloid film. The technique was patented in 1915; its effect was to save labour time — only the top cells with the moving components would need to be redrawn whilst the lower cells and the background could remain the same. It also brought about specializations,

whereby the background could be painted by one artist whilst another could draw the main poses ('Keys') and others could draw the transitions ('In Betweens'), and the finishing and colouring could be done by yet others.

7 The history of the campaign against comics and its political implications is told in Martin Barker's *A Haunt of Fears* (Pluto Press, London, 1984); Wertham's book was published in Britain by Museum Press in 1955.

8 The studio responsible for *Creature Comforts* and the Academy Award-winning *The Wrong Trousers*.

Art History ISSN 0141-6790 Vol. 18 No. 1 March 1995 pp. 37–62

Beauty and the Beast: Ridicule and orthodoxy in architectural marginalia in early fourteenth-century Lincolnshire

Veronica Sekules

Like the cartoon shorts in an evening's film programme, medieval marginalia can provide burlesque interludes and hilarious narratives, outlandish occurrences and absurd juxtapositions. They can deal in ridicule, subversion, fear, violence, laughter and mimicry. While playing with irreverence and unruliness, however, cartoon and caricature can have a paradoxical tendency, like any absurdity of the 'world turned upside-down', simultaneously to reinforce orthodoxy in a highly traditional manner. More straightforwardly, sometimes a moral goal will be pursued without any attempt at subversion, and a cartoon will be used to promote a kind of latter-day popular piety. For example, the overriding message in Disney's *Beauty and the Beast* is the triumph of good over evil and the correlation between beauty and goodness, something which the high Middle Ages, when saints were always dainty and well dressed and beasts were often not what they seemed, knew all too well.

While one can get a long way towards understanding the genres of marginalia by decoding their messages in terms which correspond with their surviving descendants, back projections from the complexities of contemporary culture are bound to introduce anachronisms which obscure the equal, if not greater complications inherent in the cultures which originated them. There are undoubtedly, as the examples cited above illustrate, continuities from past to present and from present to past, and it is easy to observe general characteristics which might be held in common over several hundred years. What is harder to retrieve and to evaluate are the intricacies and particularities of the medieval material specific to the time when it was made and consumed. Accurate and detailed and historical analysis of it in its cultural context provides a much fuller understanding of its meanings and purposes, and throws more useful light on its multiple derivatives and later manifestations.

The pioneering studies of medieval marginalia tended to concentrate on examples on the written page, where visual images of any sort are invariably read in conjunction with text, and vice versa.[1] Marginalia in architectural contexts, though the images may have been derived from similar sources, operate quite differently. Their setting, if it provides any clue to a reading, does so by association with the various functions of the building rather than with a verbal construction. And the very physicality, solidity and corporeality of the sculptures, deny them much of the doodling, fleeting quality found in manuscripts or other

graphic arts. Their context is structural and therefore their scale and opportunities for their appearance are limited by architectural convention and construction techniques. They tend to appear in certain conventional places, which are often high up and may be literally marginal: for example, among corbel stones at the edges of roofs and monuments, as gargoyles supporting rainwater drainage pipes, as the terminations of vault ribs, as replacements for volutes on capitals and finials.

The audiences of manuscript and sculpted marginalia are different too, not in the sense that they are different people (clearly sometimes they would be the same individuals) but because of the very different circumstances and expectations involved in the process of viewing. Architectural marginalia are viewed in real time and in real space. The measured pace of progress around a building and the comprehension of it and all its details in terms of the scale of the human body, makes the experience of viewing very different indeed from the 'fleeting' world of the manuscript, where a glance can summarize the contents of an entire page, where figures appear at the turn of a page, entwined around foliate border or initial, or in a *bas-de page*, varied in scale and position, only to disappear as the progressive reading of the verbal text renders them invisible once more. Architectural marginalia cannot, like manuscripts, be contemplated by the light of a warm fire or in the comfort of a desk in a library. Viewing is not necessarily a private experience. The messages, like some subsequent forms of 'mass' communication, are publicly consumed, in the open, by the spectator, along with other locals and passers-by. Text and context are negotiated between spectators, each of whom depends on varying perceptions of the function of the monument before them and of the semi-known preoccupations and priorities of those who have determined and paid for this communicative decoration.

It is the particularity of the circumstances of 'consumption' which is so often a casualty in general discussions about the interpretation of marginal imagery. Older studies assumed it to be decorative nonsense, deliberately meaningless and therefore principally of value as an entertaining curiosity. More recently, there has been a tendency for marginalia to be discussed as a genre emanating from the irrepressible folk spirit, and for its surprises and jollities to be celebrated as survivors of the oppression of the 'central' orthodoxy. However, it has lately been observed that the images are not iconographically stable, but can be assembled and recombined to yield fresh meanings. Debate has centred on how those meanings can be retrieved and what is so endlessly fascinating about marginalia is the sheer power of their imaginative range and their ability to elude and defy categorization.[2] However, what can very often be categorized are the circumstances in which and for which a particular collection of imagery has been created. If questions are centred on consumption, such as: 'at whose behest were these images made, in what context, where and why?', then a rather different approach to the material is possible, depending on analyses of the historical, physical, geographical, temporal, anthropological and cultural contexts, in which the determining force is the commissioner rather than the executor.

What follows is a highly focused and specific study of a particular commission, the parish church of St Andrew's at Heckington in Lincolnshire, and its marginal imagery. It has nearly three hundred examples of small-scale figure sculpture

at the edges of buttresses, pinnacles and roofs (plate 10). It was built in more or less a single campaign by benefactors and a rector whose social circumstances and life histories are known, and it also survives practically in its original condition. The masons who built it worked on a large number of other commissions of varying scales in the locality, so that it is possible to establish the range of their artistic behaviour and then to measure Heckington against that scale. In these historical circumstances it is possible to isolate the role of this marginal imagery against a background of detailed social and cultural information.

As with later forms of labour-intensive artistic production, such as the engraving workshop or the animation studio, the building of a parish church in the Middle Ages was a complex collaborative venture with potential creative input from a variety of directions, from among the people paying for the commission as well as by the artisans. Formally speaking, the rector was responsible for the chancel and the parish for the nave, though in effect, responsibility and building costs might have been shared between the rector, patron and a number of benefactors. The execution of the building was also collaborative between masons specializing in different branches of the craft, image-makers, painters and glaziers, each with their own craft traditions, iconographic role and means of creative expression.

While it was collaborative, the enterprise of parish church building would never have been cooperative. The principal partners exercising financial control were likely to have been the social and moral elite of the village, that is the rector and Lord or Lady of the manor. Precisely to what extent either of these had primacy and controlled the whole commission was probably never constant, but there is little doubt that however much expressive freedom was allowed to the artisans, this administrative custom favoured the prevailing orthodoxy. Each of the dominant partners would have had a vested interest in the church as an arbiter of moral codes and social convention as well as devotion and spirituality.

The church of St Andrew at Heckington was just such a collaborative venture. The nave was built in the 1290s and probably paid for by its first major patron Laura de Gaunt, widow of Gilbert de Gaunt, Lord of the manor.[3] On Laura's death in 1309 the manor passed to Edward II, who gave it to his second cousin Henry de Beaumont.[4] The king was also at that time responsible for the living and gave it to one of his own chaplains and clerks, Richard de Potesgrave.[5] Henry de Beaumont, who was a Frenchman from Beaumont in the Maine, never seems to have lived at Heckington and passed the manor over to his sister Isabella de Vesci, who was a member of Queen Isabella's household, and who had been a widow since 1289.[6] She did live there, at least for most of the time, until her death in 1334, whereupon the manor reverted to her brother. Upon his death in 1340 it passed as dower to his widow Alice, who had also been a member of the Queen's household and who also seems to have lived in the village.[7] The major phase of church building which included the chancel and transept was begun in about 1320 (plate 10). There is evidence from inscriptions recorded in the glass that the chancel was paid for by Richard de Potesgrave. There are also records of heraldry of Beaumont and Beaumont and Vesci together, suggesting major involvement in the building campaign by Isabella de Vesci and

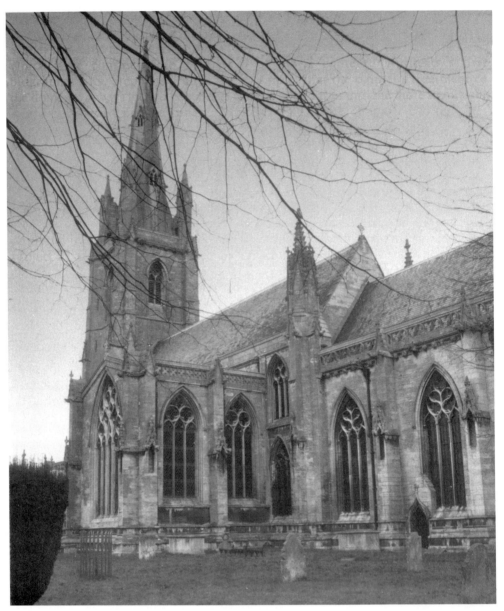

10 St Andrew Heckington (Lincs). View from south.

probably Alice de Beaumont, Countess of Buchan, rather than her husband.[8]

The devotional focus of the church, as one would expect, is in the choir, but this church has a particularly remarkable and important series of liturgical furnishings which give a very clear emphasis to the worship of Christ in a way that, for the time, was innovative. It has a Tomb of Christ, or Easter Sepulchre, built as a permanent fixture in the north wall of the chancel and carved with images associated with the burial and resurrection of Christ (plate 11). It is

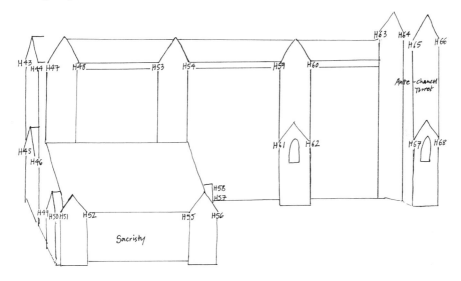

Heckington corbels: ante-chancel turret and south side of chancel

H21: bearded man; H22: mermaid; H23: crouching figure; H24: man excreting; H25: monster holding knee; H26: man with short arms; H27: man riding dog; H28: horse; H29: clothed monkey; H30: monster eating small animal; H31: woman carrying burden; H32: usurer (man carrying sack); H33: man fighting lion; H34: lion scratching chin; H35: monster clutching woman; H36: knight in boat with woman at rudder; H37: man and woman fighting; H38: king holding onto crown; H39: knight drawing sword; H40: winged monster; H41: hairy monster; H42: Tutivillus and the gossips.

Heckington corbels: ante-chancel and north side of chancel

H43: monster bearing teeth; H44: lion; H45: half-clothed monkey; H46: naked man wearing hat; H47: damaged; H48: woman with pot and ?; H49: winged monster; H50: woman with tub-shaped hat; H51: monster; H52: monster; H53: man blowing pipes and drum; H54: man playing pipes; H55: female hybrid; H56: crouching man/monster; H57: monster with wings from shoulder; H58: cat; H59: man and woman fighting; H60: man peering; H61: man with lion's body holding truncheon; H62: lion; H63: man with crutches looking up; H64: seated man looking over chancel roof; H65: bearded man holding stone; H66: man leaning; H67: monster with big head and small arms; H68: monster with big head and no body.

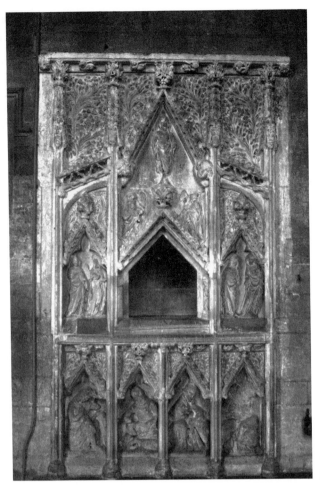

11 Tomb of Christ, St Andrew Heckington.

probably a kind of sacrament shrine, built in order to promote the veneration of the body of Christ at a time when the feast of Corpus Christi was newly instituted, and it is one of a small group of such monuments in the region, all of them made between *c*. 1290 and *c*. 1350. Opposite are elaborately carved triple sedilia and a double piscina for washing the priest's hands and mass vessels. The whole series indicates that the church enjoyed at its outset a very sophisticated pattern of worship with much ritual, elaboration beyond the normal expectations of a rural parish church.[9]

The iconography of the chancel furnishings set the theme for the imagery of the exterior. Echoing the imagery of the Tomb of Christ, the Resurrected Christ is the principal image on the south porch, which is the main entrance to the church (plate 12). He is shown seated at the pinnacle, probably originally showing his wounds, and below him kneel the crowned Virgin Mary (on his right) and St John (on his left), and below them, two angels holding instruments of the Passion. The whole scene is set in the interstices of a cusped wave moulding against a pattern of relief foliage. Compared with the Judgement porch of the

12 South porch, St Andrew Heckington.

Angel Choir at Lincoln, which in some ways is the model for Heckington, the space for the sculpture is thus very much reduced, and only the holy personae are present. There is no representation of the mouth of Hell or the damned. What is particularly interesting about the Heckington porch, however, is the prominence of the heraldry. The arms of England (gules, three leopards or) are situated immediately beneath Christ's feet. The fictitious arms of Edward the Confessor (a cross between five martlets) appear at the bottom left and the arms, probably, of St Edmund (azure, three crowns or) at the bottom right. These three coats of arms appeared together in many decorative schemes commissioned by Henry III, notably in the border of the figure of 'Debonerété' from the Painted Chamber of Westminster. They were also used together by Edward I and the tradition was continued by Edward II, who carried the arms of St Edward and St Edmund on banners in battle.[10] Their use here, undoubtedly because of the royal connections both of the Beaumonts and Potesgrave, is emphatically patriotic, making an overt association between the enthroned Christ and the shield of England beneath his feet. Just as the Hell beneath Christ's feet at Lincoln is thereby shown as subject to his authority, so the shield of England stresses very clearly the idea of the realm being subject to the rule of Christ.

It is possible to see the decoration of the church as continuing in other respects the theme of the subjection of the realm in the widest sense to the judgement

13 Niche in tower containing statue of St John the Evangelist, St Andrew Heckington.

and rulership of Christ. The exterior of the church is very elaborately decorated. The windows are large and filled with fully developed curvilinear tracery. The buttresses between each window are encrusted with sculpture in the form of gabled niches to contain statues and gabled terminations, the gables in each case supported by projecting atlas corbel figures. The chancel roof is decorated with figured corbel tables, gargoyles and an openwork wave parapet. The tower is also highly decorated with gabled niches supported by corbel atlantes. The subject matter of the exterior sculpture has to be deduced from only partial evidence, as twenty-one of the twenty-two figures which were once placed inside the image niches on the porch, tower, south transept and chancel are missing. The one remaining is a figure of St John the Evangelist in one of the four tower niches (plate 13). One can reasonably deduce, therefore, that the other three niches of the tower contained figures of the other three Evangelists, SS. Matthew, Mark and Luke. According to the dominant English pattern for exterior decorative schemes, the remainder of the inhabitants of the niches were likely to have been saints, possibly including prophets, patriarchs and confessors, notionally accompanying Christ as he is seated in the south porch on his throne of Judgement.

Without the large sculpted figures in the niches, the exterior is dominated by their originally marginal companions: the little corbel figures either side of them and above them supporting the gablets of their niches, the corbels supporting the gablets at the tops of their buttresses and at the bases of pinnacles, the heads and animals inhabiting the parapets of the roof and the gargoyles in the form of beasts and humans acting as rainwater spouts. Altogether there are more than 270 of these figures, probably the largest quantity of this category of sculpture on a medieval parish church, and some of the figures, especially the gargoyles and the corbels supporting the niche gable heads are very large, and entirely and clearly visible from the ground in all their detail, they would always have been a very noticeable and notable feature of the exterior decoration.

The Exterior Marginalia

The Dominican preacher John Bromyard made reference to the pretence at a supporting role of corbels in a sermon moralization:

> At times, on these great buildings, we see a stone displaying a grinning open mouth, and from other indications appearing as if it supported the whole edifice. But nevertheless a plain stone, sometimes hid in a corner, does far more of the work; for the other is rather for show than for support. Such may well be compared to those persons, who, when they hear the cry of poor beggars for alms, when even their friends show them their misfortunes and the losses which they have sustained by fire or water or from thieves, with open mouth bewail the ills and losses of the latter, saying 'I am sorry: may God help you!' but do not offer a helping hand by giving them anything, or by lending provisions and other necessaries.[11]

This well-known passage demonstrates very clearly how preachers in the Middle Ages would interpret a visual image to moral purpose. He understood very well that figured corbels of the kind that one finds in quantity at Heckington are normally positioned so as to appear as if they are supporting the structure above, being made to look as though they are holding up shafts or gables or supporting the roof cornices. They do not, however, perform any real structural function, and the fact that they were made to appear as if they did was a conceit, a convention of medieval architectural decoration, upon which Bromyard chose to elaborate as an analogy for decrying those people who protest at hardship or labour and who refuse to acknowledge those really in difficulty, the equivalents of the plain stones who are really bearing the load. In another passage, Bromyard likened grimacing corbels, complaining that their work was too heavy, to slothful clergy who were wont to complain of the least task. One might speculate about the origins of the convention for figure corbels as illusionistic supporters of the structure; presumably they are in part derived from Classical conventions of caryatids or atlantes. But by the early fourteenth century, when Heckington was built, the burlesque elements in the iconography of corbel sculpture were so well

14 H21: Man clutching wall; H22: woman clutching wall; H23: grinning man clutching wall; H24: man excreting onto roof below. Photo: Michael Brandon Jones, School of World Art Studies, UEA.

established that Bromyard's observations could have been inspired by actual examples of visual punning on real versus sham support. Masons also understood very well that these figures performed a sham function and that they played, often to comic effect, on the role of corbels as illusionistic weight bearers and as articulators of the structure they were pretending to support.

This was certainly the case at the parish church of St Andrew Heckington. One category of its corbel images makes witty reference to their positions on the building, and plays on the fact that they are in exposed positions or at great heights, or are apparently complaining at the enormity of their task in supposedly supporting the building. Some of those at the eastern terminations of the ante-chancel and the west end of the south transept and nave are peering over the roofs (H63, H64, H66, H1, H71, H21). One of these — in the highest position (H63) — is represented as a cripple; another is struggling to escape (H21, plate 14); one is yawning in boredom or from sloth (H1); another is excreting onto the roof below (H24, plate 14). Many are also deliberately portrayed in the act of attracting the viewer's attention, by making defiant gestures or by grinning and grimacing. Two of the men are throwing stones (H65 and H2, plate 15), one on the tower has his hands cupped either side of his open mouth as he leans over, shouting (H81). Some figures are gripping parts of their anatomy in pain (H56 and H26), or, in several cases high up on the tower, are hugging themselves and apparently shivering from cold (H103, H104, H109), or clutching the wall in order to hold it up, or for fear of falling down (H108, H115), (H118, H117, H119).

The predominance of popular imagery in marginalia and the preponderance of lower-class, rowdy personages has often been commented upon.[12]

15 H2: Man throwing stones; H5: man piping; H6: dancing bear. Photo: Michael Brandon Jones, School of World Art Studies, UEA.

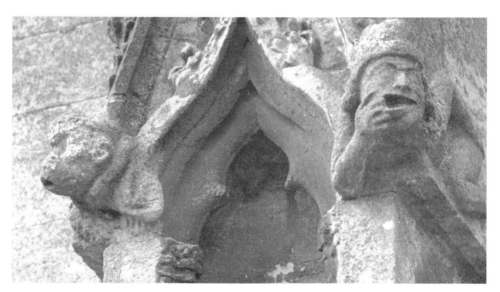

16 H45: Half-clothed monkey; H46: naked man wearing hat and pulling mouth. Photo: Michael Brandon Jones, School of World Art Studies, UEA.

Heckington has its share of these: for example, a figure of a jester paired with a dancing bear (H5 and H6, plate 15) and men playing noisy musical instruments such as pipes, drums and tabours (H53 and H54). The reversed, inverted or parodic world is also represented. One pair of figures represents a man holding a dog on a lead and riding on his back (H27), another a clothed monkey next to a naked man (H45 and H46, plate 16).

While the origins of such figures may be sought in folklore and there may be an element of subversion in their representation, one can also interpret them in the light of contemporary references to such behaviour, according to which they appear to be caricaturing social conventions or disrupting the calm of normal rural existence. For example, the images of musicians playing pipe and tabour are quite possibly representatives of the kinds of churchyard disturbances, or secular festivals centring on the church, for which there was, every now and then, a bout of clerical disapproval.[13] Robert Manning of Bourne, whose manual about sin and penance, *Handlyng Synne*, was contemporary with Heckington and written at Sempringham only three miles away, related how Bishop Grosseteste loved to hear the music of the harp, the bells, the organ, trumpets and psaltery as these were the instruments beloved of King David and appropriate, if played with skill, for the worship of God. The playing of pipes and tabour in the churchyard, on the other hand, was sacrilegious, especially while the priest was at his devotions:

Karolles, wrastlynges, or somour games,
who-soever hanteth any swyche shames
Yn cherche, other yn chercheyerd,
Of sacrylage he may be a-ferd;
Or entyrludes, or syngynge,
Or tabure bete, or other pypynge,
Alle swyche thyng forbodyn es,
Whyle ye prest stondeth at messe. . . .[14]

The 'reversed world' image of man and monkey hints even more explicitly at the overturning of social conventions (plate 16). The monkey is wearing only a tunic on the upper part of its body, so its bottom is bared. The man is only wearing a hat and is pulling his mouth with one hand and pointing to his bottom with the other, while the monkey is pursing its lips in astonishment, or disapproval at this coarse behaviour. Thus the joke is twofold: that the monkey is better clothed than the man, and that the animal is disgusted by the man's bestial character. There are many contemporary references putting this behaviour in context. Pulling the mouth open had a long history as an insulting gesture, and buttock-baring was also considered to be an insult, and one that apparently was practised, as indicated by some lines from a poem about Edward I's Scottish Wars:

The foot folk
Put the Scots in the poke
And bared their buttocks.[15]

This man is situated at the east end of the church, with his bottom pointing in the direction of the altar. He may be intended as a blasphemous character who, as in the story of Alberico da Romano, after he had lost his falcon in a hunt, dropped his trousers and exposed his rear to the Lord as a sign of abuse.[16] In gesturing vigorously to his bottom he is probably indicating that he

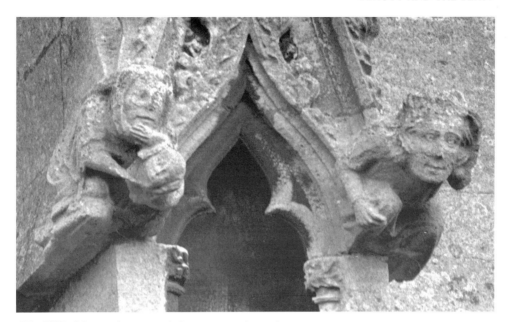

17 H37: Man and woman fighting; H38: king clinging onto crown. Photo: Michael Brandon Jones, School of World Art Studies, UEA.

has also farted, as did Lucifer in the Coventry Corpus Christi play, when on being cast out of heaven he exclaimed: 'For fere of fyre a fart I crake.'[17]

The playfulness and humour in these images may have given them immediate popular appeal to their audience, just as they still do now. They play on extremes and fantasies about human behaviour, rather like contemporary cartoons. But just as with the cartoon, one must not be lulled into a sense of security in their superficial geniality and ignore the power they undoubtedly possess, of political, moral and social comment. The messages carried by marginal images are multifarious and mutable, changing from context to context, yet to dwell on their ambiguity risks denying them any power to manipulate their audience or to deliver specific messages. This little group of figures defying the niceties of social convention is also transgressing the authority of the church, yet it is doing so on the Church's very territory, which immediately calls into question whether its role is really transgressive or in a perverse way, whether it is reinforcing its authority.

Male strength and authority and questions of class are alluded to and ridiculed among these corbels. Appearances are made by representatives of different classes of society: the king, the knight, the professional man, the bourgeois. The king is shown clinging onto his crown (H38, plate 17), which suggests a reference to the uneasy maintenance of male authority, possibly intended even as a deliberate allusion to the deposition of Edward II, exactly contemporary with the building of this church. There are three images of knights, two of which have lion devices on their shields, perhaps as an indication of strength in combat, although one of the knights has cloven hoofs and in manuals on the vices, the lion is normally equated with quarrelsome characteristics, or specifically with

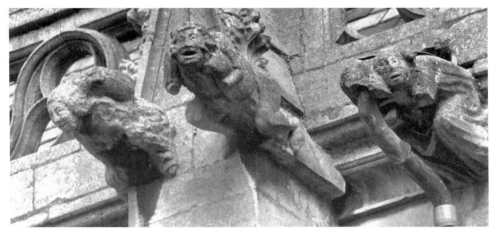

18 H31: Woman carrying load; H32: man carrying sack (usurer); gargoyle holding burden. Photo: Michael Brandon Jones, School of World Art Studies, UEA.

pride or envy. Prominently situated on the corner of the south transept is a legal official such as the 'procurators of the bench, whom we vulgarly call narrators', described by Matthew Paris (H10, plate 23). He is wearing what was probably official dress in the form of a close-fitting cap and a hooded cloak, the fur-trimmed hood resting on his left shoulder. Such costume was worn by lawyers in the fifteenth century.[18]

A common butt of hatred and a primary target for criticism in sermons, the usurer appears on the chancel as part of a group of figures bearing burdens, his being the usurer's usual attribute, a sack of gold (H32, plate 18).[19] The usurer represented the deadly sin of avarice and one of the rare sermon references to corbels on buildings makes use of the usurer as an example. A usurer entering a church to be married in Dijon in the year 1240 was crushed to death by a stone figure falling from the porch, which figure proved by the grace of God to be a carving of another usurer and his money bags being carried off by the devil. The citizens and other usurers bribed workmen to take down the remaining figures for fear of similar retribution being exacted upon them on another occasion. Even though the preacher of this sermon seemed to be expressing some surprise at the coincidence of the transgression and the punishment, this reference is particularly interesting for its explicit identification of the figure, suggesting that the custom for placing figures representing sins on the exterior of the church was not unusual, and that they served as a warning to passers-by, particularly vivid in this instance, of the dangers of imitating their example.[20]

About fifteen miles from Heckington there is another such figure with contemporary identification on the early fourteenth-century parish church at Frampton, near Boston (plate 19). On the buttress of the south-east corner of the chancel is a carving of a man baring his teeth, accompanied by the inscription:

Wot ye whi I stad her for
I forswor my savior
ego Ricardus in angulo[21]

19 Ricardus da Angulo at Frampton, Lincs. Photo: Michael Brandon Jones, School of World Art Studies, UEA.

Without the inscription, this is just an innocuous face, appearing to be half-smiling pleasantly, half-grimacing. It is of a kind that would normally go virtually unnoticed or would perhaps have had fanciful attributions made up for it — such as that it represented the mason. But clearly Ricardus's image has a mission: his transgression was against the highest authority and his punishment to be forever commemorated on the chancel wall as a warning to others, and perhaps even to perform an apotropaic function on behalf of the community.

Out of a total number of seventy-eight corbels on the nave, transept and chancel, nineteen are monsters, most of which are grimacing, grinning, or pulling open their mouths. One of the monsters on the transept is identifiable as a Serra, the scaly serpent with knotted tail from the bestiary (H4). The majority of the rest, especially those on the transept, ante-chancel and sacristy are grylli, with leonine, or deformed humanoid or bat-like heads on fat little humped bodies, some attached to pairs of long, clawed feet, some to short human legs.[22] The remaining monsters, significantly, all on the chancel, are devil-like. The only ones which are accompanied by human figures are with women. There is little doubt that one which is represented carrying off a woman represents the Devil himself, appearing as he normally does in this period, with a long, furry body, dog-like face and horns (H35). This image may well be from an exemplum. Jacques de Vitry recorded a tale of the foolish woman who was tempted by the Devil to see the world at night by riding on the back of demons.[23] Another manifestation of the Devil in relation to foolish women, which appears on a chancel corbel next to the east window, is the image of Tutivillus and the Gossips, he being the Devil who sat on their shoulders as they gossiped irreverently in church and wrote down their words — a subject very often recorded, also in a local source, by Robert Manning of Bourne in *Handlyng Synne* (H42, plate 20).

In the light of the involvement of Isabella de Vesci and Alice de Beaumont with the patronage of this church, the images of women among these corbels form a particularly interesting series. There is a higher proportion (13 out of

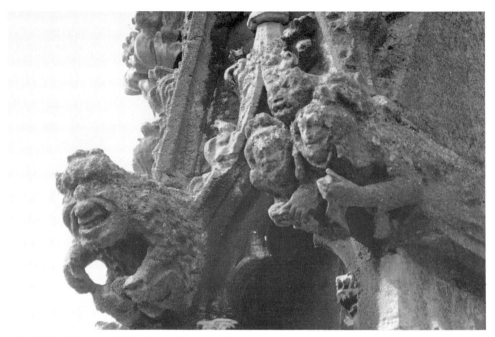

20 H41: Monster; H42: Tutivillus and the gossips. Photo: Michael Brandon Jones, School of World Art Studies, UEA.

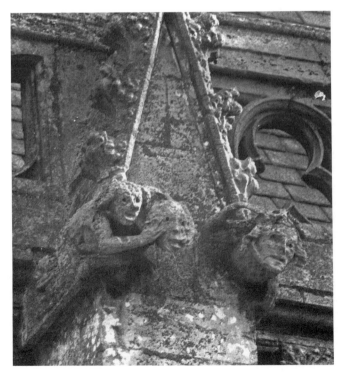

21 H59: Man and woman fighting; H60: woman peering. Photo: Michael Brandon Jones, School of World Art Studies, UEA.

78) of images showing women on this church than on any of the others in the areas which have related extensive corbel imagery. The images are also very hard on women, often alluding to women's folly, vanity or disobedience. Four corbels show relationships between men and women. On the transept a bourgeois couple are set side by side in apparent harmony (H19 and H20), but for the fact that both are crouching uncomfortably and the woman has her mouth open, as if she is scolding. On the other hand, two corbels on the chancel show fights between men and women which are very clearly battles for supremacy, with, in one case, the woman struggling to escape from the man's clutches by pushing at his chin (H37, plate 17), and in the other, the man clasping his hands in prayer as the woman grabs his head from above and pulls at his mouth (H59, plate 21).[25]

Sermon moralists discussed the obedience of women to their husbands, but it was also a common preoccupation in secular writing. In books of moral instruction and decorum the theme of the obedience of women is treated at length. The one which is likely to have been best known in England is *The Book of the Knight of La Tour Landry*, written by an upper-class French knight for the edification of his daughters. It was distributed widely in the late fourteenth century, but culled its illustrative anecdotal material from a wide variety of sources such as sermon literature, exempla and fables and manuals on the vices, well-known in England from earlier dates. In these sources, criticism of the follies and vices of women is extremely widespread.[26]

The Knight's book is a rich source of information on the seemly and pious behaviour of women contrasted with sinful behaviour. Numerous times he urged his daughters not only to be silent, especially in church, but at all times to be obedient and meek to their husbands.[27] He also instructed them in other forms of modest behaviour, such as the way to dress for church, not in finery, as that would be an insult to God, but in plain clothing. Elaborate headdresses were particularly criticized by him, presumably as common contemporary manifestations of vanity.[28] The Heckington corbel images often represent visual equivalents of the kind of unseemly behaviour mentioned by the knight, especially in relation to conventional behaviour in church. One image of a woman wearing an exaggeratedly large headdress is sculpted on one of the tower tabernacles (H93). Another, on the chancel, shows a woman wearing a ridiculous pot-like hat on top of her headdress, which may be making a similar point, but in more jocular fashion (H50). This woman, unlike the others, is also turning her head to one side. Again, the Knight mentions this under his category of unseemly behaviour. For a woman to turn her head to one side like the crane or the tortoise would make people laugh — if she wished to see something out of her line of vision, she should turn her whole body.[29]

Some of the corbels show women's occupations, almost certainly with critical intent. On the nave is a woman holding and possibly suckling a baby (H72, plate 22). This may be a straightforward representation with no moral implication, except that the woman is grimacing. Possibly she is protesting at the indignity of her position, permanently fixed to the church, next to what appears to have been a naked figure in contorted pose (damaged). She may represent the midwife who lost her child because she failed to have it christened, as in a tale related in *Handlyng Synne*:

Hys mydwyfe whan ye chylde was bore,
She helde hyt on here lappe before;
And when she sawe that hyt shulde deye,
She bygan, loude for to crye . . .[30]

Apart from the references to vanity in corbel subject matter, only two other deadly sins appear to be alluded to. A woman pouring liquid from a jug into a cup (H70) may represent an innkeeper, a common occupation for women, and one that was sometimes the subject of burlesque illustration. Alternatively, she may represent the widow advised by Elisha to sell oil to pay her debts, as she so appears in Master Honoré's *Somme le Roy*, pouring from one jug to another beneath a representation of Avarice.[31] The subject of wantonness and lechery is also referred to by the images of mermaids, one of which appears on the ante-chancel, one at the west end of the nave (H22 and H77). It is also suggested by a female hybrid figure baring her breasts on the sacristy (H55), and also by a woman with a distaff on the transept, who represents another female occupation, a spinster. Here she is paired with a goat, a common symbol of lechery and, particularly, adultery (H15 and H16).[32]

Courtesy books warned women against 'lewd looking', leading inevitably to lechery.[33] Another pair of corbels possibly illustrates this theme, by reference to an anecdote which was related in an English sermon. On the transept is a well-dressed woman looking up from a book with a sidelong glance to the knight who is next to her (H13 and H14, plate 23). The story tells of a noble woman who was wont to sit in church ostensibly reading from her primer, but in fact looking up from it every time a man entered.[34]

This last figure must have had the most resonance for the female patrons as this woman closely resembled them at their devotions, though presumably not with the element of temptation from holy thoughts. While this critical series of images might to us seem puzzling in the context of their patronage, one can only assume that Isabella de Vesci and Alice de Beaumont colluded in them, either in that it was a kind of penitential self-abnegatory act to acknowledge that these images legitimately portrayed their sex, or that they were part of a burlesque, lower-class or in a semi-fictitious moralizing tradition from which they could distance or exclude themselves. It is notable that it is only the sinful behaviour described by the Knight and the other sources which is depicted here at Heckington: vanity, avarice, lechery and lewd looking, disobedience to one's husband, gossiping in church, witchcraft and consorting with the devil. Some of the behaviour depicted here not only broke contemporary social and moral codes, but was insulting to God in that his laws were broken too. Avarice, lechery and the pride of vanity were deadly sins. Behaviour that was insulting to the laws established by the Church is also singled out at Heckington. It was ecclesiastics who condemned excessive finery for women, as it provided temptation from holy thoughts. It was the Church that preached monogamy and obedience to one's husband; that required silence during services. The images, in whatever contexts and circumstances they were generated and whatever their ancestry and folkloric allegiances, are here being employed to reinforce a strong orthodox and authoritarian attitude.

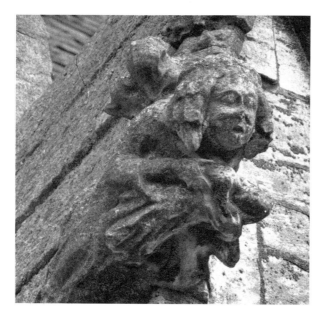

22 H72: Woman suckling baby. Photo: Michael Brandon Jones, School of World Art Studies, UEA.

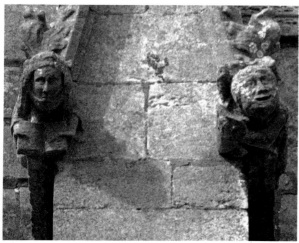

23 H13: Woman reading primer; H14: knight. Photo: Michael Brandon Jones, School of World Art Studies, UEA.

If we look at the entire series, there are many consistent features and attitudes which give it some unity, but it would be a mistake to suppose that there is any kind of 'programme' here. There are too many omissions and no real interest in order, narrative or pedagogy. For example, although *Handlyng Synne* has frequently been cited for its parallel examples of sinful behaviour, the whole series of corbels at Heckington does not make a directly comparable attempt at systematic representation of the sins. Many stories included in *Handlyng Synne* are not represented, and others appear from other sources. Correspondences between literary accounts and visual equivalents are never exact. Although there is a general, and sometimes a specific connection between the choice of subject matter for the Heckington corbels and a range of texts dealing with vices,

compared with the texts, the depictions at Heckington are more summary and selective.

Measured against written manuals with systematic approaches to conveying moral instruction, the Heckington corbels appear haphazard, with no particular order or attempt at completeness. Yet messages are clearly being carried by the images, individually in an informal and episodic way, and collectively like a chorus, each reinforcing the next and delivering overall a general impression, that we are looking at a collection of people and beings in various states of sin. It has to be remembered also that the corbels were never intended to be seen in isolation and represent a fragment of the whole schema. They probably accompanied images of the elect beneath them in the tabernacles, and the whole assembly was ruled over by Christ in Judgement in the porch. Given that among them are a considerable number of monsters and demons, their identification as the souls of sinners awaiting Judgement is a distinct possibility.[36]

The representation of souls awaiting Judgement as representatives of different classes and professions had been a commonplace equally of literature and visual media at least since the twelfth century, so Heckington would not be unusual in this respect. Where the representation of the Last Judgement at Heckington departs from the norm is that certain other common iconographic features are absent. There is no representation of St Michael weighing souls, unless he was one of the large tabernacle figures, and no literal depiction of good and evil souls taking their separate paths. It would thus not be true to say that it is merely a French type of Last Judgement transposed from a portal scheme to a whole exterior. It differs distinctly both from French twelfth- and thirteenth-century Last Judgements and from its principal antecedent in England, the Angel Choir at Lincoln, in that the actions of Judgement are not represented, and Hell and its tortures are not literally portrayed. This suggests that it is not actually intended to be a depiction of the moment of Judgement, but that it shows the time before it. The corbel figures are not represented as being physically in a place of torture other than the place they inhabit, forever on view performing a sham function as supporters of the building.[36] Rather they are represented as being examples of classes of people in a state of sin. Like Ricardus at Frampton, they are doomed forever to enact their sins for the benefit of the observer. They are accompanied by animals and demons, who are not exacting torture, but who themselves are likely both to represent sins, and to reinforce the generally evil or doomed nature of the whole assembly. This state of being conforms more to certain ideas of Purgatory than to Hell.[37]

Visual representations of Purgatory have normally been identified by their inclusion of certain persistent features, described in the majority of accounts, such as the bridge across which souls must travel to reach the places of purgatorial punishment, or the fires by which sins were painfully expiated. However, there are other persistent features, particularly it seems characteristic of Dominican views of purgatorial punishment, which are distinctly relevant to the type of Judgement portrayal at Heckington. This is the notion of punishment, as acknowledged by Albertus Magnus and Thomas Aquinas, as being not in a place apart, but within the soul, where sinners could undergo a state of inner hell, of eternal torture within their own minds.[38] Both Arnold of Liège and Jacobus

de Voragine developed the idea of earthly penance and stated that it was the fate of some sinners to do their purgation in the midst of those against whom they had sinned.[39] It is something like this kind of purgatorial state of being that is depicted at Heckington. The corbels, showing as they do a combination of representatives of different estates of society, and examples of both mortal and venial sins, represent the sinners who are purging their sins by enacting them forever as an example to the living — as Jacobus de Voragine said, 'Some souls may be punished in a certain place for our instruction, namely in order that we may know that a great penalty is exacted of sinners after this life.'[40] They are souls from Purgatory who are about to come to the final reckoning at the Last Judgement. They are represented beside the blessed whose sanctity is confirmed by the imperfect state of salvation of the sinners. They are accompanied by demons who are either assisting them in the committing of their sins, or watching over them, but who are not exacting the punishment. The sinners are both in the realm of the church, represented as literally attached to its fabric, and under the jurisdiction of Christ, who is seated in Judgement on the porch, with St John and the Virgin Mary as intercessors. Christ's dual jurisdiction over the realm of the living and over the souls of the blessed and sinners waiting for Judgement is emphasized by the heraldry beneath his feet.

The association between the conquest of sin and the efficacy of the veneration of the sacrament in the saving of souls was very much a focus of *Handlyng Synne* and of numerous early fourteenth-century sermons on the subject of penance, such as that for Corpus Christi day in the Vernon manuscript, in which the Sacrament is attributed with seven properties, each of which combats one of the deadly sins.[41] Thus, even though it does not correspond in exact detail, the imagery of Heckington, both of the exterior and of the interior, can be seen as a visual representation of the messages in these sermons, and it may well have been the introduction of the feast of Corpus Christi that brought such ideas into focus. The imagery of the exterior does not represent a Last Judgement, but a vision of the preceding stage during which penance and reform could assist salvation. It is represented in the corporeal terms described by Walter Hilton.[42] Figures of sinners and demons serve as a warning to the living, alongside saints who serve as paradigms for a good Christian life. The message of the exterior imagery, however, is only completed by that inside the chancel. The sacrament shrine is the culmination of the iconography of the whole church, in that it provides the key to the Judgement cycle with a message of hope for salvation through the Body of Christ.

If this interpretation of the corbels at Heckington is valid, then we have an instance of the art of the margins entirely reinforcing the centre, indeed acting in the service of the central devotional focus of the church and additionally the church acknowledging this potential. It is difficult not to associate Isabella de Vesci closely with this, not only because she paid for part of the building, but because of what is known about her piety and her Dominican sympathies. Her husband John de Vesci had been a close associate, some say the closest, of King Edward I. It was through his queen, Eleanor of Castile, that Isabella and her brother were related to the English royal line. John de Vesci favoured the Franciscans and had founded a monastery for sisters of St Clare at Newcastle

in 1277.[43] Yet, no doubt partly because of his widow's sympathies and kinship, his heart was buried in the Dominican church in London, in the same sepulchre as that of Alphonso, son of Edward and Eleanor of Castile.[44] Eleanor was also a strong supporter of the Dominicans and bequeathed money to thirty-nine Dominican houses and helped to found the priory at Chichester.[45] Isabella Vesci remained a widow for forty-five years. She was mistress of a number of Yorkshire manors and castles, including Scarborough, and became a major benefactor of the Blackfriars at Scarborough, paying for the building of the nave, cloisters and dormitory as well as bestowing other gifts. She was buried there in the choir.[46] While her interest in Heckington was not so close, otherwise she might have arranged to be buried there or to have founded a chantry, the devotional pattern that its imagery demonstrates, strongly emphasizing penitence and salvation through devotion to the sacrament, is precisely of a kind that was promoted by female religious orders in the thirteenth century and later became noticeably popular with secular women of the upper classes.[47]

It is logically simple, though possibly simplistic, to suppose that Isabella de Vesci or her confessor (or Alice de Beaumont and hers, though less is known about her) were therefore responsible for determining the iconography of the church. But that it is visual expression of current devotional practice is manifest. As was the case with Robert of Bourne's *Handlyng Synne*, which he wrote in order for it to be widely understood, its message, or the message of the exterior sculpture at any rate, positioned at the borderline between church and parish, was intended for local popular consumption. This raises major questions about the meaning of popular imagery: is it the product of 'the people' or designed for consumption by the people by those who wish to control their behaviour? It also brings into focus the role of the female patrons in relation to the choice of subject matter, particularly the portion of it which derides woman's weaknesses. Is there so much anti-female imagery because the patrons were female, and did they wish to pass on the moral instruction they had received to the populace at large? Or are we witnessing just another example of clerical mysogyny, manipulating women's perceptions of their own failings and sins as impressed upon them by clerics as illustrations for widespread condemnation? The meanings collected in the assembled group of images from the whole exterior suggest that some of both was going on and that the social and moral attitudes are consistent with the collaborative nature of the project, in other words there is possibly a general message and approach but several subtexts too, lampooning the very authority which is supposedly to be revered. This is also consistent with what is increasingly being recognized as a feature of marginal imagery, that it is a fugitive genre, filtering a multiplicity of cultural references and adhering to no particular canon. It was possible to approach it in a number of ways, each of which suggested a different kind of reading. In modern scholarship on the subject the particularities of patronage, workmanship and cultural climate have too easily been ignored and with them the historical framework that may enable further and deeper interpretations of the material.

Veronica Sekules
University of East Anglia

Notes

1 Lilian Randall, 'Exempla as a source of Gothic Marginal Illumination', *Art Bulletin*, vol. 39 (1957), pp. 97–107; Lilian Randall, *Images in the Margins of Gothic Manuscripts* (Berkeley, 1966); Lucy Freeman Sandler, 'Reflections on the Construction of Hybrids in English Gothic Marginal Illustration', in M. Barasch and L.F. Sandler (eds.), *Art the Ape of Nature: Studies in Honor of H.W. Janson* (New York, 1981), pp. 51–65; Lucy Freeman Sandler, 'A Bawdy Betrothal in the Ormesby Psalter', W. Clark, C. Eisler, W. Heckscher, B. Laine (eds.), *A Tribute to Lotte Brand Philip* (1985), pp. 154–9; Michael Camille, 'Labouring for the Lord: the ploughman and the social order in the Luttrell Psalter', *Art History*, vol. 10, no. 4 (December 1987).

2 Recent debate has been stimulated by Michael Camille in *Image on the Edge: The Margins of Medieval Art* (London and Harvard, 1992) and his reviewer Jeffrey Hamburger in *Art Bulletin*, pp. 319–27. Quite different aspects of marginal imagery have been discussed recently in two articles in *Gesta*: S. Hout, 'Visualisation and Memory: the Illustration of Troubadour Lyric in a Thirteenth-Century Manuscript', *Gesta*, vol. 20 (1992); N. Kenaan-Kedar, 'The Margins of Society in Marginal Romanesque Sculpture', *Gesta*, vol. 20 (1992), pp. 15–24; Hamburger discusses and cites a full bibliography of other recent relevant literature.

One of the central issues is how and by whom the margins are controlled. Camille says that the 'centre is dependent on them for its continued existence' (Preface, p.10). I believe that it is sometimes possible to assert that, but one needs to be clear about who or what represents the centre, and whose agenda is being fulfilled in the creation of any work of art where marginalia appears. On aspects of social control, see also Peter Birke, *Popular Culture in Early Modern Europe* (London, 1978), pp. 199–204.

3 She was mistress of the manor from 1294 until 1309 and her image appeared in glass in the south aisle of the nave, recorded in B.L. Add MS 36295, f.40 and B.L. Harley 6829, f.254–6, published as: *Lincolnshire Church Notes made by Gervase Holles AD 1634 to AD 1642*, R.E.G. Cole (ed.), Lincoln Record Society, vol. 1, 1911, pp. 191–2; *Knights of Edward I* (Harleian Society, vol. 80, 1929), vol. 1, pp. 101–102.

4 *Knights of Edward I* (Harleian Society, vol. 80, 1929), vol. 1, p. 77.

5 *Cal. Pat. Rolls* (1307–13), p. 107.

6 *Cal. Inq. Post Mortem*, vol. 7, no. 622, pp. 421–2; *Complete Peerage*, vol. 12, pp. 279–80; the Lay Subsidy Return for 1332 records her residence at Heckington, Lincolnshire Archives Office, FLs10, f.21. I am grateful to Nicholas Bennett for this reference.

7 *Cal. Inq. Post Mortem*, vol. 12, no. 455, p. 427; *Cal. Inq. Post Mortem*, vol. 9, no. 415, pp. 316–17. F.D. Blackley and G. Hermansen (eds.), *The Household Book of Queen Isabella of England* (Alberta 1971), p. xiv.

8 Holles 1911 (op. cit., note 4), pp. 191–2; references and discussion is given in full in V. Sekules, *The Sculpture and Liturgical Furnishings of Heckington Church and Related Monuments: Masons and Benefactors in Early Fourteenth-Century Lincolnshire*, PhD thesis, University of London, 1990.

9 V. Sekules, 'The Tomb of Christ and the Development of the Sacrament Shrine: Easter Sepulchres Reconsidered', *Medieval Art and Architecture at Lincoln Cathedral*, British Archaeological Association Conference Transactions for 1982, vol. 8 (1986), pp. 118–31.

10 P. Binski, *The Painted Chamber at Westminster* (London 1986), p. 41, pl. 2b; H. Colvin, *The History of the King's Works* (1963), vol. 2, p. 1012, refers to another example which is particularly relevant in this context in Henry III's circular chapel at the palace of Woodstock.

11 G.R. Owst, *Literature and Pulpit in Medieval England* (1933/1961), p. 238.

12 Most recently by N. Kenaan-Kedar, 'The Margins of Society in Marginal Romanesque Sculpture', *Gesta*, vol. 20 (1992), pp. 15–24.

13 D. Owen, *Church and Society in Medieval Lincolnshire* (1971), p. 105; in the Lincoln diocese, markets in churchyards, churchyard games, drinking feasts called church ales or scot ales were all condemned by Bishop Grosseteste *c.* 1239 and his prohibition was repeated by Bishop Dalderby in 1306.

14 F.J. Furnivall (ed.), *Robert of Brunne's Handlyng Synne*, Early English Text Society O.S. 166 (1901), p. 283.

15 A. Gransden, *Historical Writing in England c. 550–c. 1307* (1974), p. 484.

16 A Gurevich, *Medieval Popular Culture: Problems of Belief and Perception* (1988), p. 197. H.W. Janson, *Apes and Ape Lore in the Middle Ages* (1952).

17 K.S. Block (ed.), *Ludus Coventriae, or The Plaie called Corpus Christi*, Early English Text Society, ES CXX (1922/1960), p. 19. For a discussion of scatalogical imagery in the context of courtly literature and imagery, see Camille (1992), pp. 111–15.

18 J.H. Baker, *An Introduction to English Legal History* (1971), p. 67. In the fourteenth

century, Sergeants at Law had distinctive robes and white linen coifs. Winter dress for a judge *c*. 1350 consisted of a scarlet hood with a flat liripipe hanging behind it, and over it a roll of minever round the neck. Other legal officials wore a shoulder piece, W.N. Hargreaves Maudsley, *A History of Legal Dress in Europe until the end of the 18th century* (1963), pp. 46–50. Before 1600 the practice had emerged of hanging the hood over the left shoulder as a sign of mourning; J.H. Baker 'History of the Gowns worn at the English Bar', *Costume*, no. 9 (1975), p. 19. I am grateful to Janet Mayo for these references.

19 The usurer comes in for attack in *Handlyng Synne*, pp. 92–3, 181–92 and was one of the most persistent targets for criticism throughout the Middle Ages — as R.H. Tawney points out in *Religion and the Rise of Capitalism* (1938/1990), pp. 57–9, and Jacques Le Goff in op. cit., n. 19, p. 305, the practice was severely condemned by the Second, Third and Fourth Lateran Councils of 1139, 1179 and 1215, by the Second Council of Lyons in 1274 and the Council of Vienne in 1311. Le Goff, pp. 303–306, prints an exemplum by Caesarius of Heisterbach, about the Usurer of Liège, who was saved from Hell by the penance of his widow. Normally usurers were prime candidates for damnation, cf. Owst, op. cit., note 13, pp. 293–8.

20 The story is from Etienne de Bourbon's anecdotes for preaching and is translated in G. Coulton, *Life in the Middle Ages* (1910/1967), pp. 86–7; also quoted by Tawney, op. cit., note 21 (1938/1980), p. 49.

21 Quoted by N. Pevsner, *The Buildings of England, Lincolnshire*, p. 530.

22 J. Baltrušaitis, *Le Moyen-Age fantastique* (Paris, 1955).

23 Jacques de Vitry, p. 113; Gurevich (1988) also quotes similar stories from Burchard of Worms, pp. 83–5.

24 *Handlyng Synne*, pp. 290–2. See also Owst (1961), p. 387; Owst (1926), pp. 176–7; Sekules (1987), p. 41; M. Camille 'Seeing and Reading: some visual implications of medieval literacy and illiteracy', *Art History*, vol. 8 (1985), pp. 26–49.

25 Natalie Zemon Davis, 'Women on Top: Symbolic Sexual Inversion and Political Disorder in Early Modern Europe', in B.B. Abrahams (ed.), *'The Reversible World': Essays in Symbolic Inversion* (1977/8). D. Bushinger & A. Crepin (eds.), *Amour. Mariage et Transgressions au Moyen Age* (1984). I am grateful to Malcolm Jones for the latter reference which contains some useful articles on the theme of marital discord.

26 *The Book of the Knight of La Tour Landry*, trans. Thomas Wright, EETS, no. 33 (1868), has been frequently cited here, but it is a typical compilation of which there were numerous variants from other parts of Europe: for example, Thomasin von Zirklaere, *Der Walsche Gast*, H. Ruchert (ed.), (1852) or Robert de Blois, *Le chastoiement des dames*, J. Ulrich (ed.), (1895). See J. Bumke, *Courtly Culture, Literature and Society in the High Middle Ages* (1991); Carla Casagrande, 'La Femme Gardee', pp. 83–116 and Sylvana Vecchio, 'La Bonne Epouse', pp. 117–45 in C. Klapisch-Zuber (ed.), *Histoire des Femmes en Occident. Le Moyen Age* (1990).

27 *La Tour Landry*, pp. 17, 22–8, 56, 83–6, 91.

28 ibid., pp. 30–1, 37–8, 39, 45, 63–5. Vanity and pride in dress was also much criticized in *Handlyng Synne*, pp. 112–13, 116, 118–19. See also Owst (1961), pp. 391–2, 397.

29 *La Tour Landry*, pp. 15–17.

30 *Handlyng Synne*, p. 301.

31 For example, in 'La Somme le Roy', London BL MS Add 54180, f. 136, illust. L.F. Sandler, *Gothic Manuscripts 1285–1385* (1986), vol. 2, fig. 5, and E.G. Millar, *The Parisian Miniaturist Honoré* (1959). The story is from II Kings 4, vv. 1–7, and is illustrated beneath a personification of Avarice.

32 *Age of Chivalry*, cat. nos. 531, 536. A list of examples of the goat as a symbol of lechery is in M.W. Bloomfield, *The Seven Deadly Sins* (1952/1967), p. 249. He also quotes an early sixteenth-century example from an English poem, the 'Example of Virtue' by Stephen Hawes, of a lady riding on a goat 'in fresshe arraye right yonge of aege and lusty of intent', ibid., p.239. A ram was also a symbol of lust. According to a West Country custom, a peasant widow who was unchaste lost her entitlement to her inheritance unless she rode to court, in this case upon a ram, repeating

> Here I am,
> Riding upon a black ram
> Like a whore, as I am . . .

H.S. Bennet, *Life on the English Manor* (1937/1984), p. 255.

33 *La Tour Landry*, pp. 18, 57, 71–83. Lecherous looks and behaviour is also discussed in *Handlyng Synne*, pp. 258, 262–6.

34 W.O. Ross (ed.), *Middle English Sermons*, Early English Text Society, O.S., no. 209 (1940), pp. 154–5.

35 The interpretation of the imagery of the exterior of the church as relating to the Last Judgement was a feature of the literature on church symbolism in the twelfth century. Hugh of St Victor's interpretation in 'The Mystical Mirror of the Church' is particularly apt in this context. Speaking of the roofs of the church he said:

> 'The cock which is placed thereon representeth preachers. For the cock in the deep watches of the night divideth the hours thereof with his song he arouseth

the sleepers; he foretelleth the approach of day; but first he stirreth up himself to crow by the striking of his wings. Behold ye these things mystically: for not one is there without meaning. The sleepers be the children of this world lying in sins. The cock is the company of preachers which do preach sharply, do stir up the sleepers to cast away the works of darkness, crying, "Woe to the sleepers: Awake thou that sleepest"; which also foretell the coming of the light, when they preach of the Day of Judgement and future glory.'
Translated in Neale and Webb (eds.), *Durandus, Gulielmus: The Symbolism of Churches and Church Ornaments, a Translation of the first book of the 'Rationale Divinorum Officiorum'* (1843), pp. 198–200. Michael Camille discusses the imagery relating to the Last Judgement of the Portail des Libraires at Rouen Cathedral in *Image on the Edge* (1992), chap. 3, pp. 77–97, and also mentions the general idea of the roofs of the church as a site of imagery about sin, loc. cit., p. 91.

36 Y. Lefevre, *L'Elucidarium et les lucidaires: contribution par l'histoire d'un texte, à l'histoire des croyances religieuses en France au Moyen Age* (1954), p. 170, suggests that sculptures of the damned as stretched-out figures inspired textual references to the characteristic postures of sinners in hell. This is discussed further in Gurevich (1988), p. 161. The stretched-out posture for demons embodying the vices is also characteristic of the illustration in an English mid-thirteenth-century manuscript of Peraldus, *Summa de vitiis*, London BL MS Harl. p. 3244, where the vices are arrayed in this fashion confronting a knight armed for spiritual battle. The miniature is discussed by Michael Evans, 'An Illustrated Fragment of Peraldus's "Summa" of Vice: Harleian MS 3224', *Journal of the Warburg and Courtauld Institutes*, vol. 45 (1982), pp. 14–67. Evans points out that there is no parallel for such a demonic representation of vices as limbless monsters and winged quadrupeds. The similarity with corbels such as those at Heckington is, however, possibly not a coincidence.

37 The question as to how Purgatory was perceived in the scholarly literature of the Middle Ages has been discussed at length in Le Goff, *The Birth of Purgatory*, to whose ideas part of Aron Gurevich's book *Medieval Popular Culture* and article 'Popular and Scholarly Medieval Cultural Traditions: Notes in the Margins of Jacques le Goff's Book', *Journal of Medieval History*, vol. 9 (1983), pp. 71–90, are to some extent a response. Le Goff pointed out that Purgatory was not named and therefore was not perceived as a distinct place until the late twelfth century, although the idea of purgatorial punishment was already discussed by St Augustine and prefigured in earlier tradition. Its existence was not sanctioned by the Church until the second Council of Lyons in 1274, at which point it was defined as a place for the purgation of sins between death and Judgement, during which time prayers of the living could assist the passage of the soul of the deceased to salvation. Gurevich believes, on the other hand, that all the elements of the understanding of Purgatory were present from St Augustine onwards, and that the later contributions simply refined the doctrine. The debate is not entirely a matter of semantics, but is concerned with how doctrine was received into universal consciousness. Le Goff believes it was through the definition of arguments, rules and precise terminology by scholars. Gurevich believes that perceptions of the afterlife evolved gradually, that scholarly redefinitions were a separate exercise which had little immediate impact on popular understanding and that persistently held traditional beliefs were never shaken off. The question is crucial here, in order that the nature of the perception of the afterlife, of the Last Judgement at Heckington, can be interpreted. Does it conform to a scholastic idea of Purgatory? to St Augustine's idea? to a popular tradition? to an idea that was up-to-date for the 1320s? The answer will have to be a combination of all these, in that Le Goff must be right in assuming that scholarly ideas did filter through beyond the confines of the University of Paris and it is quite clear that artists were aware of them, quite probably via learned advisers. As I discussed above, though, artists were constantly dealing with long-standing visual traditions which were independent of the literary sphere, so there will never be a perfect match between written ideas and visual ones. The question is also crucial, as although Gurevich suggests that demonic beings as represented on gargoyles and corbels may have something to do with the perception of the afterlife, both he and Le Goff, and other scholars, in looking for representations of Purgatory have sought depictions of tortured souls being rescued from flames.

38 Albertus Magnus, *De Resurrectione*, before 1246, and his commentary on the four books of *Sententiae* of Peter Lombard. Le Goff (1984), pp. 256–64; Thomas Aquinas's discussion of Purgatory is principally found in the *Supplement* to *Summa Theologica*, which was not written by Aquinas himself, but by disciples citing him verbatim, Le Goff (1984), pp. 266–78.

39 Arnold of Liège, *Alphabetum narrationum*, available in the fourteenth and fifteenth centuries in Latin and in vernacular translations into English, Catalan and French, Le Goff (1984), pp. 315–6; Jacobus de Voragine, *The Golden Legend*, trans. and adapted G. Ryan and H. Ripperger (1969), pp. 648–57, esp. 650. The discussion of Purgatory is the text for the 'Commemoration of All Souls'.

40 William of Malmesbury peopled the other world with bishops, evil confessors, vassals of the king and a member of the royal family: J.A. Giles (ed.), *Gesta Regum* (1847), pp. 102–104, *Golden Legend*, p. 650. The emphasis on characteristics of Purgatory and its punishments being related to familiar aspects of daily life is made in various vernacular descriptions of visions of the afterlife. For example, the peasant Thurchill's vision of Purgatory took place at a basilica in the centre of the world, and he met friends and relatives from his village in Essex. The peasant Gottschalk from Holstein visited a town of the dead in which the souls were arranged according to their parishes and were recognizable to him not only because of their appearance but because of familiar locations. Thurchill's vision (of 1206) was recorded by Roger of Wendover in the *Flores Historiarum* and by Matthew Paris in the *Chronica Maiora* and summarized by Le Goff (1984), pp. 373–4; Gottschalk's vision (of 1189) was written in two forms: *Godeschalchus* and *Visio Godeschalchi* Erwin Assmann (ed.), vol. 74 (1979) in *Quellen und Forschungen zur Geschichte Schleswig-Holsteins*. Both visions are discussed by A. Gurevich, 'Oral and Written Culture of the Middle Ages: Two "Peasant Visions" of the Late Twelfth–Early Thirteenth Centuries', *New Literary History*, vol. 16, no. 1 (1984), pp. 51–66.

41 For example, in the sermon 'De Festo Corporis Christi' in C. Horstman (ed.), *The Minor Poems of the Vernon MS*, Early English Text Society O.S. 98 (1892), pp. 168–97. *Handlyng Synne* has an elaborate passage on the seven properties of the sacrament in overcoming the seven deadly sins, following a story of the eucharist coming to life,
pp. 312–17. This is also copied in the Vernon manuscript, pp. 198–221, and in variations discussed in Bloomfield (1952/1967), pp. 173–4.

42 'They judge of divine things from the analogy of corporeal things, imagining that God in his own nature has a body of a man like their own, thinking that the three persons in the Trinity are separate beings and so forth . . . By a certain carnal reverence, their mind is stirred to adore with bodily humiliation that image rather than any other and their intention is habitually directed towards God in whose name they do worship such an image' G. Owst, *Literature and Pulpit* (1933/1961), pp. 138–9 from an unpublished fourteenth-century treatise in defence of images by Walter Hilton, an Augustinian canon of Thurgarton, Nottinghamshire.

43 *Knights of Edward I*, (Harleian Society, vol. 84, 1932), vol. 5, pp. 118–19.

44 A. Clapham, *Archaeologia*, vol. 63, pp. 57–84.

45 W.A. Hinnebusch, *The Early English Friars Preachers* (Rome, 1951), pp. 73, 78.

46 ibid., pp. 97–8; Goldthorpe, 'The Franciscans and Dominicans in Yorkshire', *Yorkshire Archaeological Journal*, vol. 32 (1935), pp. 365–428; T. Hinderwell, *The History and Antiquities of Scarborough* (York, 1811), Victorian County History, *Yorkshire*, vol. 3, p. 277.

47 Jeffrey F. Hamburger, 'Art, Enclosure and the Cura Monialium: Prolegomena in the Guise of a Postscript', *Gesta*, vol. 31/2 (1992), pp. 108–34; P. Bange, G. Dresen, J.M. Noel, ' "Who can find a virtuous woman?" Married and unmarried women at the beginning of the modern time', *Saints and She Devils* (London 1987), pp. 9–38; Susan Groag Bell, 'Medieval Women Book Owners; Arbiters of Lay Piety and Ambassadors of Culture', in M. Erler and M. Kowaleski (eds.), *Women and Power in the Middle Ages* (Athens and London, 1988), pp. 149–87; Paul Vandenbroeck, *Le Jardin Clos de l'Ame, L'imaginaire des religieuses dans les Pays-Bas du Sud, depuis le 13e siècle* (Brussels, 1994); Jennifer Ward, *English Noblewomen in the Later Middle Ages* (1992), pp. 143–63.

Art History ISSN 0141-6790 Vol. 18 No. 1 March 1995 pp. 63–96

Why the Atom is our Friend:
Disney, General Dynamics and the USS *Nautilus*

Mark Langer

The state's use of atomic energy for military purposes exists not only in the physical apparatus of the armed forces, but also in cultural representations of the atom. Jacques Derrida has called this a

> phenomenon whose essential feature is that of being *fabulously textual*, through and through. Nuclear weaponry depends, more than any weaponry in the past, it seems, upon structures of information and communication, structures of language, including non-vocalizable language, structures of codes and graphic decoding. But the phenomenon is fabulously textual also to the extent that, for the moment, a nuclear war has not taken place: one can only talk and write about it.[1]

Peter Schwenger observed that representations of atomic warfare are found in painting, mixed media, opera, oratorio, dance, film, television and popular music.[2] To this list, one might also add such commonplace media as fashion, comic books, architecture, public celebrations, museums and amusement parks, as well as the names of businesses, streets and municipalities.[3] Many of these representations of atomic technology depicted swords as ploughshares. This article will use one media event depicting atomic technology — the broadcast of a particular episode of a television series — as the investigatory locus of the relationships among Walt Disney's interests, and the interests of other corporations and the government. This study proposes an interlocking relationship of business and governmental entities surrounding the Disney enterprises which accommodated the government's and defence contractors' views and ends regarding the use of atomic energy. This interlocking network assisted the state in the management of discourse representing atomic weaponry. The broadcast of Walt Disney's *Our Friend the Atom* (1957), made for the *Disneyland* television programme, will be examined as a paradigm of the kinds of synergistic relationships that Disney maintained within his Magic Kingdom, as well as the cooperative and mutually beneficial nature of his relationships with other larger, corporate and governmental institutions.

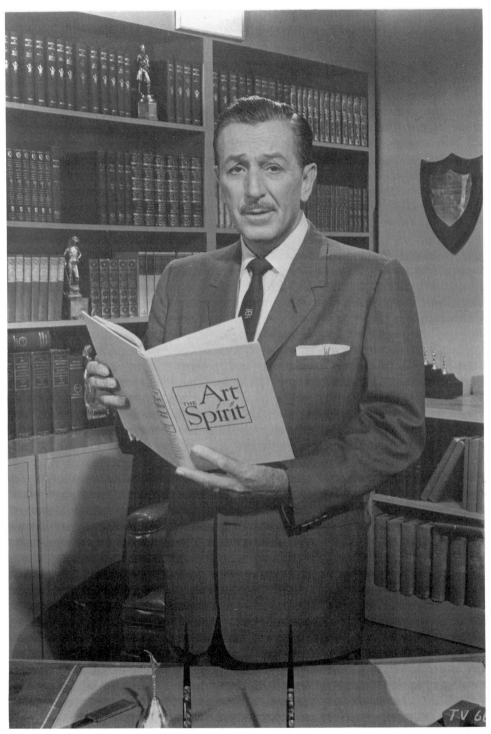

24 Walter Elias Disney. © The Walt Disney Company.

Atomic Institutions

In the post-war period the domestic use of atomic energy played an important role in stated U.S. government policy. On 1 August 1946 President Truman signed the Atomic Energy Act, which established an Atomic Energy Commission. The Atomic Energy Act called for such objectives of atomic energy as the promotion of world peace, the improvement of general welfare, an increase in the standard of living and the stengthening of free competition in private enterprise. However, these goals were 'subject at all times to the paramount objective of making the maximum contribution to the common defense and security . . . '.[4] As D.M. LeBourdais observed of the Act, this limitation meant that since 'the responsibility for determining what constitutes "defence and security" is left almost entirely to those who believe that security can best be attained by armed might, the possibilities of atomic energy fade considerably.'[5]

By 1950 the activities of the Atomic Energy Commission involved the labour of 5,000 government employees and 68,000 contractor employees. Roger M. Anders notes, 'Although the atom promised one day to deliver its share of peaceful technological marvels, the primary task of the chairman and the commission was to build, improve and increase the atomic arsenal.'[6] Links among members of the Atomic Energy Commission, government defence interests and major defence contractors were particularly close. Gordon Dean, Chairman of the Atomic Energy Commission from July 1950 to June 1953, is a case in point. Dean was the first Chair of the AEC to join the National Security Council. After leaving the AEC, Dean was named to the boards of several corporations. He then organized the Nuclear Science and Engineering Corporation and merged his company in 1955 with the General Dynamics Corporation, manufacturers of nuclear submarines for the Navy. Dean also joined the board of directors of the Atomic Industrial Forum, an association of business leaders with interests in nuclear technology that had been organized by T. Keith Glennan, Dean's predecessor as Chair of the AEC. Gordon Dean later returned to government work by heading a Council on Foreign Relations panel to explore American foreign policy in the nuclear age.[7]

The evolution of the nuclear submarine project began in January 1948, when the Department of Defense asked the Atomic Energy Commission to design, develop and construct a nuclear reactor to be used for submarine propulsion. By August 1949 the chief of Naval Operations established a 'ready-for-sea' date for the craft of January 1955. Funds for the construction of the *Nautilus* were authorized in the budget for the fiscal year 1952.[8]

The construction of the nuclear submarine was planned at a time of rising opposition in the scientific community to the military use of atomic energy. This opposition resulted in loyalty investigations of many American scientists in the 1950–55 period and Robert Oppenheimer's loss of security clearance in 1954. There was a lack of public consensus, both nationally and internationally, on the use of nuclear technology. Public alarm over the American multimegaton thermonuclear tests beginning in 1952, and the subsequent Soviet tests, hit a peak in 1954, when radioactive ash resulting from American testing spread over an area of 7,000 square miles in the Pacific. Nearby islanders had to be evacuated

and a number of Japanese fishermen were killed by the fallout. Concerns about nuclear testing were reflected in the popular press, which ran articles dealing with the deleterious effects of atomic blasts and radiation on typical homes, animal life and even the weather. Public unrest increased to the point where President Eisenhower, in a news conference on 4 February 1954, called for a halt to the spread of fear in connection with the American possession of nuclear weapons. However, a shower of radioactive rain on Chicago in 1955 and a succession of similar incidents did little to dispel anxiety. A corresponding series of events affected the image of the armed forces in the United States. Although support for the American military had been high at the beginning of the Korean War, it declined markedly as casualty figures began to be reported. Further damage was done to the reputation of the armed forces by the Senate Armed Services Subcommittee hearings on waste, theft and overrunning costs in military construction held from 1950 to 1952.[9]

Other factors related to the arms industry may have been involved. After World War II the arms industry became institutionalized on a larger scale than ever before. Because of technological change, military goods could no longer be produced in hastily converted domestic plants. They required factories made especially for the purpose, staffed by highly trained and specialized employees. The long time necessary to develop atomic and other technologies raised costs dramatically. Contracting for the military moved from such established and broad-based firms as General Motors to smaller arms specialists such as General Dynamics, builder of the nuclear submarine, USS *Nautilus*. These smaller firms needed to develop their public constituencies.[10]

Imagining the Unimaginable

The nuclear war for which the *Nautilus* and its descendants were designed had not yet been fought — it was only a hypothetical concept. With the exception of survivors of Hiroshima and Nagasaki, the public only knew the subject through its representations. Since, as Derrida points out, one could only talk and write about nuclear war, control of atomic discourse entailed influencing the structures of information and communication through which nuclear discourse could be created. The discursive 'reality' of nuclear war would be shaped and contained through a series of public rituals. Toward this end, a series of theatrical pseudo-events was devised to shape the mind of the public regarding the *Nautilus* project — events which drew upon, or mimicked, traditional forms of public ceremony. Early in the construction of the submarine Captain Hyman Rickover, coordinator of the project for the Navy, arranged a keel-laying ceremony. Normally, a keel-laying was not a major ceremonial moment in ship construction. However, publicity needs could not wait for the more conventional launching ceremony. A new 'tradition' was to be orchestrated as a public commemoration in order to give the imprimature of ceremony and office to the planned nuclear navy. There was yet another layer of simulation involved. Due to the nature of the *Nautilus*'s design, the submarine did not have a keel in the conventional sense. A section of bulkhead acted as a simulacrum of a keel for this ceremony. The

'keel-laying' was actually a bulkhead-laying ceremony.

Rickover persuaded Senator Brien McMahon, Chair of the Joint Committee on Atomic Energy and an advocate of a nuclear arsenal, to invite President Truman to dedicate the keel. On 14 June 1952 Truman, accompanied by the Presidents of General Dynamics, Westinghouse and General Electric, along with a host of admirals and government dignitaries, spoke before an invited crowd and the press. Just weeks before the Democrats were to choose Adlai Stevenson as Truman's replacement in the upcoming presidential elections, Truman discussed his commitment to atomic energy. In the waning days of a sixteen-year Democratic administration, Truman recalled that humankind had discovered the power of the atom under his administration. Although the *Nautilus* was a military project, the President heralded it as part of the progression towards the peaceful use of atomic energy, which would some day be used to provide electrical power 'for everyday use in an ultimate golden age . . . '. Truman asserted, 'Now we have a working power plant for peace. This vessel is the forerunner of atomic-powered merchant ships and airplanes.' At the conclusion of his speech, Truman signalled for the 'keel' to be laid. The President then walked down to it, and chalked his initials on the bulkhead plate. Seconds later, a welder inscribed the presidential imprimature permanently into the metal surface.[11]

This 'keel-laying' ceremony was but one of many acts designed to maximize publicity and influence discourse regarding the navy's use of nuclear power. The USS *Nautilus* was christened by Mamie Eisenhower and launched on 21 January 1954 at Groton, Connecticut (plate 25). Pat Sullivan, press officer for the ceremony, urged reporters to mention the name of General Dynamics in their coverage. Not one of the speeches given that day mentioned the *Nautilus*'s military purposes — to serve as a test vehicle for a fleet of nuclear submarines carrying nuclear-tipped Polaris ICBMs, which were then under development. The hoopla surrounding this milestone was more like a commercial product launch than a ship's launch. One spectator remarked of the event, 'More than anything else, it was like the opening of the General Motors show at the Waldorf.'[12]

The publicity regarding the USS *Nautilus* was to be part of a long-term Navy programme to 'foster universal public acceptance of the nuclear ship' by means of 'several history-making voyages with its nuclear submarines', which combined such traditional discursive patterns as those associated with sports events, trade shows and celebrity endorsements. The *Nautilus*'s sea trials were designed as much for promotion of the Navy's project as for testing the craft. A series of records were quickly established. The *Nautilus* underwent more than fifty dives, a first for submarine sea trials. The newly promoted Admiral Rickover discussed the preparation of the test report with *Nautilus* Captain Eugene P. Wilkinson for the greatest publicity value. The ship's trials were extensively covered in the press, and defence contractors such as Westinghouse, General Dynamics and General Electric advertised their contributions. On her maiden voyage in May 1955 the *Nautilus* remained submerged from London, Connecticut to San Juan, Puerto Rico — more than ten times further than any submarine had travelled underwater before. William R. Anderson, Commander of the *Nautilus*, recalled that, 'Since her commissioning, Nautilus [sic] has been a kind of floating exhibit of practical nuclear power. . . . ' Within months of the submarine's launch, 68

25 (left to right) President John Jay Hopkins of General Dynamics and an unidentified
Navy official look on as Mamie Eisenhower christens the *Nautilus*, 21 January 1954.
Courtesy Dwight D. Eisenhower Library/US Navy.

members of Congress, 186 admirals and the Secretaries of the Navy and the
Defense Department visited the craft. On 21 July 1955 the Navy launched the
second nuclear submarine, the *Seawolf*, simultaneously with the keel-laying of
the *Skate*, the first of a new class of attack submarines. The conjoining of these
two events was designed to maximize the publicity for General Dynamics and
the Navy's programme.[13]

Promotional events advancing public perceptions about the peaceful use of
the Navy's atomic, missile and submarine technologies have an almost surreal
quality from today's perspective. For example, early in March of 1955
Representative Melvin Price rose at a meeting of the Joint Committee on Atomic
Energy to announce that the Committee's next session would take place 'at an
undisclosed depth off the east coast of the United States'. During this gathering
on board the *Nautilus*, the ship's Executive Officer Dean L. Axene lamented
to the Representatives and Senators that Walt Disney's *20,000 Leagues under
the Sea* (1954) could not be shown on board, as there was no room for
CinemaScope. Two days before the launch of its first atomic sub with a nuclear
ballistic missile capacity — the USS *George Washington* — the Navy delivered

mail to Mayport, Florida by means of a guided missile fired by a submarine at sea.[14] Such media stunts and advertising, although effective, had limitations. Since they were arranged directly by the organizations that profited from the atomic submarine programme, there was the possibility that promotion would reach a level where it would become too transparently self-serving. Furthermore, media stunts and advertising tended to be restricted to local or national press coverage. Other venues needed to be established for the dissemination of atomic discourse. More significantly, means were sought to empty the discourse of the atom of its real social context and meaning. This was accomplished by gradually changing the terms of the discourse from that of nuclear warfare under the control of the government to commodities in the hands of consumers. Imagining the unimaginable would be done through traditional vehicles used to merchandise fantasies. These included comic books, amusement parks, television and the cinema.

Coverage of American military affairs in the cinema was as old as American cinema itself. Films like *The Battle of Santiago Bay* (1898) or *Fighting with our Boys in Cuba* (1899), originally produced for a domestic audience, were reliable money-earners for their manufacturers and a valuable propaganda tool for the state. By the time of the First World War, the film industry was the primary media export of the United States. Such early examples as D.W. Griffith's *Hearts of the World* (1917) and Winsor McCay's animated film *The Sinking of the Lusitania* (1918) demonstrated the film medium's power to transmit ideas consistent with government policy. Direct military involvement in film-making dated back at least as far as General Hap Arnold's appearance in *Military Scout* (1911). Government participation in film-making tended to be in cooperation with existing film companies. By the Second World War, all Hollywood studios had good relations with the armed forces. Technical assistance and the use of military facilities and personnel were routinely given by the armed forces in return for script approval.[15]

Following the use of the atomic bomb at Hiroshima and Nagasaki, several film studios began development of films with atomic themes. In March 1946 the Federation of Atomic Scientists protested vigorously against producer Sol Wurtzel's planned production of 20th Century-Fox's *Rendezvous 24* (1946), which was billed as an 'atomic bomb exposé' about German scientists and their attempt to blow up Paris by radio-controlled atomic energy. The scientists' organization claimed that the treatment of atomic weaponry in Wurtzel's low-budget quickie was not 'in-keeping with its world-shaking importance'. Most major studios rushed into production with films exploiting the topic of atomic weaponry. In order to cope with an avalanche of requests for technical advice and professional endorsements, the Federation of Atomic Scientists appointed a coordinator for its activities in regard to motion pictures. The Federation also withheld its endorsement from an M-G-M production about the atomic bomb on the grounds that this endorsement was requested without Federation representatives being able to see the finished film. This M-G-M historical epic, called *The Beginning or the End* (1947), was to recreate the government project to develop the atomic bomb. *The Beginning or the End* went into production at the same time that Hal Wallis Productions announced the filming of its

depiction of the Manhattan Project in *Top Secret*. The race between Wallis and M-G-M caused considerable furore within the industry and some discomfort among government agencies as each company claimed priority over the other in the establishment of shooting schedules on location at nuclear sites in Oak Ridge, Tennessee, Los Alamos, New Mexico and Hartford, Washington.[16]

By the 1950s such conflicts were rare. Government and other institutions routinely participated in film projects related to atomic arms. *Pattern for Survival* (1950) was a twenty-one-minute short produced by the Cornell Film Co. of New York. The film was made with the cooperation of the American Red Cross, the National Securities Resource Board and the American Armed Forces. Narrated by William Laurence, the film explained to the viewer that there was a defence against atomic attack 'if we do not permit fear to overcome our power to reason.' The film promoted such safety measures as atomic shelters and the stockpiling of food. It also suggested covering the eyes with one's arms and lying on the ground as a survival tactic during a nuclear explosion.[17] Individual action replaced national action as a strategy for coping with atomic weapons.

With a view to the promotion of its submarine and missile projects, the Navy cooperated with Columbia Pictures Corporation in the production of *The Flying Missile* (1950). This Glen Ford vehicle depicted the star as a crusading submarine captain intent on persuading his superiors that V-2 rocket technology could be adapted in order to turn American submarines into underwater launching pads. Contrary to actual events, the development of this technology was portrayed in populist terms, originating from Ford's 'everyman' hero in opposition to the 'top brass'. Footage taken at the United States Naval Air Test Missile Center at Point Mugu, California was included in the film. Advertisements for the film trumpeted the virtues of this 'Smash Hit! . . . For your protection, the Department of Defense has approved no films of this astounding weapon for public viewing — until now!' According to one reviewer, *The Flying Missile* was 'comforting evidence that swords are being forged'. Despite this, the film was criticized for its weak story, and was not well received by the public.[18]

General Dynamics explored the use of other media. While pre-war media exports had been largely limited to films, the post-war period saw the expansion of transnational media culture into television programmes, books, magazines and other transmitters of corporate and governmental information.[19] In 1954, following the suggestion of John Jay Hopkins, Chairman of General Dynamics, company representatives contacted the M. Philip Copp Company. Copp was a publisher of comic books produced to promote the interests of business and governmental institutions. Copp's first great success had been the production in 1950 of the comic book *Eight Great Americans* for the Department of State. This publication, which extolled the virtues of such people as Washington, Jefferson, Edison and George Washington Carver, was printed in eleven languages. The American government distributed 1,250,000 copies internationally. Following this, the Copp Company designed and published similar comic books for corporations including defence contractors Lockheed Aircraft, General Electric, Douglas Aircraft, B.F. Goodrich, Republic Aviation and General Motors.

For General Dynamics, Copp spent a year producing *The Atomic Revolution*.

The first drafts of the text for this comic book were written by Oliver Townsend, who previously had been an assistant to Gordon Dean when the latter was Atomic Energy Commissioner. *The Atomic Revolution* was largely devoted to the peacetime use of the atom. Half a million copies were distributed free to General Dynamics shareholders, employees and 'public groups interested in learning something about the fundamentals of atomic life'.[20] These 'fundamentals' disguised the military purpose of the technology by turning it into something that provided goods and services. 'Atomic life', rather than appearing to be an oxymoron, became a promise of a commodified future of abundance.

Disney's Strategy and Government Policy

The shaping of discourse regarding atomic arms, both nationally and internationally, became a central concern of the Eisenhower administration. Following Dwight D. Eisenhower's directives given in Denver on Labour Day of 1955, Abbott Washburn, Acting Director of the United States Information Agency, began to coordinate a publicity campaign to promote a more positive view of the atom. In a letter to Eisenhower on 20 December 1955, Washburn suggested that this campaign would be accomplished by 'a number of specific projects (involving joint action by private citizens and our Government) . . . to help make the truth of America's peaceful aims known to more people . . . on a positive rather than a negative approach'.[21] Washburn suggested that this crusade be conducted through a number of venues, ranging from the 'Letters Abroad' pen pal organization, U.S. firms with overseas operations, labour unions, publishers, women's groups, radio and television, to Hollywood films. Stated Washburn,

> American movies are seen overseas by 195 million foreign viewers each week. We have had good talks with Eric Johnston and Mr. DeMille exploring the possibility of one or more feature films based on the theme of America's devotion to peace . . . We have also had favorable preliminary conferences with Walt Disney (whose overseas audience surpasses all others) on an 'Atoms for Peace' cartoon . . .[22]

Walt Disney's company was an ideal venue for the expression of government points of view. *Time* noted in 1954 that in the previous twenty-five years, almost one billion people had seen at least one Disney film. Thirty million copies of *Walt Disney Comic Books* were bought in twenty-six countries every month and a hundred million copies of more expensive books had been merchandised since 1935. Not only was Disney an enthusiastic supporter of Eisenhower, but Disney's company historically had particularly good links with the government, major arms contractors and a variety of entertainment media. Indeed, the financial success of Disney's company depended in large measure on these links.[23]

At the end of the Second World War Walt Disney Productions was in a precarious financial position. Although the company's animated shorts remained popular with the public, this popularity was not reflected on the bottom line

of the Disney account books. Wartime restrictions on merchandising and publishing supplies had cut into the company's revenue from the licensing of names and characters for commercial uses. The company's lack of product and greater demand for working capital resulted in a longer wait before profits would accrue. Rising labour costs had made the production of animated films more expensive, while returns from exhibitors had not increased significantly.[24] The company's long-term strategy before the war had been based on the production of feature-length animated films. After the war this policy changed to one wherein motion pictures (both animated and live-action) became part of not only more diversified production, but more cooperative, integrated and synergistic ventures.[25]

On Christmas Day of 1950 NBC broadcast Disney's foray into television — a special on the making of *Alice in Wonderland* (1951) called *One Hour in Wonderland*. This promotional documentary, sponsored by the Coca Cola Company, reached twenty million viewers. The programme was a success for the sponsor and network, and was widely considered to be worth a million dollars at the box office to *Alice in Wonderland*.[26] This experience, stated Roy Disney, ' . . . leads us to believe that television can be a most powerful selling aid for us, as well as a source of revenue. It will probably be on this premise that we enter television when we do.'[27] The company looked upon television as a way to assist in the exploitation and marketing of its products to 175 million people in the United States and Canada.

Another form of diversification was the Disneyland theme park. In part, Disneyland was an effort to synchronize the activities of Walt Disney Productions with its business allies for mutual benefit. For half a million dollars, Walt Disney Productions acquired a 34 per cent interest in Disneyland, Inc. The other principal stockholders in the company were American Broadcasting-Paramount Theatres, Inc., Western Printing and Lithographing Company and Walt Disney himself. ABC's financing was contingent upon the Disney production of a weekly *Disneyland* series for the network. ABC trailed its competitors NBC and CBS in the ratings. The *Disneyland* show marked an unprecedented commitment by a major Hollywood movie studio to television production. It became ABC's first hit television series.[28] Western Printing and Lithographing Company, publishers of Whitman and Golden Books, held exclusive rights to reproduce Walt Disney characters for juvenile books, colouring books and comics since 1932. For Western Printing, the partnership in Disneyland was an extension of a long-term mutually profitable relationship. Disneyland, Walt Disney Productions, the *Disneyland* show on television and publications based on the films, shows and theme park would all promote each other. Interlocking business relationships among these leisure industries created interlocking systems of promotion. The Disneyland park and television series became the linchpin of these systems (plate 26).[29]

Walt Disney Productions had similar relationships with institutions other than the businesses just described. Within days of American entry into the Second World War, Walt Disney was in Washington conferring with Secretary of the Treasury Henry Morganthau and Commissioner of Internal Revenue Guy Helvering. This resulted in the production of the promotional short *The New*

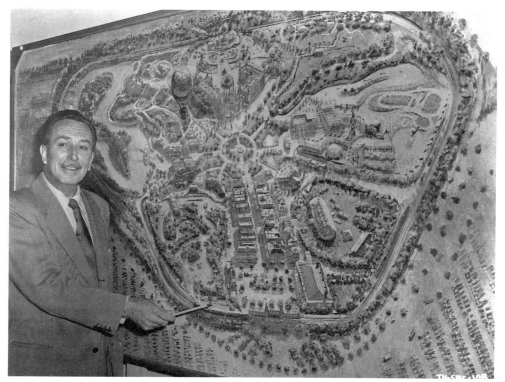

26 Walt Disney displays a map of the Disneyland park on the Disneyland television show. Edison Square is at the bottom, with Main Street running up the middle to the Sleeping Beauty Castle. Tomorrowland is at the right, with the Submarine Voyage just above the 'Trip to the Moon' rocket and 'Autopia' freeway. © The Walt Disney Company.

Spirit (1942), which encouraged citizens to pay 'taxes to smash the Axis'. During World War II the studio forged strong links with the United States federal government and with military contractors. Disney manufactured industrial films (like *Four Methods of Flush Riveting* for Lockheed in 1941), educational films (like *Something You Didn't Eat* in 1945), government propaganda (like *Education for Death* in 1943), or military training films (like *Fixed Gunnery and Fighter Tactics* in 1943). A series of psychological tests and reaction studies conducted by the Signal Corps and the Air Force's Psychological Test Film Unit during the war determined that animated educational films used for technical instruction and orientation were superior to other forms of training and indoctrination. A number of animation units were set up within the armed forces, and many films were contracted out to other companies like Warner Bros., but Disney remained the pre-eminent supplier of animated films for the war effort. Much of the studio's wartime output was devoted to government production. These films accounted for $2,600,000 worth of contracts in the first year of the war alone. Industrials brought in additional revenue.[30]

These relations were advantageous to all parties concerned. For example, through the encouragement of John Hay (Jock) Whitney, head of the Motion

Picture Section of Nelson Rockefeller's Office of the Coordinator of Inter-American Affairs, Disney was sent on a goodwill tour of South America to promote government interests in 1941. For Jock Whitney, the Latin American orientation of the film industry had 'a share in the task of imparting the full force of the meaning of freedom and sovereignty to a quarter of a billion people in the Americas . . . Wherever the motion picture can do a basic job of spreading the gospel of the Americas' common stake in this struggle, there that job must and shall be done.'[31] While the struggle for Latin American hearts and minds was the announced motive for this cooperation between state and industry, more pragmatic commercial motives may have existed. Indeed, for some in the motion picture industry, the battle against totalitarianism may have had more of a financial than an ideological function. The term 'democratic' was often a euphemism for 'hospitable to American interests'. Al Steen, writing in the industry publication *The 1941 Film Daily Yearbook*, stated that:

> The one bright spot on the foreign picture horizon is Latin America. Business was solid and strong last year and is likely to continue at least through the present year. A tendency on the part of one or two countries to lean toward totalitarian forms of government has resulted in efforts to levy special taxes on American films, a move, which if successful, is likely to be costly to the American industry.[32]

Support for the Good Neighbour Policy was coherent with the Disney studio's strategy, and the strategy of other American corporations, for opening up Latin American markets to replace lost sources of revenue in Europe and Asia. The footage resulting from Disney's trip became the basis or later inspiration for the Disney features *Saludos Amigos!* (1943) and *The Three Caballeros* (1945). Although government contracts were infrequent after the end of hostilities, the relationship with the government, and with companies doing business with the government, continued after the war and into the development of both the *Disneyland* television series and the Disneyland theme park.[33]

Disneyland Discourse and its Patrons

World Fairs and Universal Exhibitions have traditionally served a number of interests. According to Peter Greenhalgh, such events 'were seen as a remarkably efficient medium for the conducting of commercial, political, industrial, military and artistic business.'[34] Says Greenhalgh,

> They were a principal means whereby government and private bodies presented their vision of the world to the masses; because of this, the funding behind them invariably involved political machination of one kind or another. Those who paid for the exhibition normally had motives which went undiscussed in the official literature. . . . [The exhibitions] were intended to distract, indoctrinate and unify a population; as the electorate swelled toward the turn of the century,

these three intentions swelled also, their realization being hoped for through particular themes.[35]

The years that saw the rise of the great Universal Exhibitions and World Fairs were also the years of practical Utopianism, where, in the words of Michael Sorkin, the 'contrast between this positivistic, optimist vision of the perfectible future and the increasingly degraded condition of the migrant-swollen industrial city precipitated a range of proposals that took increasingly physical form.' These forms included the 'White City' of the 1893 Columbian Exposition in Chicago, the 1933 Century of Progress in Chicago and the 1939 World's Fair in New York City, which evoked Utopian visions of the future.[36]

Cinema and Universal Exhibitions have long and related histories. Edison's Kinetoscope is said to have been exhibited at the World's Columbian Exposition at Chicago in either 1893 or 1894. The 1895 Cotton States Exposition in Atlanta introduced the Jenkins-Armat Vitascope projector. The Exposition Universelle of 1900 at Paris featured a number of early cinema devices, from the balloon ascension effect offered by the Cinéorama to the Lumières' giant screen cinema in the Galerie des Machines. As early as 1915 the World's Fair declared a 'Francis X. Bushman Day' to celebrate the Metro studio star.[37] Early cinema appeared as one of many futuristic wonders in exhibitions. Like other technological devices, cinema was used to present consumer goods and dream-like experiences as focal points of public desire. Rosalynd Williams has noted, 'The seemingly contrary activities of hard-headed accounting and dreamy-eyed fantasizing merged as business appealed to consumers by inviting them into a fabulous world of pleasure, comfort and amusement.'[38] In his integration of television and film with the Disneyland theme park, Walt Disney continued the association of moving pictures and exhibitions. Rather than the earlier practice of the park containing and surrounding the cinema, Disney's combined film, broadcasting and publishing ventures would form an integrated, synergistic extension of the earlier theme park model of consumption. This integrated structure, which reached an international audience, formed a transnational space for selling both goods and cultural images. Disney promotion for the televised opening of Disneyland stressed the simultaneity and homogeneity of experience shared by those at the park and those viewing at home. An advertisement informed potential television viewers,

> Tonight, you tour Disneyland — Walt Disney's Magic Kingdom. Dial 7 at 7.30 tonight for the biggest 'live' telecast in history, as Walt Disney himself guides you through the 160-acre wonderland he has created in Anaheim, California. You will steam down the rivers of America in a real old-fashioned stern-wheeler, *The Mark Twain*; trek to darkest Africa for a look at wild animals; ride a rocket to the moon — all in the comfort of your living room.[39]

In order to dovetail the park and television programme, the *Disneyland* television series presented four kinds of alternating programming that corresponded to the four main sections of the Disneyland theme park — Adventureland, Fantasyland, Frontierland and Tomorrowland — creating

simulacra of experience for commercial and ideological ends. In Disneyland's original design, one entered the park through the American past, by means of a nineteenth-century Main Street U.S.A. and Edison Square. To the left were Adventureland and Frontierland. To the right was Tomorrowland. Straight ahead, and rising high above all the other areas, was the Sleeping Beauty Castle of Fantasyland, which served as the symbol of the entire theme park. Architecturally, the Main Street to Fantasyland axis was the spine of the park. Small-town America and Disney fantasy formed the pivot around which both past and future — the old and new frontiers — revolved. In Disneyland discourse, the future was projected as consistent with an American/Industrial/Great Man version of the past. Synthesized by Disney fantasy, past and future, as well as technology and capitalism, were combined into Disney entertainment. Walt Disney described this to the crowd at the dedication of Disneyland, saying:

> Disneyland is your land. Here age relives fond memories of the past
> . . . and here youth may savor the challenge and promise of the future.
> Disneyland is dedicated to the ideals, dreams and the hard facts which
> have created America.[40]

Tony Bennett observes that 'expositions have usually aimed to overlap these two times — of nation and of modernity — onto one another by projecting the host nation as among the foremost representatives of the time, and tasks, of modernity.'[41] Bennett's remarks were made in relation to short-term events, such as Brisbane's Expo 88. But even an institution almost forty years old is subject to short-term conditions. It must be observed, however parenthetically, that projections of modernity into the future create problems for more permanently institutionalized exhibitions such as Disneyland. As a Disneyland spokesperson recently put it, 'Tomorrowland has always been in danger of becoming Yesterdayland.'[42] The Disneyland theme park has been regularly reformulated ever since its opening through various rebuilding projects and the construction of other Disneylands in various parts of the world. At the original Disneyland in Anaheim, California, the Trip to the Moon ride was later altered to a Mission to Mars exhibition, which has now been replaced by Mickey's Toontown. This study deals with this original Disneyland from its opening in 1955 through its first major reconstruction in 1959 with the completion of the Monorail, the Matterhorn and the submarine ride.

In its original organization, Disneyland serves as a useful illustration of Bennett's observation. Frontierland, Main Street U.S.A. and Edison Square reinforced sentimental myths of an American past where, in the words of one promotional article, 'somewhere in the distance a barbershop quartet will be harmonizing'[43] Adventureland was 'an explorer's paradise' where 'intrepid travellers may take an explorer's boat on the tropical rivers of the earth'[44] in emulation of nineteenth-century agents of empire. Frontierland portrayed the achievement of America's Manifest Destiny and celebrated the progress of the past. Tomorrowland projected this myth of progress into the future. This 'Mickeytropolis' was described in a Disney publication: 'This is Walt Disney's

76

realm designed by scientists and inventive men of industry where time marches only toward the future in the simplified understandable language of entertainment.'[45]

Tomorrowland presented the future as controlled by benign and paternalistic forces of science and industry for the amusement and betterment of humankind. Representations of this future were depicted in the form of consumer goods and services. Time-travelling tourists could visit the Monsanto 'Hall of Chemicals' and 'House of the Future' to see how people would live in 1987, when common household objects would be transformed by science into such marvels as push-button telephones and microwave ovens.[46] Atlantic Richfield presented 'The Story of Oil', and the American Dairy Council (co-sponsor, with American Motors, Swift and Gibson Cards, of the *Disneyland* TV series) presented an exhibition on dairying. TWA, and later Douglas Aircraft, sponsored a simulated 1987 'Trip to the Moon'. Visitors also could ride cars on the American Motors 'Autopia' freeway of the future. Corporate franchises and sponsorships were everywhere. For example, in Frontierland, visiting buckaroos could buy refreshments at Pepsi-Cola's Frontier Saloon. Fifty-five companies leased commercial plots within the theme park. By the time that Disneyland opened for business on 18 July 1955, it was open for business in every sense of the phrase. Outside firms invested over seven million dollars in the venture.[47] Past, present and future became entertainment commodities sponsored in the same fashion as television shows.

Disneyland was opened by Governor Goodwin Knight of California and later-to-be-president Ronald Reagan.[48] The 'Trip to the Moon' ride was designed with the help of Willy Ley and Wernher von Braun.[49] Highly publicized U.S. State Department-promoted tours of Disneyland brought such notables as Kings Mohammed of Morocco and Hussein of Jordan, Presidents Sukarno of Indonesia and Jiminez of Costa Rica, Prime Ministers Suhrawardy of Pakistan and Mohammed Daud of Afghanistan, and a host of other dignitaries. One State Department official observed that there really was no reason for showing foreign potentates anything but Disneyland — everything was right there.[50] Margaret J. King has said that Disneyland drew on Disney's

> own intuitive knowledge of deeply entrenched American beliefs: the mechanistic, deterministic view of the doctrine of progress; pragmatism, applied science, the Protestant Ethic, materialism (the parks are, of course, monuments to both consumption and production); collectivism (the parts, and the entire Disney enterprise, are operated on a close-knit 'family/team' basis); the Social Ethic, specialization and centralization. In an American Studies sense, the parks are perfect museums for the study of each of these features of the system of American popular beliefs, as well as American beliefs about other cultures.[51]

For the U.S. Government, Disneyland was used as a paradigm of American achievement. As Supreme Court Chief Justice Earl Warren said, 'Everywhere I travel in the world, people ask me about Disneyland.' Disneyland was not just a convenient simulacrum of the United States. It had an ideological function.

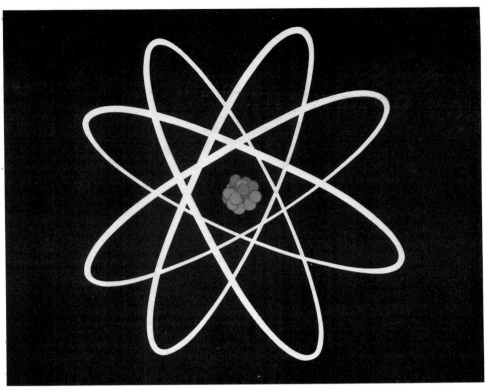

27 The atom was Disney's emblematic symbol of the future. © The Walt Disney Company.

The amusement park celebrated America's culture, and it demonstrated American command over a techno-corporate Utopia of the future.[52]

Disneyland's discourse announced that America had become the engine of international progress. Notes Bennett, ' . . . where national time is also imperial time, its internationalization is but a discursive hop, step and a jump.'[53] As a reporter for the *New York Times* commented at the park's opening, ' . . . the ceremonies took on the aspect of the dedication of a national shrine.'[54] At the opening Disney remarked that Disneyland was created ' . . . with the hope that it will be a source of joy and inspiration to all the world'. The world did come to Disneyland. In its first twelve months, 3,646,751 people were admitted. In its first four years, 15,600,000 people from over 100 nations passed through the park's gates.[55]

Our Friend the Atom

Each Disneyland section had its own logo, ranging from the castle of Fantasyland, the crossed flintlocks of Frontierland, the globe and compass of Adventureland, and the atom of Tomorrowland. Space constraints preclude full exploration of the implications of all these logos, but it is clear that in the construction of Disneyland myths, the atom was emblematic of the future (plate 27).[56]

The same logos were used in the opening credits of the *Disneyland* television series. Each week on the Disney television broadcast, Tinkerbell would select one of the Disneyland domains as the theme of that particular show. *Our Friend the Atom*, the '"Atoms for Peace" cartoon' originally envisaged by Abbott Washburn in 1955, was the Tomorrowland selection for 23 January 1957, just two days after Eisenhower's second inauguration. *Our Friend the Atom* was a partially animated programme relating the history and future of atomic energy. It was released concurrently with a book version by Disney's ally, Western Publishing.[57] This TV programme and accompanying book portrayed atomic energy as consistent, not only with the past, but with Disney production itself. Furthermore, it presented atomic energy through a discourse similar to those used in the Disneyland theme park. In this sense, the show explained the benefits of atomic energy not only through reference to history, but through a series of comparisons, analogies and other mediating strategies found at the theme park.

Our Friend the Atom opens with clips from Disney's earlier *20,000 Leagues Under the Sea* that depict Captain Nemo's ship *Nautilus* and its atomic power plant. Nemo, we are told, rather than letting this 'power fall into the hands of an immature mankind, chose rather to destroy his own work' in 'the tremendous mushroom of an atomic explosion'.[58] In the original Jules Verne novel, the *Nautilus* had been powered by a sodium 'Bunsen' apparatus. With the release of Disney's *20,000 Leagues Under the Sea*, the use of atomic power was only implied by the mushroom-shaped cloud rising over the ruins of Nemo's hideout in Volcania. By the time of *Our Friend the Atom*, Verne's prophecy had been rescripted by the Disney studio into an unambiguous prediction of atomic energy.[59] This introductory sequence is followed by the appearance of Walt Disney grasping a model of an atom. Disney thanks General Dynamics, builders of the USS *Nautilus*, for their technical help in making the programme and for their commitment to 'build an exhibit for . . . [Disneyland] which will show you atomic energy in action'.[60] Humanity had progressed to where atomic energy was more safely in the hands of twentieth-century sponsoring corporations than it had been in the hands of nineteenth-century individuals.

Disney then introduces the head of the studio's new Science Department, Dr Heinz Haber, who is depicted standing in his department (plate 28). In actuality, there was no Disney Science Department. What appeared on screen was the corner of a studio set, where male and female extras garbed in white lab coats posed as studio science workers.[61] Haber, formerly of the Kaiser-Wilhelm Institute for Physical Chemistry in Berlin, was one of a group of forty German scientists brought to the White Sands Proving Grounds in New Mexico after World War II to work on the American guided missile project. He became an adviser to Walt Disney Productions (with Willy Ley and Wernher von Braun) during the preparation of an earlier Tomorrowland programme called *Man in Space* (1955).[62] From this point on, Haber replaces Disney as the narrator of the show, and as the voice of the atomic past, present and future.

Haber functions as a key element in the transnational strategy of *Our Friend the Atom*. The fatherly figure of Disney was vocally coded as a mid-westerner. Disney introduces Haber, a scientist coded by his accent as European. Disney as American entertainer/businessman/narrator is reconstituted into Haber as

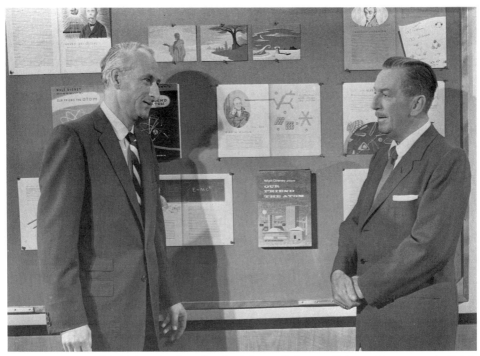

28 Disney introduces Heinz Haber, head of the studio's new 'Science Department'. © The Walt Disney Company.

an international historian/scientist/narrator in a system that blends these concepts into 'the simplified understandable language of entertainment'. The studio's Science Department — a non-existent promotional conceit — became a commodified simulacrum of the government's utilization of international groups of scientists earlier employed on the Manhattan project or the U.S. missile project at White Sands.[63] Through this, science is portrayed as a transnationalized effort under American supervision.

The overriding metaphor of *Our Friend the Atom* is found within a sequence reminiscent of Fantasyland. In an animated fairy tale, Haber narrates the story of the Fisherman and the Genie. A fisherman pulls up a brazen vessel in his net. Uncorking the jar, the fisherman is confronted with a hostile genie who explains that, after centuries of confinement, he has resolved to kill whoever liberates him from his prison (plate 29). The fisherman tricks the genie into returning inside the jar. In order to get out again, the Genie relents and grants the fisherman three wishes. Says Haber, ' . . . the story of the atom is like this fable, come true through science. For centuries we have been casting our nets into the sea of the great unknown in search of knowledge. Finally we found a vessel and — like the one in the fable — it contained a Genie.'[64] This Disney fantasy mediates between technology and the audience. As in the Navy's keel-laying ceremony for the *Nautilus*, *Our Friend the Atom* situates atomic energy within a teleological historical discourse composed in this case of an intersection of technology, nautical tradition and magic. This discourse is typical of more

80

29 The fable of the Fisherman and the Genie from *Our Friend the Atom*. © The Walt Disney Company.

conventional forms of advertising, which Raymond Williams has characterized as a 'system of magical inducements and satisfactions, functionally very similar to magical systems in simpler societies, but rather strangely coexistent with a highly developed scientific technology'.[65]

Disneyland discourse continues as *Our Friend the Atom* explains the development of atomic power through reference to great figures and to the past — conceptions seen in both Main Street U.S.A. and Frontierland. The development of atomic energy is represented as part of an historical pageant stretching from Democritus through Becquerel, Curie, Einstein and Rutherford (plate 30), just as Disney portrayed American history as a pageant of great men like Davy Crockett (portrayed by Fess Parker in a *Disneyland* television series in 1954), Abraham Lincoln (recreated by Disney technicians as an 'audio-animatronics' effigy for the *Great Moments with Mr Lincoln* exhibition at the 1964 New York World's Fair) and Thomas Edison (honoured in Edison Square of the original Disneyland).[66] Consistent with these treatments of American heroes, *Our Friend the Atom* commodifies history into a transnational procession that culminates in the American domination and ownership of atomic technology.

Like the Monsanto House of the Future, *Our Friend the Atom* defines technology and progress in terms of common substances and household products.

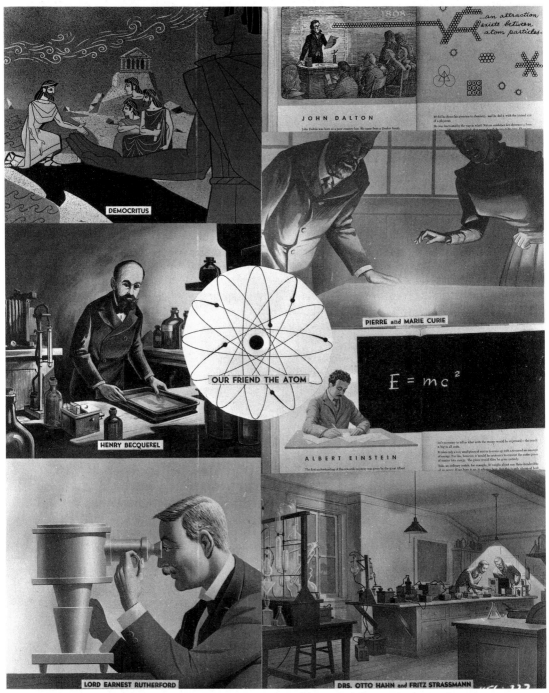

30 The development of atomic energy as a procession of historical figures is depicted in *Our Friend the Atom*. © The Walt Disney Company.

31 Haber demonstrates a nuclear chain reaction with mousetraps and ping-pong balls.
© The Walt Disney Company.

Democritus tells the viewer that atoms are like grains of sand that can be moulded into any desired form. Radioactive atoms are compared to mouse traps. Nuclear power is demonstrated by a table of set mousetraps with ping-pong balls balanced on each one. Haber throws one ping-pong ball onto the table top, setting off a trap, which hurls its balls onto other traps, setting them off, and so on, to simulate an atomic chain reaction (plate 31). An atomic reactor, the viewer is told is 'really just a furnace with thick concrete walls to encase the atomic fire'.[67] An atomic explosion might be like the angry genie, but with the nuclear reactor and the magic power to make ordinary materials into radioactive tools in science and medicine, 'here lies our chance to make the atomic Genie our friend.'[68]

Our Friend the Atom ends with predictions of how the atom will be used in a 'Tomorrowland' to be. Echoing Truman's speech, Haber informs the viewer that atomic merchant ships, submarines, planes, rockets and cars will carry passengers. Grimy coal and oil-fired plants will be replaced by clean nuclear reactors. Atomic rays will be used to produce bigger and richer crops and animals. Nuclear medicines will cure disease through the use of 'friendly' cobalt bombs. Says Haber, 'We have inherited a wealth of knowledge from the great thinkers of the past . . . and our last wish will come true if we use the power of this knowledge in their spirit. Then the atom will become truly our friend.'[69]

This attitude to atomic power was not unique to Disney's product. Such positive approaches were a significant part of the discourse of atomic energy.[70]

There were also factors related to the private concerns of individuals involved in the creation of the television show or active in the Disney organization that might explain why Disney would produce this programme endorsing the development of atomic energy. Several Disney associates have explained this in terms of Walt Disney's personal enthusiasm for scientific progress. Walt was excited about the benefits of any sort of new technology, so a programme was developed praising atomic energy.[71] Members of the Disney board of directors may have had some influence. A large block of stock in Walt Disney Productions was owned by Disney board member Floyd Odlum of the Atlas Corporation. In 1954 Odlum spent nine million dollars on a uranium mine.[72] Nevertheless, institutional factors appear to have been more influential determinants. Disney and the U.S. Navy used each other's good offices for mutual benefit. General Dynamics had the apparatus of submarine technology. Disney had the promotional apparatus.

On the evening of 17 February 1957, in a ceremony hosted by Lowell Thomas, Walt Disney was presented with the fifth annual Milestone Award of the Screen Producers Guild at the Beverly Hilton Hotel. The evening opened with Eddie Fisher singing the 'Star-Spangled Banner' and the invocation was delivered by Lt Thomas E. Moye, chaplain of Mine Force Pacific Fleet. Screen Producers Guild President Samuel G. Engel read a message from President Eisenhower to Disney. Eisenhower stated, 'As an artist, your work has helped reveal our country to the world, and the world to all of us. As a man, your sympathetic attitude toward life has helped our children develop a clean and cheerful view of humanity, with all its frailties and possibilities for good.' General Omar Bradley spoke of Disney's contributions to Armed Services' morale. A message was read from Lewis I. Strauss, Chairman of the Atomic Energy Commission, which praised Disney's 'great contribution to wider understanding of how man's inventiveness can serve the cause of peaceful progress and enrich the lives of people everywhere' in *Our Friend the Atom*. Following the playing of taped remarks by Vice-President Richard Nixon and a speech by Disney, Gene Kelly introduced to Disney thirty small children dressed in costumes of their native countries. Each child said the name of Mickey Mouse in his or her native language. Kelly then led the children in singing 'When You Wish Upon a Star' — a song from *Pinocchio* (1940) which had become the *Disneyland* programme signature tune. Pat Boone joined the chorus for the last verses.[73]

Following this ceremony commemorating Disney's role in the coordination of state and show business, came another joint venture. The cooperation between Disney and General Dynamics that Walt announced in *Our Friend the Atom* was applied to the Disneyland theme park and synchronized with the interests of both companies and the government. While *Our Friend the Atom* promoted atomic energy on the basis of its peaceful possibilities, General Dynamics was busy promoting atomic energy for military purposes.[74] On 9 June 1959, at Groton, Connecticut, General Dynamics launched the USS *George Washington* — an atomic submarine equipped with the capacity to fire nuclear-tipped Polaris missiles. The hull and reactor of this vessel were substantially the same as those of the earlier *Nautilus*. In the United Kingdom on 12 June, Prince Philip dedicated the keel of Britain's first nuclear submarine, the HMCS *Dreadnought*. Both Prince

32 Vice-President Richard Nixon and family lead a parade down Main Street in Disneyland, 13 June 1959. © The Walt Disney Company.

33 Disney and the Nixon family disembark from the Monorail for the official opening of the Submarine Voyage, 14 June 1959. © The Walt Disney Company.

Philip and Earl Selkirk, the First Lord of the Admiralty, praised Hyman Rickover, Westinghouse and General Dynamics for the technology that made this vessel possible.[75]

Disneyland soon had its own submarines. General Dynamics helped to design a $2,500,000 amusement ride fleet for the theme park. The Disney underwater armada was composed of eight air-conditioned 'atomic' submarines.[76] This was part of a multi-million dollar refurbishment of Disneyland projected to attract 4,600,000 customers in fiscal year 1959. On 13 June 1959, as 24,000 paying customers and millions of television viewers looked on, Vice-President Richard Nixon and his family led a parade down the Main Street of Disneyland to celebrate the opening of the 'atomic' submarine ride and other new features of the park (plate 32). Floats depicting Japan, Mexico, China, Greece, Spain, Italy and Scotland were interspersed with Polynesian dancers and Arabian equestrians. In effect, the world paraded behind Nixon to the nuclear future of General Disneydynamicsland. Over 1,500 members of the press and their families covered the event. Nixon, who was facing a challenge as candidate for the presidential nomination at the upcoming 1960 Republican convention, described this California appearance as non-political. A contemporary observer quipped that it was 'as non-political as a county paving contract'.

In a gala ceremony on the following day, Machinist Mate N.M. Nelson of the USS *Nautilus* and his wife, along with Rear Admiral Charles C. Kirkpatrick, chief of information for the U.S. Navy, christened the Disneyland submarine fleet. Richard Nixon and his family were the first passengers on the ride, which featured a trip past a graveyard of sunken ships (plate 33). The real meaning of atomic weapons technology had been contained through its transformation into an amusement. A reporter for the *Christian Science Monitor* enthused that 'all these things were turned, by Disney magic and with Disney color, to sheer fun, as though the real purpose of technological achievement, after all, was human happiness.'[77]

Evidence suggests that the *Disneyland* TV series was not limited to the promotion of Disney's business ventures or those of his allies at ABC or Western Publishing. Although *Our Friend the Atom* complemented the film *20,000 Leagues under the Sea*, the submarine ride in Disneyland and other Disney products, it also served as a point of contact for Disney, the Federal Government and the General Dynamics Corporation, builders of America's nuclear-powered undersea fleet. In this sense, *Our Friend the Atom* typifies the role of the *Disneyland* series and the theme park as synergistic connections, in the largest possible sense, connecting the Disney company, the film industry, the broadcasting networks, the publishing industry, defence contractors and the state.

<div style="text-align: right">

Mark Langer
Carleton University

</div>

Postscript

May 19, 1959.

Dear Dick

We are very happy that you can be with us at Disneyland on the 14th — and we're hoping time will permit you to spend the preceding day, Saturday the 13th, at the Disneyland Hotel. I feel sure you and your family would enjoy it as it was planned for the comfort and pleasure of families with special thought given to the children. Maybe Julie is right — it could be the major reason for coming to California.

I am looking forward to my visit with King Baudoun tomorrow at the Park. Mrs. Disney and I had a very enjoyable evening with the Royal Family of Belgium when we were over there last summer. We had dinner with them and found them to be a very happy family. Then last Fall I had the pleasure of taking Leopold through Disneyland when he was out here traveling incognito. He said at that time he wanted to have his family see the Park.

We will follow through with your Aide, Don Hughes, and see that all arrangements are taken care of, and I want to assure you that this entire affair will be handled in good taste and in the American tradition.

With all my best, and I'm looking forward to seeing you and your family in June.

Sincerely,

The Honorable Richard M. Nixon,
Vice President of the United States,
Senate Office Building,
Washington, D.C.

WD:DV[78]

June 22, 1959

Dear Walt:

This is just a note to tell you how much all the Nixons appreciated everything that you did to make our visit to Disneyland such a memorable one.

Perhaps our family will never quite agree on just what one feature made this visit so enjoyable, whether it was the gracious hospitality of the Disneys, the parade, which was certainly one of the most outstanding we have ever seen, the Monorail dedication, or the breathtaking ride on the atomic submarine to mention just a few. You may be sure that Disneyland will be the main topic of conversation for Tricia and Julie for many months to come.

Again my thanks to you as well as to Tommy Walker and Jack Sayer for their excellent cooperation.

With best wishes from all of us to you and Mrs. Disney.

Sincerely,

Richard Nixon

Mr. Walt Disney
500 South Buena Vista Street
Burbank, California[79]

Notes

The author wishes to thank David Smith, Robert Tieman and Rose Motzko of the Walt Disney Archive, Paul Wormser of the National Archives — Pacific Southwest Region and Herbert L. Pankratz of the Dwight D. Eisenhower Library. Susan Ohmer has been a valuable provider of source information, particularly in regard to atomic energy. The contributions of David Marshall, Marcia Pointon, Martin Rubin, Bill Mikulak, Chris Dornan, Karl Cohen, Michael Mastronardi, Will Straw and Paul Attallah should be acknowledged. A shorter, preliminary version of this article was presented at the Society for Cinema Studies Conference in New Orleans, 12 February 1993.

1 Jacques Derrida, 'No Apocalypse, Not Now (full speed ahead, seven missiles, seven missiles)', *Diacritics*, no. 14 (Summer 1984), p. 23. Within this essay, I will interchange freely the terms 'state' and 'government'. By these terms, I mean to include not only elected officials, but the entire civil service, military and all other organs of the ruling apparatus. In North American democratic culture, John J. MacAloon observed, ' "The government", which is the popular term, tends to be equated with what [we] . . . styled the state. However, as befits democratic ideology, elected officialdom always epitomizes this entity and synecdochically suppresses awareness of its other components.' Although the U.S. went through two changes of elected administration during the time covered by this study, the atomic interests of the ruling apparatus, whether called 'state' or 'government', remained consistent. John J. MacAloon, 'Steroids and the State: Dubin, Melodrama and the Accomplishment of Innocence', *Public Culture*, vol. 2, no. 2 (Spring 1990), p. 63.

2 Peter Schwenger, 'Writing the Unthinkable', *Critical Inquiry*, vol. 13, no. 1 (Autumn

1986), pp. 34–5.

3 Examples of such cultural representations are legion. In 1946, the bikini bathing suit was created and named after the Marshall Islands atoll site of an atomic bomb test. The U.S. boasts an Atomic City in Idaho, while Toronto, Canada has an Atomic Avenue. The Ottawa/Hull telephone book lists an Atomic Painting and Decorating company. Listings of drive-in theatres during the 1950s yield such names as the Atomic Drive-Ins in Oklahoma and Texas, the Radium Drive-In in California, the Uranium Drive-In in Colorado, the Bomber Drive-In in Oklahoma, the Jet Drive-Ins in Alabama, California, Georgia, Louisiana, North Carolina and Texas, as well as theatres named Rocket Drive-In in Alabama, Arizona, Colorado, Kansas and Texas. The annual bachelor's ball held for young socialites at the Westwood Country Club in St Louis was converted into 'The Atomic Ball' in 1952. The celebration featured such drinks as 'Dry Martians', 'Whiskey Solars' and 'Old Fissions'. Participants wore lead costumes, or dressed as 'products of planned evolution', etc. The Strategic Aerospace Museum in Bellevue, Nebraska, the Museum of Science and Energy at Oak Ridge, Tennessee, the Titan Missile Museum in Green Valley, Arizona, the Scientific Museum in Los Alamos and the National Atomic Museum in Albuquerque, New Mexico, all commemorate the development of nuclear weapons for the pleasure and education of passing tourists. Charles S. Aaronson (ed.), *1956 International Motion Picture Almanac* (N.Y.: Quigley Publications, 1955), pp. 536–92; *Ottawa/Hull January 1992–1993* (Toronto: Tele-Direct Publications, 1992), p. 41; 'Life Goes to The Atomic Ball', *Life*, vol. 32, no. 5 (4 February 1952), pp. 98, 100–103; Mike Wilkins, Ken Smith and Doug Kirby, *The New Roadside America* (N.Y.: Simon and Schuster, 1992), pp. 74–7.

4 D.M. LeBourdais, *Canada and the Atomic Revolution* (Toronto: McClelland and Stewart, 1959), p. 172.

5 ibid.

6 There had been several attempts to ban or internationalize atomic technology after World War II. However, the U.S.S.R.'s acquisition of the atomic bomb in August 1949, far ahead of the time that they were expected to acquire such a capability, ended America's atomic monopoly and exerted strong pressure on the U.S. to proceed with the development of thermonuclear bombs and other advanced nuclear warfare systems. Roger M. Anders (ed.), *Forging the Atomic Shield: Excerpts from the Office Diary of Gordon E. Dean* (Chapel Hill, N.C.: University of North Carolina Press, 1987), p.XI; Richard Falk,

'Emergent Nuclearism', in Robert Jay Lifton and Richard Falk, *Indefensible Weapons: The Political and Psychological Case Against Nuclearism* (updated edition) (N.Y.: Basic Books, 1991), pp. 202–203.

7 Fred I. Greenstein, *The Hidden-Hand Presidency: Eisenhower as Leader* (N.Y.: Basic Books, 1982), pp. 126–7; Anders, pp. 272, 273. This panel resulted in Henry Kissinger's influential book *Nuclear Weapons and Foreign Policy* (N.Y.: Harper & Brothers, 1957). Dean wrote the foreword for Kissinger's book.

8 Plans for a nuclear navy actually predate the dropping of the atomic bomb on Hiroshima. Richard C. Tolman, 'Report of Committee on Postwar Policy, December 28, 1944', *Atomic Power and Private Enterprise*, Joint Committee on Atomic Energy, 82d Cong. 2d sess., December 1952 (Washington: G.P.O, 1952), p. 168; Captain John E. Moore (ed.), *Jane's Fighting Ships 1974–1975* (London: Jane's Yearbooks, 1975), p. 397; 'Atomic Submarines Seen For U.S. Within 3 Years', *New York Times*, 23 December 1950, p. 3.

9 Paul Boyer, *By the Bomb's Early Light* (N.Y.: Pantheon, 1985), pp. 352–3; James Cloffelter, *The Military in American Politics* (N.Y.: Harper & Row, 1973), pp. 100–167; 'Editorial: The Oppenheimer Case', *Bulletin of the Atomic Scientists*, vol. 10, no. 5 (May 1954), p. 173; Falk, pp. 190–207; Marcel C. LaFollette, *Making Science Our Own: Public Images of Science 1910–1955* (Chicago: University of Chicago Press, 1990), pp. 165–8; James Pollard, 'Eisenhower and the Press: The First Two Years', *Journalism Quarterly*, vol. 32, no. 3 (Summer 1955), p. 293; 'Irradiated Rat Grows Fangs', *Life*, vol. 34, no. 5 (2 February 1953), p. 78; 'A-Bomb vs. House', *Life*, vol. 34, no. 13 (30 March 1953), p. 21; H. Allen Smith, 'Where's That Crazy Weather Coming From?', *Saturday Evening Post*, 1 August 1953, p. 30; 'Investigations into Overspending by Military. The Objective: $52.1 Billion', *Life*, vol. 32, no. 7 (18 February 1952), p. 46–51.

10 Cloffelter, pp. 53–5.

11 Robert H. Ferrell, *Off the Record: The Private Papers of Harry S. Truman* (N.Y.: Harper & Row, 1980), p. 256; Richard G. Hewlett and Francis Duncan, *Nuclear Navy 1946–1962* (Chicago: The University of Chicago Press, 1974), pp. 178–9; Anthony Leviero, 'Truman Assails "Cut-rate" Security As He Dedicates Atomic Submarine; Eisenhower Says He Is a "No-Deal" Man', *New York Times*, 15 June 1952, p. 1; 'The Presidency: A Matter of $40 Billion', *Time*, vol. 59, no. 25 (23 Juney 1952); p. 15; 'The Atom: Subs and H-Bombs', *Newsweek*, vol. 39, no. 25 (23 June 1952), p. 27.

12 Michael Amrine, 'Our Submerged Hope for a

Brighter World', *Bulletin of the Atomic Scientists*, vol. 10, no. 5 (May 1954), pp. 156, 192; Commander William R. Anderson, U.S.N., *Nautilus 90 North* (N.Y.: New American Library, 1959), pp. 9–10. In light of the Navy's failures with the turbines for the Mitscher-class destroyers and Walther hydrogen-peroxide submarine engine prototypes, some public scepticism was voiced regarding the Navy's ability to handle the more advanced nuclear technology. Hanson Baldwin, 'New Naval Era Opens', *New York Times*, 21 January 1954, p. 4.

13 William R. Wendt, 'Nuclear Ship Traffic in World Seaports', *United States Naval Institute Proceedings*, vol. 88, no. 1 whole no. 707 (January 1962), p. 44; Hewlett and Duncan, pp. 220, 298; Moore, p. 397; Hanson Baldwin, 'The New Face of War', *Bulletin of the Atomic Scientists*, vol. 12, no. 5 (May 1956), pp. 154–5; Anderson, p. 39; 'Navy Set to Launch Ballistic Missile Sub', *Bulletin of the Atomic Scientists*, vol. 12, no. 5 (May 1956), p. 5.

14 Clay Blair Jr., 'What It's Like to Dive in the Atom Sub', *Life*, vol. 38, no. 15 (11 April 1955), pp. 53–5; 'Navy Delivers Mail Via Guided Missile', *Christian Science Monitor*, 8 June 1959, p. 1.

15 Military subjects were common in early American films, such as the *Grant Day Series* produced by Edison in 1897, which featured footage of G.A.R. veterans, General Porter's oration, the Sixth U.S. Cavalry and the National Lanciers. Britain was an early leader in the use of such films to provide propaganda around the world for its activities in the Boer War of 1899–1901. The British film industry declined, along with other European cinemas, during the Great War. This created greater export opportunities for the American film industry. The power of the American film industry was recognized by the British government, which invited Griffith to make *Hearts of the World* as a propaganda feature in order to aid the war effort. McCay's *The Sinking of the Lusitania* was part of the *Hate the Hun* film series. Although films had been made by the United States Federal government from 1911, most had been made for internal purposes. With the exception of films sponsored by the Creel Committee on Public Information during the Great War, the American government did not give serious consideration to the production of films meant to be exhibited through commercial channels and aimed at the general public until 1935. *Catalogue of Edison Films For Projection and Other Purposes* (N.Y.: Edison Phonograph Agency, 1898), pp. 6–7; Erik Barnouw, *Documentary: A History of the Nonfiction Film* (N.Y.: Oxford University Press, 1974),

p. 23; Albert E. Smith with Phil A. Koury, *Two Reels and a Crank* (Garden City, N.Y.: Doubleday, 1952); pp. 53–68; Elizabeth Grottle Strebel, 'Imperialist Iconography of Anglo-Boer War Film Footage', in John L. Fell (ed.), *Film Before Griffith* (Berkeley: University of California Press, 1983), pp. 264–71; Terry Ramsaye, 'International', *Motion Picture Herald*, vol. 154, no. 6 (5 February 1944), p. 7; Iris Barry, *D. W. Griffith: American Film Master* (N.Y.: The Museum of Modern Art, 1965), p. 28; John Canemaker, *Winsor McCay: His Life and Art* (N.Y.: Abbeville, 1987), pp. 149–56; Arch A. Mercey, 'Films by American Governments', *Films: A Quarterly of Discussion and Analysis*, vol. 1, no. 3 (Summer 1940), p. 5; Lawrence Suid, 'The Pentagon and Hollywood. *Dr Strangelove or: How I Learned to Stop Worrying and Love the Bomb* (1964)', in John E. O'Connor and Martin A. Jackson (eds.), *American History/American Film: Interpreting the Hollywood Image* (N.Y.: Frederick Ungar, 1980), pp. 221–4.

16 Part way through its disputes with Wurtzel, Wallis and M-G-M, the Federation of Atomic Scientists changed its name to the Federation of American Scientists. I have retained the earlier name throughout the account of this dispute for the sake of clarity. Despite the opposition of the Federation of Atomic Scientists (which threatened to enlist against the film 'a flock of big-name, highly articulate scientists who have been prominent recently in trying to impress the world with the tremendous seriousness of the weapon which they helped to create'), *Rendezvous 24* was completed and released by 20th Century Fox. One suspects that Wurtzel was delighted by the promotional opportunity afforded by his opponents' threatened attack. Eventually, both the Wallis and M-G-M projects were combined in an unprecedented agreement between the studios negotiated by Joe Hazen of Hal Wallis Productions and Nick Schenck of Loew's Inc. Under the agreement, Hal Wallis Productions transferred all story material and research information to M-G-M, which would proceed to make *The Beginning or the End*. M-G-M would finance the film entirely, but Hal Wallis Productions would receive a share of the gross. This arrangement was endorsed by the Federation of Atomic Scientists.

Depictions of the role of atomic energy in the continuing struggle against Fascism and Communism can be found in films from most American studios and in several productions from elsewhere in the world. These include Alfred Hitchcock's *Notorious* (1946) for Selznick/RKO, Fritz Lang's *Cloak and Dagger* (1946) at Warner Bros., Leo Joannon's *Atoll K* (also known as *Utopia* or *Robinson*

Crusoeland 1951) for Fortezza/Sirius, Norman Panama and Melvin Frank's *Above and Beyond* (1952) at M-G-M, Josef von Sternberg's *Jet Pilot* (1951–7) for Howard Hughes Productions/Universal, Leslie Martinson's *The Atomic Kid* (1954) at Republic, Jerry Hopper's *The Atomic City* (1952) and Anthony Mann's *Strategic Air Command* (1955) at Paramount. In a few instances, these films produced some tension between the director and governmental or industry authorities. Hitchcock later maintained that he was put under FBI surveillance for three months as a result of his interest in atomic weaponry in *Notorious*. The end of Fritz Lang's *Cloak and Dagger* was cut from the film after preview screenings. Lang alleged that his criticism of the destructive power of the atomic bomb in this film's conclusion was censored. The director refused to speculate as to the party responsible for this censorship. 'Atom Scientists Train Sights on Wurtzel's Pic as "Trivial", "Quickie" ', *Variety*, 20 March 1946, p. 18; 'Hal Wallis (Sans Par) To Share in Metro's Atombomb Pix Pool', *Variety*, 20 March 1946, p. 18; Francois Truffaut, *Hitchcock/Truffaut* (N.Y.: Simon and Schuster, 1967), p. 121; Stephen Jenkins (ed.), *Fritz Lang: The Image & The Look* (London: The British Film Institute, 1981), p. 162; Peter Bogdanovich, *Fritz Lang in America* (N.Y.: Praeger, 1969), pp. 69–70.

17 Milton, J. Salzburg, producer for Cornell Films, followed *Pattern for Survival* with another civil defence film, *Target U.S.A.* (1951), which dealt with civil defence for business and industry. Civil defence films were made by other private corporations, generally with government assistance. Such films included *Atomic Alert* (1950) produced by Encyclopaedia Britannica Films Inc. for school audiences, as well as *You Can Beat The A-Bomb* (1950) and *Disaster Control* (1951) by McGraw-Hill Text Films. The Public Affairs Division of the Federal Civil Defence Administration initiated production of a series of nine-minute films based on FCDA booklets, beginning with *Survival Under Atomic Attack* (1951) made by United World Films Inc., and *Fire Fighting for Householders* (1951) made by Teletran. 'Individual Protection Against Atom Bomb Depicted in a New 21-Minute Color Film' *New York Times*, 21 December 1950, p. 8; Warren Cheney, 'You and Your Atomic Future', *Film News*, vol. 11, no. 8 (September 1951), pp. 4, 5, 7, 27.

18 Work on this submarine missile technology had actually been carried out during the war by the Nazis, not the Allies. The ability of film to promote the interests of atomic powers was well established by the end of the decade. *Power Among Men* (1959), a feature-length film produced by Thorold Dickenson for the United Nations, was an anti-war film. The last section of this motion picture was devoted to the peaceful use of atomic energy. Footage was supplied by the AEC and its corresponding Soviet counterpart. Advertisement for *The Flying Missile*, and Bosley Crowther, 'The Screen: Four New Films Arrive', *New York Times*, 25 December 1950, p. 25. Suzanne Davis, 'War-Peace Alternatives Are Depicted', *Christian Science Monitor*, 26 May 1959, p. 13.

19 The U.S. government was quick to exploit the services of non-film media in order to publicize the nuclear weapons programme. Although newsreel companies refused to allow television broadcasters to participate in their pool coverage of the atomic bomb tests at Bikini Atoll in May of 1946, an agreement was made between the government and representatives of NBC, CBS, ABC and DuMont in New York, WPTZ in Philadelphia and WBKB in Chicago to send a film cameraman to shoot the event. The film taken was flown back to Anacostia D.C. where it was processed by the Navy Photo Science labs and given security clearance. Video broadcasters had available to them all film of the test taken by the Army Signal Corps, as well as by Navy and Coast Guard photographers. 'Tele A-Bomb Pool May Sink Reels', *Variety*, 20 March 1946, p. 18; Herbert I Schiller, 'The Privatization and Transnationalization of Culture', in Ian Angus and Sut Jhally (eds.), *Cultural Politics in Contemporary America* (N.Y.: Routledge, 1989), p. 327.

20 Richard Rutter, 'Industry Turns to Comic Books', *New York Times*, 16 July 1955, pp. 19, 23.

21 Abbott Washburn, letter to Dwight D. Eisenhower, 20 December 1955. Administration Series. Box 37 U.S.I.A. Dwight D. Eisenhower Library. Abilene, Kansas.

22 ibid.

23 'Father Goose', *Time*, vol. 64, no. 26 (27 December 1954), p. 30. On 8 November 1956 Eisenhower sent Disney a letter of thanks for his participation as a member of the Committee of the Arts and Sciences for Eisenhower. Disney was later invited to the swearing-in ceremony at the Capitol and given tickets to the ball for Eisenhower's second inaugural. Dwight D. Eisenhower, letter to Walt Disney, 8 November 1956; Thomas E. Stephens, letter to Mr and Mrs Walter Disney, 11 January 1957. President's Personal File, Box 979 PPF 1636, Dwight D. Eisenhower Library, Abilene, Kansas.

24 'Goofy and His Pals Voted Winning Money-Making Shorts by Exhibitors', *Motion Picture Herald*, vol. 158, no. 2 (13 January 1945), p. 28; Roy O. Disney, 'Outlook for 1946',

Annual Report, Walt Disney Productions Fiscal Year Ended September 29, 1945 (Burbank: Walt Disney Productions, 1945), pp. 4–5; Terry Ramsaye, 'Cartoons and Policy', *Motion Picture Herald*, vol. 160, no. 6 (11 August 1945), p. 7 Susan Ohmer, 'That Rags to Riches Stuff', Disney's *Cinderella* and the Cultural Space of Animation', *Film History*, vol. 5, no. 2 (June 1993), p. 235.

25 'Disney Plans Post-War Industrial Films', *Motion Picture Herald*, vol. 159, no. 12 (23 June 1945), p. 21; 'Realign Disney Organization's Top Personnel', *Motion Picture Herald*, vol. 160, no. 11 (15 September 1945), p. 56.

26 'As We Go to Press', *Walt Disney Productions Annual Report Fiscal Year Ended September 30, 1950* (Burbank: Walt Disney Productions, 1950), p. 1; Sidney Lohman, 'Christmas on the Airwaves', *New York Times*, 24 December 1950, p. 13; 'The Television Year', in Red Kann (ed.), *The 1951–52 Motion Picture Almanac* (N.Y.: Quigley Publications, 1951), p. 909.

27 Roy O. Disney, 'Walt Disney Productions Interim Letter to Shareholders 26 Weeks Ended March 31, 1951' (Walt Disney Archive, Burbank, California).

28 Tim Brooks and Earle Marsh, *The Complete Directory to Prime Time Network TV Shows 1946–Present* (N.Y.: Ballantine Books, 1985), p. 879. The *Disneyland* television show was promoted by ABC as 'a new milestone in television entertainment' and 'the greatest innovation of the season'. Alexander Stronach, Jr., 'Healthy Growing Pains', in Charles S. Aaronson (ed.), *1955 Motion Picture and Television Almanac* (N.Y.: Quigley Publications, 1954), p. 543.

29 Western's comic book rights were eventually shared in a joint venture with Dell, beginning with the publication of *Walt Disney's Comics & Stories* in the fall of 1940. This collaboration virtually cornered the market in comic book adaptations of animated film series over the following decade. Ron Goulart, *Over 50 Years of American Comic Books* (Lincolnwood, Ill.: Publications International, Ltd., 1991), pp. 141–2.

30 During the war Disney continued the practice of producing industrial films for purposes unrelated to war industries. However, films that promoted government interests formed a significantly larger part of the studio output, and were much more widely seen. For example, *The New Spirit* was seen on 11,795 screens within a few weeks of its release. Sometimes the interaction between studio and government took rather convoluted forms. Disney bought the motion picture rights to U.S. Air Corps Reserve Major Alexander de Seversky's *Victory Through Air Power* in 1942

for a feature film of the same title released the following year. Although made without the official imprimatur of the American government, it allegedly had an effect on war policy. Winston Churchill, on hearing that Roosevelt was unfamiliar with the film, had a print air-freighted to the Quebec Conference. Roosevelt subsequently ordered the film shown to the Joint Chiefs of Staff. It is claimed that this film helped to influence the air strategy employed by the Allies after this. 'Disney Cartoon Produced for Auto-Lite Company', *Motion Picture Herald*, vol. 155, no. 10 (3 June 1944), p. 43; 'Morgenthau on "New Spirit"', *Motion Picture Herald*, vol. 146, no. 13 (28 March 1942), p. 48; Richard Holliss and Brian Sibley, *The Disney Studio Story* (N.Y.: Crown, 1988), p. 47, 49–52; 'Disney Sees Morgenthau on Film for War Bonds', *New York Times*, 6 January 1942, n.p.; 'Disney Speeds Up U.S. Training Films', *New York Mirror*, 29 August 1942, p. 18; 'Walt Disney: Great Teacher', *Fortune*, vol. 26, no. 2 (August 1942), pp. 91–6, 154–7; 'Disney Plans Post-War Industrial Films', p. 21; 'Disney Health Films In National Release', *Motion Picture Herald*, vol. 160, no. 1 (7 July 1945); p. 47; John Hubley and Zachary Schwartz, 'Animation Learns a New Language', *Hollywood Quarterly*, vol. 1, no. 4 (July 1946), pp. 360–3.

Recent studies by the U.S. Defence Department have demonstrated that cartoon images are superior to photos, plain text and illustrated text in conveying information. Roger Sabin, *Adult Comics: An Introduction* (N.Y.: Routledge, 1993), p. 8.

31 Quoted in Allen A. Woll, 'Hollywood's Good Neighbor Policy', *Journal of Popular Film*, vol. 3, no. 4 (Fall 1974), p. 279. See also 'Majors and Uncle Sam Join In Propaganda Program', *Motion Picture Herald*, vol. 157, no. 7 (18 November 1944), p. 17.

32 Al Steen, 'Foreign Markets', in Jack Alicoate (ed.), *The 1941 Film Daily Yearbook* (N.Y.: The Film Daily, 1941), p. 57. Motion picture producers also sponsored short-wave broadcasts to South America that promoted artistic freedom in an attempt to combat restrictions on American films. Allan W. Palmer, 'Cecil B. DeMille writes America's history for the 1939 World's Fair', *Film History*, vol. 5, no. 1 (March 1993), p. 47.

33 During the war more than forty countries were supplied with American films. Four out of the top six markets for American films were in Latin America. 'Serve Latin American Taste Or Lose, Producers Warned', *Motion Picture Herald*, vol. 157, no. 2 (14 October 1944), p. 19; Thornton Delehanty, 'In Hollywood', *New York Herald-Tribune*, 14 December 1941, n.p.; J.B. Kaufman, 'The Latin

American Films of Norm Ferguson', unpublished paper, Society for Animation Studies Conference, U.C.L.A., October 1989; 'Wartime Exports', *Motion Picture Herald*, vol. 160, no. 12 (22 September 1945), p. 9; 'Good Neighbor', *Motion Picture Herald*, vol. 161, no. 2 (13 October 1945), p. 9.

34 Peter Greenhalgh, *Ephemeral Vistas: The Exhibitions Universelles, Great Exhibitions and World's Fairs 1851–1939* (Manchester: Manchester University Press, 1988), p. 49.

35 ibid., pp. 27, 49.

36 Michael Sorkin, 'See You In Disneyland', in Michael Sorkin (ed.), *Variations on a Theme Park: The New American City and the End of Public Space* (N.Y.: Hill & Wang, 1992), p. 213.

37 John Belton, *Widescreen Cinema* (Cambridge, Mass.: Harvard University Press, 1992), pp. 85–6; 'Metro Day At World's Fair', *Moving Picture World*, vol. 25, no. 1 (3 July 1915), p. 41 cited in Janet Staiger, 'Announcing Wares, Winning Patrons, Voicing Ideals: Thinking about the History and Theory of Film Advertising', *Cinema Journal*, vol. 29, no. 3 (Spring 1990), p. 10.

38 Rosalynd Williams, 'Dream Worlds of Consumption', *Communication in History: Technology, Culture, Society* (White Plains, N.Y.: Longman, 1991), p. 160.

39 Advertisement in *New York Times*, 17 July 1955, p. 12. Michael Sorkin observes similarities shared by the Disneyland theme park and television. 'Disneyland, with its channel-turning mingle of history and fantasy, reality and simulation, invents a way of encountering the physical world that increasingly characterizes daily life. The highly regulated completely synthetic vision provides a simplified, sanitized experience that stands in for the more undisciplined complexities of the city.' Thomas Hine noted a similarity between the Disneyland park and Disney's films by characterizing the park as 'a movie that could be walked into'. Sorkin, pp. 205–32; Thomas Hine, *Populuxe* (N.Y.: Alfred A. Knopf, 1986), p. 151.

40 Quoted in Holliss and Sibley, p. 70. Main Street U.S.A. was modelled after the main street in Disney's home town of Marceline, Missouri before World War I. According to Richard V. Francaviglia, Main Street reflected 'a deep collective longing for pre-urban Anglo-America that was and indeed still is widely embraced by Americans of all backgrounds'. Louis Marin gives an interpretation of the significance of Disneyland's geographical layout that differs from the one that I have offered. Marin sees Main Street U.S.A. both as a 'centered space' that leads the visitor into the centre of the Disneyland text, and as a 'district' that 'separates and links Frontierland

and Adventureland on one hand, and Tomorrowland on the other'. Frontierland and Adventureland 'represent the two distances of history and geography' while Tomorrowland represents 'the universe captured by science and technology'. Richard V. Francaviglia, 'Main Street U.S.A.: A Comparison/Contrast of Streetscapes In Disneyland and Walt Disney World', *Journal of Popular Culture*, vol. 15, no. 1 (Summer 1981), p. 143; Louis Marin, 'Disneyland: A Degenerate Utopia', *Glyph*, no. 1 (1977), pp. 50–66.

41 Tony Bennett, 'The Shaping of Things to Come: Expo '88', *Cultural Studies*, vol. 5, no. 1 (January 1991), pp. 30–1.

42 John McClintock, quoted in Jessica Seigel, 'Disney tries to keep future in Tomorrowland', *Ottawa Citizen*, 20 February 1993, K6. Sheldon Waldrep suggests that 'the future, as a theme, has caused Disney more problems than any other. As an indirect critique of the present, the future easily catches up with Disney: it is a much more difficult place to hide one's agenda than the past. If the Disney future is in need of frequent revising, then might there be a problem with its thinking about the present?' Sheldon Waldrep, 'The Contemporary Future of Tomorrow', *South Atlantic Quarterly*, vol. 92, no. 1 (Winter 1993), p. 142.

43 'A Disney Preview: Mickey Mouse's Fabulous New Playground', *Fortnight* (17 November 1954), p. 18.

44 *Disneyland* (Anaheim: Public Relations Dept: Disneyland, Inc., 1954), p. 5. Adventureland was a restatement of earlier colonial displays at world exhibitions into neo-colonial terms. Alexander Wilson dubs the Jungle Cruise 'simulacra of local pasts now increasingly transnationalized. In the collapsed time and space of the adjoining gift shop, imported commodities become the displaced souvenirs of a trip through history never taken'. Alexander Wilson, *The Culture of Nature: North American Landscape from Disney to the Exxon Valdez* (Toronto: Between the Lines, 1991), p. 162; Williams, pp. 159–60.

45 'A Disney Preview: Mickey Mouse's Fabulous New Playground', p. 18; 'Let's Blast Off — Destination Moon!', *Disneyland Holiday* (Spring 1958), p. 4.

46 'Preview of Tomorrow: Monsanto's House of the Future', *Disneyland Holiday* (Fall 1957), p. 3. Monsanto was a partner in a project to develop electrical power from a nuclear reactor for the Atomic Energy Commission beginning in 1951. Edwin J. Putzell, Jr., 'The Prospects for Industry', *Bulletin of the Atomic Scientists*, vol. 8, no. 8 (November 1952), pp. 275–7.

47 Participants not mentioned elsewhere in this study included the Bank of America, Carnation Co., TWA, Santa Fe Railroad, Van Camp,

National Lead, Crane Co., Pendleton Mills, Quaker Oats, Coca-Cola and Welch's Grape Juice, who sponsored such exhibitions as displays on chemistry, aluminum, paints and *The Bathroom of the Future*. Prospective sponsors for both the park and the *Disneyland* TV show were led on a tour of Disneyland (then under construction) by Fess Parker and Buddy Ebsen, stars of the successful *Davy Crockett* telefilms, as part of the effort to woo commercial partnerships. 'U.S. Again Is Subdued by Davy', *Life*, vol. 38, no. 17 (25 April 1955), pp. 30–1; 'Disneyland Grand Opening Is Scheduled for July 18: Preview Getting 90-Min. Telecast', *Hollywood Reporter*, 19 May 1955, p. 8; 'How to Make a Buck', *Time*, vol. 71, no. 30 (29 July 1957), p. 76; 'Disneyland: Uncle Walt packs his new park with the stuff children's dreams are made on', *Life*, vol. 39, no. 7 (15 August 1955), pp. 39–42; 'World of Tomorrow ... here today!', *Disneyland Holiday* (Summer 1958), pp. 24–5. Other firms advertised their contributions to the park, e.g. Kaiser Aluminum and Chemical Co. took a full page ad in the *New York Times* to publicize its product being used both in the TWA space rocket of Tomorrowland and Sleeping Beauty's castle in Fantasyland. Advertisement in *New York Times*, 18 July 1955, p. 11.

48 *Disneyland: The First Quarter Century* (Burbank: Walt Disney Productions, 1979), p. 33.

49 'Let's Blast Off — Destination Moon!', p. 4.

50 Kimmis Hendrick, ' "New" Disneyland Captures Nixon', *Christian Science Monitor*, 16 June 1959, p. 3. Michael Sorkin states that Disneyland is a model of Los Angeles. 'Fantasyland, Frontierland, Tomorrowland — these are the historic themes of the city's own self-description, its main cultural tropes.' One might also observe that the main cultural tropes of the U.S.A. also can be described as Fantasyland (streets paved with gold, land of opportunity), Frontierland and Tomorrowland. Sorkin, p. 217.

51 Margaret J. King, 'Disneyland and Walt Disney World: Traditional Values in Futuristic Form', *Journal of Popular Culture*, vol. 15, no. 1 (Summer 1981), p. 129. Scott Bukatman characterizes Disneyland as 'another kind of virtual reality system, one which is largely conditioned by the narrative strategies that move guests through a technologically informed yet fundamentally conservative and historically bound vision of "the future".' Scott Bukatman, 'There's Always Tomorrowland: Disney and the Hypercinematic Experience', *October*, no. 58 (Summer 1991), p. 73.

52 'A Backward Glance and a Look Ahead', *Vactionland* (Spring, 1960), pp. 8, 9. My comments here are based on the assumption

that there was a generalized belief in the 'reality' of the nation and culture that formed the referent of Disneyland. Turning this assumption on its head, Jean Baudrillard has stated that 'Disneyland is there to conceal the fact that it is the "real" country, all of "real" America, which *is* Disneyland ... Disneyland is presented as imaginary in order to make us believe that the rest is real, when in fact all of Los Angeles and the America surrounding it are no longer real, but of the order of the hyperreal and of simulation. It is no longer a question of a false representation of reality (ideology), but of concealing the fact that the real is no longer real, and thus is saving the reality principle.' Jean Baudrillard, *Simulations* (N.Y.: Semiotext(e), 1983), p. 25.

53 Bennett, p. 31.

54 Holliss and Sibley, p. 70; R.S., 'Disney Dedication From Coast', *New York Times*, 18 July 1955, p. 41.

55 'A Backward Glance and a Look Ahead', pp. 8, 9.

56 *A New Concept in Family Entertainment: Disneyland*. Promotional brochure, *c.* 1954. (Margaret Herrick Library, Academy of Motion Pictures Arts and Sciences, Los Angeles). The atom was promoted as the key to the future in Disney publicity. A Disney publication of the period described Tomorrowland: 'The world of the future, with its wonderful new frontiers unfolded by the Atomic Age, is brought to life for Disneyland visitors in the 1987 realm of Tomorrowland.' 'World of Tomorrow ... here today!', p. 24.

57 Heinz Haber, *Our Friend the Atom* (N.Y.: Golden Press, 1956).

58 *Our Friend the Atom* 2nd revised Shooting Script, 19 January 1956, A.B. (Walt Disney Archive). Originally, the Tomorrowland section of the Disneyland park featured some of the sets from *20,000 Leagues Under the Sea*.

59 Richard Fleischer, director of *20,000 Leagues Under the Sea*, disavows any deliberate intent to have implied that an atomic explosion destroyed the *Nautilus* and Volcania. Fleischer claims that the miniature explosion set off for the effect was only mushroom-shaped by coincidence. Richard Fleischer, interview with author, 18 May 1991.

60 *Our Friend the Atom*, p. 2. Disney's interest in atomic energy was a long-standing one. On 4 May 1949 Disney announced his contemplation of a film on atomic fission in his *True-Life Adventure* series. Disney planned to show 'what the atom means to the future of humanity', but stated that he would 'go into its destructive powers as far as security measures will permit'. Disney unsuccessfully sought outside funding for this project. A submarine ride for Disneyland was planned as

far back as 1952, simultaneous to the first preparation for *20,000 Leagues Under the Sea* and the first federal budget allocation for the *Nautilus*. The construction of the ride was delayed due to lack of sufficient capital to develop the entire area set aside for Tomorrowland. Hedda Hopper, 'Hollywood', *New York News*, 12 May 1949, n.p.; 'Disney Playland: Studio Seeks Permit For Amusement Center', *Hollywood Citizen-News*, 28 March 1952, p. 6.

61 *Our Friend the Atom*, p. 3.

62 'Popular, aber niemals simpel', *Hannoversche Allgemeine Zeitung* (15 February 1990), p. 12; J.E. Tallman, 'Sprechen Sie Deutsch?', *Tales of a Librarian*, pp. 45–7 (Walt Disney Archive).

63 Harry H. Tytle, interview with the author, 17 May 1991.

64 *Our Friend the Atom*, p. 7.

65 Raymond Williams, 'Advertising: The Magic System', in *Problems in Materialism and Culture* (London: New Left Books, 1980), p. 185.

66 The 'Davy Crockett' shows on the *Disneyland* television series in 1955 consisted of 'Davy Crockett, Indian Fighter', 'Davy Crockett Goes to Congress' and 'Davy Crockett at the Alamo'. These were edited into two theatrical features, *Davy Crockett, King of the Wild Frontier* (1955) and *Davy Crockett and the River Pirates* (1956), which were distributed in cinemas both inside and outside of the United States and Canada. Ancillary merchandising of Davy Crockett products resulted in phenomenal income for the studio from the sales of such items as over ten million Davy Crockett coonskin caps. Holliss and Sibley, p. 69.

67 *Our Friend the Atom*, p. 42.

68 ibid., p. 44.

69 ibid., p. 57. It should be noted that the earlier genie in the bottle episode of *Our Friend the Atom* depicts the power of the genie as a myth associated with the Arabian or Persian oil-producing areas of the world. Atomic energy is the new, modern replacement for this older energy form. The end of *Our Friend the Atom* proposes that atomic energy fuel motor cars, power plants, ships and airplanes — all traditional users of petroleum products modernized by an American-controlled energy source.

Aspects of the discourse of *Our Friend the Atom* also inform other films promoting the use of atomic energy. For example, John Sutherland Productions produced the animated film *A is for Atom* (1964) for General Electric, manufacturers of nuclear reactors and warheads, as part of the GE sponsored *Adventures in Science* series. The film's opening narration stated, 'On December 2, 1942, in a squash court at the University of Chicago . . . mankind . . . found the answer to a dream as old as man himself. A giant of limitless power at man's command. And where was it that man found this giant? In the atom.' The envisaged giant was physically similar to the genie in *Our Friend the Atom*. *A is for Atom* promised that nuclear power would propel subs, ships and space travel, and that it would provide medical and agricultural advances. An animated montage sequence shows an international array of nuclear power plants — each one viewed as the background to an activity such as farming or sport fishing. Echoing the end of *Our Friend the Atom*, the conclusion of this later film claimed, 'Truly the superpower which man first released over two decades ago from within the atom's heart, is today man's faithful servant.'

70 See, for example, 'Vast Power Source in Atomic Energy Opened by Science', *New York Times*, 5 May 1940, p. 1; J.D. Ratcliff, 'Your Servant the Atom in the World of Tomorrow', *Coronet* (June 1946), p. 43; Gordon Dean, 'Atomic Energy for Peace', *Atlantic Monthly* (February 1954), p. 36; William L. Laurence, 'The Promise of Tomorrow', *Collier's* (23 December 1955), p. 46. Such praise for atomic energy sometimes took strange forms. In 1956 the Atomic Energy Commission's Chariman Lewis Strauss hailed hydrogen bomb tests because the reduction of fallout compared to atomic bombs made them superior' not only from a military point of view but from a humanitarian aspect'. In Ralph Lapp, 'The "Humanitarian" H-Bomb', *Bulletin of Atomic Scientists*, vol. 12, no. 7 (September 1956), p. 263.

71 Tytle, interview; Fleischer, interview; Ward Kimball, interview with the author, 28 May 1991; A. Kendall O'Connor, interview with the author, 24 May 1991.

72 'Motion Picture Corporations', in Charles S. Aaronson (ed.), *International Motion Picture Almanac for 1957* (N.Y.: Quigley Publications, 1956), p. 413; LeBourdais, p. 140.

73 Dwight D. Eisenhower, letter to Walt Disney, 12 February 1957. President's Personal File, Box 979 PPF 1636 Disney, Walt. Dwight D. Eisenhower Library, Abilene, Kansas; 'Eisenhower Lauds Disney, Recipient of Milestone Award', *Hollywood Reporter*, 18 February 1957, n.p. (clipping in Walt Disney File, Federal Bureau of Investigation); 'Television Hollywood's "Blessing in Disguise", Walt Disney Tells SPG', *Variety*, 18 February 1957, p. 47. Nixon had been a proponent of atomic arms ever since Adlai Stevenson made an end to nuclear testing the centrepiece of the 1956 Presidential Election campaign. Eisenhower was plagued with ill health. Consequently, Lewis I. Strauss, head of the

AEC, realized that Nixon might bcome President. Despite Eisenhower's desire to keep Nixon from the nuclear programme, Strauss made every effort to involve the Vice-President. Strauss went so far as to invite Nixon to attend a nuclear warhead test in May 1957. Nixon accepted the invitation, but this acceptance later was vetoed — possibly by Eisenhower. Stephen E. Ambrose, *Nixon: The Education of a Politician 1913–1962* (N.Y.: Simon and Schuster, 1987), pp. 418–19, 441.

74 Carol Cohn observes that terminology composed of domestic metaphors is commonly used to describe nuclear weapons technology. For example, nuclear missiles are based in 'silos' and the nuclear missiles on Trident submarines are called 'the Christmas tree farm'. According to Cohn, these terms minimize the nuclear phenomenon. Carol Cohn, 'Sex and Death in the Rational World of Defense Intellectuals', *Journal of Women in Culture and Society*, vol. 12, no. 4 (1987), pp. 697–8.

75 'Navy to Launch Ballistic Sub'; 'Missile Sub Launched at N.E. Shipyard', *Christian Science Monitor*, 9 June 1959, p. 8; Walter H. Waggoner, 'Atomic Submarine Begun for Britain', *New York Times*, 13 June 1959, p. 5.

76 *Disneyland: The First Quarter Century*, pp. 57, 58. The submarines were constructed at the Todd Shipyards in San Pedro. The investment in the submarine ride compares with the $1,500,000 cost of the miniature Matterhorn (complete with bobsleds and 'glacier grottoes'), and the $1,300,000 cost of the first operable monorail system in the U.S. 'Spectacles: Disneyland & Son', *Time*, vol. 73, no. 26 (29 June 1959), p. 44.

77 'Nixon Ambles Back Home', *Christian Science Monitor*, 15 June 1959, p. 15; Charles Hillinger, 'Nixons Lead parade at Disneyland Dedication', *Los Angeles Times*, 15 June 1959, pp. 1, 2, 32; *Celebrities in Dedication Day Parade and Pre-Parade*, Disneyland file (Margaret Herrick Library); Hendrick, p. 3. Robert Tieman of the Walt Disney Archive maintains that passengers were admitted to the submarine ride on 6 June 1959, while the Nixons opened the monorail and rode in the submarine ride more than a week later. This suggests that the ceremony in which Nixon and Admiral Fitzpatrick participated, commemorating the opening of the simulated 'atomic' submarines, celebrated a simulated opening. Robert Tieman, telephone interview with the author, 4 February 1993. The opening of the submarine ride was an advertised attraction (along with the parade, the Matterhorn and the monorail) in a special *Disneyland '59* ninety-minute television presentation on ABC the next evening. Potential viewers were urged to '*Explore the Depths* of the seven seas aboard one of Disneyland '59's new submarines . . . through the lost continent of Atlantis, the graveyard of sunken ships, dive beneath the Polar Icecap in the world of "liquid space" beneath the oceans!' Advertisement in *New York Times*, 15 June 1959, p. 54.

Although urged by Leo Szilard to support nuclear disarmament in his campaign against Kennedy in 1960, Nixon decided not to do so. Walt Disney was an active Nixon supporter in the 1960 campaign through the Celebrities for Nixon Committee, along with Helen Hayes, Mervyn LeRoy, John Wayne and Mary Pickford. Ambrose, pp. 562–3.

78 National Archives — Pacific Southwest Region. Richard M. Nixon Pre-Presidential Papers, General Correspondence, Series 320, Box 217, Folder: Walt Disney.

79 ibid.

Art History ISSN 0141-6790 Vol. 18 No. 1 March 1995 pp. 97–111

The Wolf and the Lamb:
An Image and its Afterlife

Linda Rozmovits

In December 1890 *Punch* magazine featured a parody of William Mulready's celebrated painting *The Wolf and the Lamb* of 1820 (plate 34) in an illustration accompanying an item entitled 'A Portia A La Russe'.[1] The text, which is based on Portia's 'quality of mercy' speech from the trial scene in Shakespeare's *The Merchant of Venice*, attacks the views of Olga Novikoff, an aristocratic Russian political writer and lobbyist for Anglo-Russian accord who was living in London, and whose activities had earned her the nickname 'The MP for Russia'. Since Novikoff was known as an apologist for the Tsar and, more specifically, as an apologist for his policies with regard to Jews, Portia's speech provided the obvious vehicle for an assault on the sort of advocacy for which Olga Novikoff was renowned.

Beyond the fact that *The Merchant of Venice* was a familiar chronicle of relations between gentiles and Jews, the play had a special prominence in late Victorian society. The play was considered to represent the height of Shakespeare's comic achievement and to be a universally acknowledged masterpiece of literature; it was to late Victorian popular discourse about art what *Hamlet* or *King Lear* might be now. *The Merchant of Venice* was also a favoured text in pedagogical circles where it ranked as one of the preferred vehicles for a child's induction into the serious study of literature; it was felt to be an accessible text from which modern educators could wrest the full value of literary study. In the world of the London theatre, Henry Irving's Lyceum production of *The Merchant of Venice* set 'a record without precedent in the annals of the stage', running for two hundred and fifty consecutive performances, opening 1 November 1879. In the course of that season it was estimated that 330,000 people had visited the Lyceum, generating receipts amounting to some £59,000.[2] For these, among other reasons, Portia's speech on the quality of mercy had become something of an icon of liberal morality and, as I said, provided the obvious vehicle for an assault on Olga Novikoff's representations on behalf of the Tsar.

The *Punch* illustration, tagged 'The Russian Wolf and the Hebrew Lamb. (After a well-known Picture.)' (plate 35), conscripts Mulready's painting — which depicts a fight between two boys on their way home from school — by substituting a cossack for a bully, a Jew for the cowering child, and a woman labelled 'Dame Europa' for the mother who appear in the original work.

The towering figure of the cossack who dominates the illustration indicates that what this satire is chiefly intended to convey is a sense of the considerable

34 William Mulready, *The Wolf and The Lamb*, 1820. The Royal Collection. Reproduced courtesy of HM the Queen.

hostility which characterized English public opinion about Russia in the period between the Crimean War and the eventual re-establishment of Anglo-Russian *entente*. Simply put, the image depicts what English liberalism at the time perceived to be the difference between Russian autocracy and itself. We can see this more clearly if we consider not just the text of 'A Portia A La Russe', but also the circumstances which prompted its appearance.

From about the 1870s onwards Jews living in Russia were subject to a series of oppressive dictates issued by the Tsar. They were financially debilitated by racially specific forms of taxation, and subject to stringent restrictions with regard to the ownership of property and the pursuit of trades. Jews were expelled from major centres like Moscow and St Petersburg, as well as many other smaller towns, and forced to live within the Pale of Settlement. Jewish families were compelled to surrender their children to military service which, depending on the age of the child, could run to a term of over twenty-five years.

During the months preceding the appearance of 'A Portia A La Russe' the *Times* had written of the so-called 'Jewish Question' in Russia, frequently and sometimes at considerable length. Endorsing a liberal position, the paper had responded to the familiar litany of allegations that, unless they were subject to restrictions, Jews would eventually take over the world. It was in opposition to this bad press that Russia was getting in the *Times* that Olga Novikoff herself went into print arguing that the common interests of the two great imperial nations far outweighed their differences.

That Novikoff's position was not merely that of a politically isolated but socially well-placed eccentric is indicated by the fact that J.A. Froude, the prominent Victorian historian, had himself championed Novikoff's cause. In his preface to a book of Novikoff's entitled *Is Russia Wrong?*, Froude described such a vision of the common Anglo-Russian destiny:

> To Russia and England has fallen the task of introducing European civilization into Asia. It is a thankless labour at the best; but circumstances have forced an obligation upon both of us, which neither they nor we can relinquish . . . If we can work harmoniously together as for a common object, the progress of the Asiatic people will be peaceful and rapid. If we are to be jealous rivals watching each other's movements with suspicion . . . the establishment of the new order of things may be retarded for centuries. . . . On the broadest grounds, therefore, it is our interest to be on good terms with Russia.[3]

In the interest of this common good Novikoff had written a letter to the editor of the *Times*, which appeared on 22 November 1890, about four weeks before the publication of 'A Portia A La Russe'. In it she refuted liberal criticism of the Russian situation by arguing that the lot of Jews in Russia was no worse than that of 'one-tenth the population of your free and civilized England . . . ', and that in light of general disregard for 'the horrors of the Congo' or the treatment of aboriginal people in Australia, she was rather surprised by the 'exceeding . . . sensitiv[ity] about the treatment of convicted murderers in Siberia and . . . [the] indigna[tion] at every tale of violence told by the escaped prisoners

290 PUNCH, OR THE LONDON CHARIVARI. [DECEMBER 20, 1890.

THE RUSSIAN WOLF AND THE HEBREW LAMB.

(*After a well-known Picture.*)

35 'The Russian Wolf and the Hebrew Lamb (After a well known Picture)', *Punch*, 20 December 1890.

from the penal settlement of any country'.[4] Moreover, she declared on another occasion — and this quote actually appears as a head note to 'A Portia A La Russe' — Russia, as 'a great military Power, having at her disposal an army of two millions of well-disciplined and drilled soldiers' could easily withstand 'both the wild attacks of unscrupulous publicists, and [the] mistaken protests of philanthropic meetings . . . '.[5] It is, precisely, this 'Might is Right' attitude that becomes the object of *Punch*'s satirical assault.

Punch's satire on Novikoff's letter is topical and its nuances are consequently difficult to retrieve, but what is unmistakable is the sharp focus on Novikoff's autocratic rationale. 'The quality of mercy is o'erstrained,' the satirists begin:

It droppeth twaddle-like from Lord Mayor's lips
Upon a Russian ear: strength is twice scornful,
Scornful of him it smites, and him who prates
Of mercy for the smitten: force becomes
The throned monarch better than chopped logic;
His argument's — two millions of armed men,
Which strike with awe and with timidity
Prating philanthropy that pecks at kings.
But Mercy is beneath the Sceptre's care,
It is a bugbear to the hearts of Czars.
Force is *the* attribute of the 'God of Battles';
And earthly power does then show likest heaven's
When Justice mocks at Mercy. Therefore Jew,
Though mercy be thy prayer, consider this,
That in the course of mercy few of us,
Muscovite Czars, or she-diplomatists,
Should hold our places as imperious Slavs
Against humanitarian Englishmen . . .

By dressing Novikoff's arguments up as Portia's famous speech celebrating the spirit of mercy over the letter of the law, *Punch* makes its point about the consequences of failing to recognize the difference between liberal tolerance and 'Might is Right'.

The choice of illustration, however, is rather more remote, for while the caption 'After a well-known Picture' clearly directs us to the original work on which Punch's image is based, the relation between a celebrated image of childhood in the domestic genre (painted some seventy years earlier) and a political cartoon about one of the most contentious public debates in England in the late nineteenth century is far from clear. Moreover, the relation between the two pictures seems to require investigation in that the distinction between English liberalism and Russian autocracy which the text offers us is, as I shall argue, much more difficult to sustain through the visual image.

The difficulty in sustaining this distinction is evident in two ways, the first of which concerns the drawing of the liberal/autocratic divide. The claim being advanced in the written text, namely that for the natural affinity of English liberal humanitarians for the Jewish victims of Russian oppression, is compromised

in the visual text by the appearance of racial stereotypes. We can see this, for example, in the near-grotesque hairiness of both the adult combatants in *Punch's* image which contrasts so markedly with the fresh-faced naturalness of the boys in Mulready's painting. Similarly, the hats, which seem so much a part of the indigenous costume of English schoolboys in Mulready's work, become signifiers of an innate militarism and an innate otherness when attached respectively to the figures of the cossack and the Jew. This compromise highlights the classic liberal predicament, namely that while the claim is one for universalist toleration, it relies on an aggressive application of racial stereotypes which suggest that the real affinity here is not that between liberals and the oppressed, but that which exists between all foreigners by virtue, simply, of their foreignness, and which distinguishes them, absolutely, from natural-born Englishmen. When English boys fight, it is the act of fighting which is the aberration. When English liberalism represents a conflict between Russians and Jews, the aberrance is displaced from the situation onto the racial identities of the combatants.

A second source of ambiguity derives from the fact that the onlooker in this picture is a woman, and while in the domestic setting of Mulready's original this fact is consonant enough, in the overtly political and historical context of *Punch's* satire the female presence is much less obviously well-placed. To put it another way, the presence of a watchful female where, conventionally, there should be none introduces domestic standards of morality into a public, political debate. It domesticates what should be, strictly speaking, a public/historical event, and thus unsettles the distinction between 'us and them', 'here and there', 'international politics and domestic affairs'.

Moreover, this element of female vigilance signals a domestication of the historical in a metaphorical sense by reminding us that between 1880 and 1914 the foreign problem of Russian Jewish oppression became a domestic concern when, of the estimated 2.75 million Jews fleeing Eastern Europe for the west, 150,000 of them came to live in England.

Predictably, the response to the arrival of these immigrants was overwhelmingly unfavourable. Conservatives raised the spectre of social and racial degeneration, trade unionists saw the newcomers as an army of blacklegs, and the established Anglo-Jewish community feared that the arrival of thousands of their indigent co-religionists would threaten their own newly acquired status and security. The only significant pro-alien voice seemed to be that of the liberal. But while this fact would appear to support claims for the difference between liberal tolerance and Russian autocratic oppression, it in fact leads us back to confusion. Conventional wisdom may have held that this sympathy for the Jews extended from a commitment to religious toleration as 'one of the deepest and oldest of Liberal principles'[6] but liberal discourse about the 'Jewish question', in fact, suggested rather a different set of political priorities. For beyond the qualified sympathy of those whose antagonism for Russia led them to defend 'the enemy of mine enemy', the liberal defence of the Jews was, unapologetically, a defence of the doctrine of laissez faire, as legislation which restricted the right to own property, to pursue certain trades, or to choose freely where to live, threatened the ideology of the free market. This fact is evident not only in liberal responses to anti-alien allegations, but, indeed, in the very manner in which they

formulate the problem. *The Times* noted:

> The Jew, it is said, is so intelligent, so industrious, and so temperate, he has been trained in so hard a school, he is satisfied with so little profit that it would be impossible for the Russian Christian to compete with him in an open market. The presence of the Jew everywhere, ready to undersell the Christian, is compared to the Chinese immigration question in the colonies. But from the larger standpoint of the State, the parallel is in no sense true. The Jew pays taxes, he contributes military service, he fosters trade, he maintains schools and public institutions, he employs labour. He is a source of wealth socially as he is a source of strength politically. Seeing these things, hearing from his most trusted Ministers that the Jews are the 'excelling' element in the population, it is scarcely to be credited by common sense that any governor of the State can desire to eradicate and destroy this element of his own prosperity. . . . The five millions of Russian Jews of whom it is feared that they will 'excel the rest of the people in everything' constitute perhaps, the most valuable unit of the Empire.[7]

In effect, liberals sought not to refute claims of a Jewish conspiracy, but rather to exploit them as a largely untapped resource. If poor Jews were willing to work for lower wages than their Christian counterparts under conditions that no gentile would tolerate, then the system would have to remedy itself by 'removing the causes which have forced the Jew to be content with less': if wealthier Jews sought to circumvent restrictive legislation by bribing public officials, then it fell not to the politicians but to 'the Stock Exchanges of the world' 'to carry through a gigantic system of counterbribery or compulsion'.[8]

What I am suggesting, in other words, is that the liberal response to the so-called 'Jewish Question' is not what it might at first appear. I have tried to make this point in a preliminary way by briefly considering aspects of *Punch*'s visual representation of the problem. What I want to go on to suggest, however, is that the most intriguing complications in this story are to be found not simply in the parodic form it takes in *Punch* magazine at the end of 1890, but rather in the relation between that version of the story and the version which Mulready produced some seventy years earlier when he engaged questions of domestic morality by representing a fight between two English boys. I shall argue that the questions of race and gender which, as we have seen, tend to complicate a late nineteenth-century attempt to distinguish English liberal morality from the might of Russian autocracy, figure in very similar ways in an early nineteenth-century representation of the attempt to distinguish right from wrong in the domestic sphere.

II

The attraction of *The Wolf and the Lamb*, to its viewers, was consistently located in what commentators perceived to be its realization of the paired virtues of

domesticity and Englishness. Rather than relegating the painting to the sphere of parochialism or the undistinguished genre, these two qualities, particularly as they appeared in tandem, were seen to elevate the work above its Dutch models, which were considered to be devoid of moral content.[9] Mulready's first biographer F.G. Stephens argued, for example, that the painter's treatment of the domestic always moved beyond its generic boundaries into the more significant world outside the private sphere. Mulready, he wrote, 'imparted to the class of *genre* subjects that artistic completeness of execution we generally seek in historical painting';[10] the painter 'imparted . . . what we may call philosophy to his works', so that they 'taught as well as pleased the spectator.'[11] According to Stephens, Mulready's 'genius is not to be considered mean because it was exercised on homely subjects . . . [but] . . . on the contrary, to be exalted' because of the ways in which it 'clothed simple themes with art.'[12]

This sense of *The Wolf and the Lamb* as a painting which, although in the domestic genre, could nevertheless powerfully 'universalize the domestic subject',[13] was equally expressed by critics reviewing the work when it was shown at the Exposition Universelle in Paris in 1855. There the painting earned acclaim for the way in which it seemed 'to play, within its narrow frame, a scene from the eternal comedy'.[14] Moreover, the philosophical universality of the work was identified as being peculiarly English in character. The drama it represented, one critic remarked, 'is given with the exquisite feeling for expression and action, which since the time of Hogarth seems to be the appanage of English painters.'[15] But this identification of Mulready as English *'intus et in cute'*[16] was more than just an inevitable response from the French. Stephens's account of the painter is equally preoccupied with protecting an investment in Mulready's English character. For Stephens, Mulready was 'thoroughly English'[17] and unlike Wilkie, who 'ran to seed in Spain and Italy', a painter 'never absent from England after his arrival in childhood', a painter who chose to 'exercise his genius on homely subjects'.[18] The urgency with which this sense of Mulready's unassailably English character is conveyed is made perhaps even more remarkable by the fact that Mulready was, in actuality, the son of an Irish Catholic leather breeches-maker from Ennis, County Clare.[19]

Beyond this sort of critical appraisal, Mulready further acquired the status of Englishness through the material reception of *The Wolf and the Lamb*. The work was the subject of four engravings, the most celebrated of which is that by J.H. Robinson (1828), which Mulready donated in aid of the Artists' Annuity and Benevolent Fund with the sale of prints amounting to more than £1,000. The original painting was acquired by George IV with whom it was believed to be a particular favourite, and, as Kathryn Heleniak suggests 'it may have been a particular favourite with Queen Victoria as well' since 'Henry Cole noted its location in the Queen's private sitting room.'[20] It was also exhibited in Manchester in 1857 as one of the art treasures of the United Kingdom.

In *The Wolf and the Lamb* a bully menaces a weaker child on their way home from school, while a younger sister and a small dog seem to implore the mother witnessing the event to intervene. The bully has thrown his books, his gloves and his hat to the ground in preparation for the assault while the other boy, still clinging to his book bag and looking strangely formal and unprepared

104

in his hat, cowers behind an arm upraised in self-defence. Pinned against a fence, with a large tree directly behind him and the barking dog directly in front of him at his feet, the boy is completely hemmed in and cannot possibly flee.

As Marcia Pointon has argued, the effect of a title like *The Wolf and the Lamb* is to elicit associations with the Biblical parable, or the Sunday school lesson which raises a series of questions to be answered:

> They would have asked . . . which is the wolf and which the lamb? Why is the lamb not in his fold? Will the 'shepherd' save the lamb from the wolf's clutches? Will the wolf lie down with the lamb or will continued hostilities be inevitable?[21]

In certain respects, the answers to these questions are unmistakable; as with any good moral parable. Mulready's painting could not possibly allow for confusion of the identity of the wolf with that of the lamb. Other questions, however, are considerably more fraught, and of these the one which is most obviously at issue here is that of 'will the shepherd intervene'? The mother leaning out of the doorway behind the combatants is obviously fearful of the outcome of the fight. But her desire to intervene, suggested by the degree of her leaning or physical inclination, is apparently overridden by her compliance with the belief that the boys must sort things out for themselves, a suggestion conveyed visually by the position of her hands which hold her back — one clutching the banister, the other held to her breast in self-restraint. Despite the obvious distress in the foreground, the good sense of the mother's domestic non-intervention is bolstered by the appearance of a couple of neighbours gossiping in the background unperturbed by the drama before them. Over their heads the sky is relatively calm and blue, offsetting the theatrical lighting of the foreground which so sharply spotlights the combatants. If the painting is indeed a sort of parable, then its lesson seems to be that the fight is entirely a natural occurrence and that only by deciding the outcome for themselves will the boys derive their lesson for life.

An interesting comparison with *The Wolf and the Lamb* is provided by Mulready's *The Fight Interrupted* (1815–16) (plate 36), a painting which similarly represents a contest between a bully and a smaller boy. In this instance, however, the smaller boy has won and would clearly be celebrating his victory had not the schoolmaster intervened.

As in *The Wolf and the Lamb*, what is centrally at issue in *The Fight Interrupted* is the value of conflict, or unregulated competition, as one of the crucial lessons of boyhood. On one level then, the painting simply addresses the 'impropriety' of children 'fighting and quarrelling'.[22] But, on another, it brings us, in a curious way, back to Stephens's claim for Mulready as a painter whose treatment of the domestic could evoke a sense of historical or, in more contemporary terms, to Marcia Pointon's characterization of Mulready as a painter who 'exploit[s] categories of privacy, intimacy and familiarity in the production of discourses around power and politics in the public sphere.'[23] For a commentary on the work, which appeared in the *New Monthly Magazine* in 1816, reminds us of the more adult forms of national identification that Mulready's representation of the schoolyard brawl excited in some of its viewers:

36 William Mulready, *The Fight Interrupted*, 1815–16. Reproduced by courtesy of the Trustees of the Victoria and Albert Museum, London.

The interest which this picture excites would doubtless astonish, and perhaps disgust a foreigner, who, unused to such scenes, might censure the taste of the artist in the selection of his subject, but for our own parts we prefer the representation of a fight of this sort, which is purely national, to all the pictures of Waterloo which we have yet seen: — in fact, we have now no small authority for our preference, for, at a late public dinner, a gallant general, who has fought and bled for his country, declared that he owed all his success and reputation to the first black eye he received at Westminster; and, 'no less strange than true', this remark was followed by a similar avowal from a British judge. . . .'[24]

In so far as it reiterates familiar perceptions of Mulready as a painter too English to be appreciated by foreigners, and as one who, on occasion, tended toward 'subject[s] unfit for pictorial representation',[25] this comment is a predictable

one. However, that this viewer should consider the subject matter represented in *The Fight Interrupted* to be a more engaging expression of English might than representations of the defeat of Napoleon comes as more of a surprise. Effecting an identification with the black-eyed victor robbed of his moment of glory, the commentator finds, in *The Fight Interrupted*, a powerful expression of that English morality which shapes public policy whether at home or abroad.

This awareness of the public policy barely perceptible in the private scene may similarly be activated by considering *The Fight Interrupted* and *The Wolf and the Lamb* side by side. Without meaning to strain the relation of one picture to the other, one might even consider the latter as a sort of sequel to the former on the basis both of shared visual elements and of common narrative concerns.

Visually, the pictures have at least two compositional similarities, the first and more obvious of which is the scattering of objects on the ground. In both cases, but especially in *The Wolf and the Lamb*, this detail serves to problematize the sense of 'eternal comedy' by foregrounding the disorder and urgency of the present moment. Indeed, an allusion to the violent end which awaits the weaker boy may be found in the sheath of arrows lying on the ground in the far right of the picture. Barely visible beside the edge of the fence, this detail is brought to our attention by the one arrow which has come out of its sheath and whose tip directs us to confront the bully's menacing expression after leading us inch by inch up his full height. Interpolating the perspective of a viewer lying at the bully's feet, this object leads us to reassess the meaning of a collection of objects that was once just a scattering of books and cricket bats. The second and perhaps less obvious similarity concerns the framing of the combatants. For the fence and the trees which define the visual territory of the victor in *The Fight Interrupted* reappear in a highly compressed form in *The Wolf and the Lamb*. Interestingly, not only has the perspective been foreshortened bringing the viewer much closer to the fight, but the fence and trees behind the smaller boy have moved up, with the trees now crossing behind him, translating the inevitability of boyish conflict into a much more adult sense of *huis clos*.

These visual elements, I would argue, generate a new set of questions about the parable of the Wolf and the Lamb. For having acknowledged the discourses of power contained within the seeming domesticity of the image, questions like 'who is the wolf and who the lamb?' give way to questions of a more socially urgent kind, such as: What happens to the lesson of the schoolyard once the conflict moves beyond its bounds? Why is it appropriate for the schoolmaster but not for the mother to intervene? And with what do the proponents of laissez faire identify now?

Once outside the bounds of the schoolyard, the conflict undergoes an intense magnification of the violence at its core; without the self-validating rationalizations of an enclosed, all-male environment in which it is structurally impossible for anyone to blame boys for being boys the conflict, like the bully, shows its other face. The fact that the two sides in *The Fight Interrupted* maintain their respective formations despite the intervention of the schoolmaster communicates the tenuousness of the ceasefire. Thus, to believe that such conflicts are naturally self-limiting or that future combatants will necessarily submit to the interventions of their elders and betters is surely a precarious proposition. Once school is over

and the combatants have moved beyond its bounds, the fight begins anew, this time in the absence of restraints. And it is at this point that we may begin to appreciate the extent to which the idea of fruitful, self-regulating competition is a product of the liberal masculine imagination.

One element which strongly conveys this suggestion is the marginalized presence of female figures in *The Wolf and the Lamb*. For the mother — gender identity secured by the needlework, scissors and pin cushion which hang from her like emblematic female body parts — and the small faceless sister, back turned toward the viewer, moving away from the scene, clearly belong only to the space behind the tree which marks out the area of combat. Unlike the dog, who is allowed to remain, the female figures may be witnesses to, but never participants in, the masculine domain. Their exclusion from the fight — or in other words from the event which enhances the status of the image by making the domestic historical — reminds us of the unarticulated meanings which non-intervention acquires when considered as a gendered concept.

The possibility of reading *The Wolf and the Lamb* as a fantasy of laissez faire is similarly endorsed if one attempts to transfer the liberal viewer's identification with the smaller boy in *The Fight Interrupted* to the corresponding figure in *The Wolf and the Lamb*. Just as the nostalgia for books and cricket bats is dispelled when the scattered objects come to include the arrow, an item which complicates the distinction between weapons and toys, so the association which the viewer sets up between himself and the David robbed of his victory over Goliath, is exposed as a sort of antediluvian fantasy sustainable only in the most idealized terms. One could hardly imagine the viewer celebrating the salutary effects of the battle scars about to be received by the weaker boy in *The Wolf and the Lamb*. Rather, the identification of the liberal masculine viewer effects a disingenuous retreat since, under the newly intensified threat posed by the bully in *The Wolf and the Lamb*, laissez faire re-appropriates a domestic identity, locating itself in the obliviousness of the gossiping neighbours and in the mother's reluctant self-restraint.

Identifying the element of fantasy in these images of laissez faire is also useful in so far as it helps explain the currency of Mulready's early nineteenth-century pictures of childhood for *Punch*'s late nineteenth-century satire on the 'Jewish question'. The way in which it does so, I would argue, is by recalling the link between these fantasies of laissez faire and those invoked by late nineteenth-century liberals on behalf of the Jews.

III

The fact that the 'lambs' in this story of advocacy were poor, religious refugees, and Jews, created a special situation for the liberal. As John Garrard has argued, Jewish immigrants in the late nineteenth century were an obvious magnet for liberal attention as they displayed all the 'attributes that inevitably aroused . . . those emotions and attitudes which . . . had provided Victorian Liberalism with its unity, [and] its emotional dynamism'.[26] Moreover, Garrard maintains, at a time when the tenets of liberalism

were being called into question . . . the Liberal defence of the alien became a means of rediscovering identity, an act of nostalgia, harking back to a time when every Englishman 'was something of a Liberal at heart'. To attack the destitute Jewish immigrant was [thus] to attack Liberalism [itself].[27]

As in our earlier discussion of the liberal defence of the alien as a defence of the tenets of laissez faire, the economic considerations underlying this nostalgic identification with the Jews were very much in evidence. Prominent among them, for example, was that part of the defence of free trade which argued that if one was going to deal in cheap goods produced by poorly paid labour, then it was preferable to do so as the exporter rather than as the importer of those goods. If one opposed the protection of commodities, then one could hardly advocate protection of the labour that produced them. But without meaning to underplay these considerations, in a sense, it is precisely the sentimentality of the liberal stance which is at issue here. This is so because 'at a time when the English worker was resembling less than ever the classical Economic Man, the "Jewish worker" was regarded as a reversion to that mythical type.'[28] Unlike the English poor, who had chronically failed to appreciate the potential of thrift and industry or the opportunities for advancement and small-scale entrepreneurship that their poverty afforded them, the indigent Jewish alien seemed to underwrite the logic of laissez faire — at least in the liberal imagination — by application of the appropriate principles of self-improvement and self-help. The Jewish immigrant was

industrious . . . worked for long hours for low wages . . . was thrifty . . . sober . . . law-abiding, and so religious that he was given to denouncing the Anglo-Jew for moral laxity . . . his great ambition, and frequently, his crowning achievement in life, was to become 'a small master' with the minimum of delay.[29]

To return to Mulready's paintings we can, as it were, retroactively anticipate the importance of the figure of the Jewish alien to what, seventy years later, would be a 'slowly crumbling but still nostalgically satisfying . . . economic and social morality'.[30] For what is missing in those earlier accounts of the wolf and the lamb is, precisely, a lamb who unequivocally fulfils his typological imperative, one who helps himself to weather the storm of non-intervention and thus completes the logic of laissez faire. Neither of the lamb figures in the paintings we have been discussing could be said to fill this role since the first is not a victim but a victor cheated of his moment of recognition, and the second, a figure whose victimization is captured in perpetuity. It was only with the arrival of the Jewish alien that the fantasy could be complete since the Jewish alien 'was perhaps the only working example of the principles of laissez faire and individual self-help that had ever existed.'[31]

To turn, by way of conclusion, back to *Punch*'s parody of *The Wolf and the Lamb*, we are confronted, one last time, by the impossibility of locating the liberal view. The deliberately stereotyped presentation of the Russian as a robust

and naturally aggressive Slav communicates the forcefully intended disavowal of any similarity between English liberalism and Russian might. And while the exaggeration of violence in the representation of the cossack may raise suspicions about the liberal failure to acknowledge the violence inherent in its own morality, it is clearly not with the figure of the Russian that a liberal viewer could be said to sympathize. Similarly, the pathetic and equally foreign appearance of the Jew dispels any lingering identification between the liberal viewer and the soon-to-be victim of the aggression: as in the original version of *The Wolf and the Lamb*, the risk of violence too heavily outweighs the nostalgia. The only figure remaining in the image is that of the woman, but here too complications arise. Whereas in Mulready's painting the figure of the mother supplied a domestic context as a refuge for the proponent of laissez faire, no such refuge exists in *Punch*'s version of the image. For the identity of the woman has been altered by the words 'Dame Europa' inscribed along the hem of her apron. No longer the quintessentially English mother whose presence allows one confidently to exercise fantasies of laissez faire by maintaining an escape route back into the private sphere, Dame Europa, like Olga Novikoff, is foreign, meddling in politics, and thus likely to compound the moral incomprehensibility and potential treachery of the situation.

Where then is the figure of the English liberal in all this? Evidently, but not unfittingly, I would argue, he is not there, for it is precisely this absence that most accurately conveys the liberal stance. There could be no more fitting representation of the liberal fantasy of laissez faire.

Linda Rozmovits
Department of Cultural Studies
University of East London

Notes

1 'A Portia A La Russe', *Punch*, 20 December 1890, p. 291.

2 Laurence Irving, *Henry Irving*, London, 1951, p. 357.

3 J.A. Froude, 'Preface', in Olga Novikoff, *Is Russia Wrong*, London, 1878, p. viii.

4 Olga Novikoff, 'The Jews in Russia', letter to *The Times*, 22 November 1890.

5 'A Portia A La Russe', op. cit., p. 291.

6 John Garrard, *The English and Immigration 1880–1910*, London, 1971, p. 86.

7 'The Jews in Russia', *The Times*, 13 October 1890, p. 4. See also, 'The Jews in Russia', *The Times*, 9 October 1890, p. 13.

8 'The Jews in Russia', *The Times*, 13 October 1890.

9 I am indebted to Marcia Pointon for mentioning this fact to me.

10 Frederic G. Stephens, *Memorials of William Mulready*, London, 1867, p. 1.

11 ibid., p. 2.

12 ibid., p. 94.

13 Marcia Pointon, 'Pictorial Narrative in the Art of William Mulready', *Burlington Magazine*, vol. 122, no. 925, April 1980, p. 234.

14 'Le tableau joue dans son cadre étroit une scène de la comédie éternelle.' T. Gautier quoted in Pointon, 'Pictorial Narrative . . . ', p. 233.

15 Anonymous review quoted in 'French Criticism on English Art', *Art Journal*, new series, vol. 1, 1855, p. 282.

16 ibid.

17 Stephens, op. cit., p. 1.

18 ibid., p. 94.

19 ibid., p. 8.

20 Kathryn M. Heleniak, *William Mulready*, New Haven, 1980, p. 253.

21 Pointon, op. cit., pp. 230–1.

22 Wilderspin quoted in Marcia Pointon, *Mulready*, London, 1986, p. 100.

23 Pointon, *Mulready*, op. cit., p. 100.

24 Quoted in Heleniak, op. cit., p. 200.
25 Marcia Pointon, 'William Mulready's "The Widow": A subject "unfit for pictorial representation" ', *Burlington Magazine*, vol. 119, no. 890, May 1977, p. 347.
26 Garrard, op. cit., p. 85.

27 ibid.
28 Lloyd P. Gartner, *The Jewish Immigrant in England, 1870–1914*, London, 1960, p. 64.
29 Garrard, op. cit., p. 96.
30 ibid.
31 ibid.

Art History ISSN 0141-6790 Vol. 18 No. 1 March 1995 pp. 112–134

REVIEW ARTICLES

Watching the Detectives
Jon Kear

Street Noises. Parisian Pleasure, 1900–1940 by *Adrian Rifkin*, Manchester: Manchester University Press, 1993, 221 pp., b. & w. illus., £35.00 hdbk, £14.95 pbk

> 'J'ai bien des fois rêvé d'écrire sur Paris un livre qui fût comme une grande promenade sans but où l'on ne trouve rien de ce qu'on cherche, mais bien des choses qu'on ne cherchait pas. C'est même la seule façon dont je me sente capable d'aborder un sujet qui me décourage autant qu'il m'attire. Et tout d'abord, il me semble que je ne dirai mot des grands monuments et de tous les endroits où l'on s'attendrait à une description en règle. Pour les avoir trop regardées peut-être, je ne vois plus les gloires ... de Paris avec toute le liberté d'esprit nécessaire.'[1]
>
> Julian Green

There are moments when a particular history becomes so familiar that it is not only oblivious to its own modes of production but, indeed, effects a kind of blindness to its exclusions.[2] Adrian Rifkin's *Street Noises* is a text which reminds us of this, a subtle and absorbing study of Parisian culture which will not easily be assimilated within the quintessential histories of Parisian modernity, but which will, nevertheless, leave its mark upon subsequent histories of urban culture. The reader/flâneur making his familiar *trajet* through the city might well feel that if all roads still lead to Paris, many of the signposts designating the route have been changed. There is no trace of Toulouse-Lautrec; Proust is safely locked away in his cork-lined room; Miller, Hemingway and the Steins might as well have stayed in America, and writers like Genet and Colette only get the occasional look in. Baudelaire remains, but only residually as 'a sign in the memory of languages and identity'. 'No such absences are unintended,' the author informs us.

Rifkin's subject matter is the *faits divers* of the Parisian 'popular' entertainments industry, exploring the production, regulation and definition of the pleasures and sociability of Parisianism. This involves investigating an array of cultural forms which have largely been pushed from the centre into the margins, invariably providing the mere background noise of histories of Parisian culture. Therefore, *Street Noises* examines in detail the variety and cabaret singer — most notably Chevalier, Fréhel and Piaf; the lyrical conventions and rhetorics of passion and regret of their songs; as well as the *ritournelle* of the dailies and sensational weeklies like the engrossing *Détective*. This material is symptomatically probed for the resonances that pervade the narratives and figures that populate the headlines and song lines of Parisian popular culture; figures such as the detective, the voyeur, the prostitute, the legionnaire, the matelot and so forth.[3]

In its search for the complex interrelations and logics that structure the perception

and representation of Paris and cut across its discursive boundaries, *Street Noises* ranges more widely and restlessly from film to radio; from opera to various kinds of literary and archival sources; from the records of police surveillance and the 'Dossiers Banaux' of the Parisian judiciary, to the literary ventures into 'the margins' and 'lower depths' of Paris by writers of the Académie Goncourt. Even in the more self-contained chapters, the text weaves together an extraordinarily diverse array of materials. Discursive components drift in and out of focus, intersecting in ways which forge unexpected and sometimes ironical correspondences between them. Jean Genet and police surveillance squads rub shoulders as they scrutinize the illicit pleasures of Parisian vice. Quotes from Benjamin and Adorno are intertwined with narratives from popular song, auto-biographies of music hall stars and passages from Charpentier's celebrated opera *Louise*, in a bid to explore the ways in which Parisian culture might be investigated as a 'system of aural imagery'. Similarly, although focused on the period 1900–1940, we constantly find ourselves drifting beyond such tidy boundaries to the Paris of the Second Empire and the Third Republic — in particular to the complex legacy of the Commune — or to the milieu of post-World War II Paris, in search of the genealogies and trajectories of urban mass culture.[4]

Through the interweaving of these diverse materials Rifkin articulates what he terms 'a timeless dream of the popular, deeply worked in the unconscious of social relations', unravelling the senses and non-senses of this ostensibly 'timeless popular'. *Street Noises* therefore examines the 'orders of reality' that it weaves together, the strategies of naturalization deployed in its representation and shows how the image of Paris, especially the relation of the city to notions of 'the people', is ceaselessly worked, inflected and appropriated as the material for contending ideological interests.

One of the virtues of *Street Noises* is the way it maps out the conditions of generation and repetition of the grammar and tropes of this populist Parisianism, in a manner which attends also to its contradictions and historical discontinuities. Many of its most impressive insights come from examination of the shifting significations underlying the impression of continuity and integrity which the prevailing tropes, languages and images that make up the image repertoire of the city suggest. In this respect Rifkin is very adept at bringing out the ironies in his material. He shows how, for instance, after World War I there emerged 'gallant magazines' whose imagery and address was structured through the experience of the flâneur but whose public was now female. Or how the significations of the accordion, essentially a modern instrument emerging on the 'stage of mass cultures' around the time of the picture postcard and the gramophone, became a crucial signifier in the imaginary ideal of popular spontaneity for city poets such as Carco. The accordion therefore became the privileged signifier of a sentimental evocation of 'Old Paris', displacing the *orgue de babarie*, banished from the Paris streets by the Prefect in 1902 as part of the gentrification of some traditional quarters.

From this it is clear that though it calls itself a study of Parisian pleasure, *Street Noises* is far more than this might seem to imply at first glance. At once an inquiry into the archeologies of the protean adjective 'popular', it is inevitably also an exploration of memory, history and myth; celebrity, subjectivity and social and sexual classification; an inquiry into all those forms which make up the urban *social imaginaire* of Paris. The image of the city that emerges from the book is of multiple social differences across which a set of hegemonic class, gender and racial perspectives are superimposed.

Street Noises is a text which investigates both the tropes and the edges of systems of representation, examining the constructed links but also the gaps between signifiers and signifieds.[5] It opens up a fragile space of reflection upon the repressed histories of Paris: those histories that dwell in the shadows of its contradictions and which have been marked by silence; the histories of those possessing no access or means to represent

themselves outside the dominant system of representations that circumscribe, refashion and cover them. Rifkin writes of his aim to 'release some of the repressed materials' of the mythologies of Paris in order 'to free them from those conventions that conscript them in the cruel objectivity of glamour'.[6]

Rifkin writes with great sensitivity on the history of the Zone — the name ascribed to the marginal region between Saint-Ouen and Clignancourt inhabited by the urban poor; a place where 'because nothing official could be built, everything unofficial was.'[7] As successive administrations deliberated on what to do with this 'problem sector', it not only became a focal point for debates about the rationalization and redevelopment of Paris, but evolved into a 'repository of the imaginary margins of the city's history', fantasmagoria margins which had and continued to be the myth materials for the increasingly elegiac and nostalgic depiction of the city and its social differences.[8] The Zone attracted a form of urban tourism centred on the flea markets so enamoured of Cocteau and the Surrealists. These markets, made up of detritus and curiosities, antique dealers and the urban poor, provided for them a 'marvellous and heteroclite' version of everyday consumption, places where the urban poor, petit bourgeois and connoisseur jostled for position in their avid search for cut-price bargains and the urban poetic. The Zone was a place of 'secret' and 'exotic' pleasures for the city connoisseur to interrogate. It was celebrated in popular song as the sphere of 'cut-price hearts', 'popular regrets' and souvenirs. Analysing the urban poetics of the lyrics of realist and popular songs, Rifkin shows the manner in which the marginal is brought to the centre of the cultural field and 'fixed there' as 'a value'. But this representation is a potentially inflammatory one: 'If the line between a picturesque and fascinating glamour and the deterioration of the race cannot be cleanly drawn in the picturing of the people, then it becomes a minefield.' (p. 181) Rifkin points to the gulf that separates the Surrealists' experience of the flea markets and the stall holders' lot, the lack of irony in the Surrealists' representations of the Zone, but beyond this he goes on to elaborate the position of the marginal life of the Zone in structuring the narratives of Parisianism: 'Its juxtaposition to the City of Light was a paradigm for the system of differences that articulate the narratives of Paris, the echo of each of them: the *beaux quartiers* and Belleville, the Champs Elysées and the Marais, the glamour and the underside.' (p. 195) Eventually co-opted into post-war plans for the continued 'sanitization' and embourgeoisement of Paris — a project which effectively continued the 'cleaning up' and destruction of the marginal life at the city's edges that the Nazi occupation forces had already begun in 1943 — the destruction of the Zone implied not only a restructuring of the idea of Paris but also the loss of a particularly resonant and fraught set of ideas about the people and the margins; ideas which had been at the heart of contested definitions of the popular, and had been permeated by Utopian fantasies of dissent and resistance.

The Zone was of course invariably the place the realist singer — the predicate of such margins — looked back to as a place of origins and belonging but also as a place from which to escape. In tracing the passage of the popular cabaret singer from fin-de-siècle literary bohemia to product of the emergent technologies of the mass media Rifkin shows how, from Bruant to Chevalier, or Fréhel to Piaf, 'being of' or imagining oneself into the people is a crucial but nevertheless precarious passage into the 'power of representation'. What is at stake is the authenticity of the claim to represent the 'real voice of the street'.

Making good use of the autobiographies and feature articles on these *artistes*, Rifkin draws out the ironies of the position these singers occupied in an increasingly burgeoning culture industry, charting their shifting public personae and showing the way in which their autobiographies are dialogically constructed out of memories, press cuttings, snatches of song. These autobiographies are wrought out of the contradictions of the

114

position they occupy within the cultural appropriation and commodification of the life of the margins and the street.[9]

This concern with the constellation of significations and practices which establish the relation of the margins to the centre of the cultural field is extended beyond the domain of class to those of gender and sexuality. For instance, in a chapter entitled 'Neighbouring states (soldiers and sailors)', Rifkin makes very interesting use of André du Dognon's autobiographical memoirs *Les Amours buissonnières* and the dossier in the Archives nationales accumulated by the Naval Prefect in Toulon between 1928 and 1933 (detailing the surveillance of homosexual and communist sailors), in exploring the complexities of the articulation of sexual and social alterity within the tropes of Parisian culture, a culture in which homosexual desire — '*les plaisirs dangereux*' of 'inverted sexuality' — is hemmed in at every turn by the policing of bourgeois classifications of normalcy and transgression.[10] He charts a pattern of masquerade, travesty, equivocation and confusion within the common languages of popular culture, revealing the ways in which the figure of the matelot or the legionnaire could strategically become the sign around which forms of 'transgressive' and 'marginalized' desire are given complex expression. He reveals how 'popular' fascination with the matelot or the legionnaire makes him into a fantasmatic object, whose body becomes the site of secret encodings, encodings which project it into a network of contradictory and overlapping discourses about nationalism and colonialism, masculinity and political and sexual transgression. Through this he discloses how figures conscripted into the service of the representation of exotic fantasy predictably uncover the repressions and tensions of a metropolitan culture.

Beyond the specific details of the genealogies it charts, *Street Noises* raises questions about the writing of history itself. For though it makes no claims to being a contribution to theoretical debates, artfully weaving its psychoanalytic and semiotic framework into the fabric of the *moyenne durée*, nevertheless through its historical method and strategies of representation it allusively raises issues about the way in which history as a tableau of presences and absences is constructed. Rifkin opens *Street Noises* self-reflexively in a narrative historical mode, recounting his first glimpses of Paris via Manchester in the anecdotes of his grandmother. This statement of individual memory as a starting point is there not simply to remind us that it represents only one particular trajectory replete with its own pre-history, but also to raise the question of the differential nature of Paris as a sign within the writing of its histories. Apropos, Rifkin indicates the way histories are always already complexly pre-figured within a series of overlapping discourses, many of which belong to other times, cultures and milieux.

But if on the one hand he points to the alterity of this sign and to the over-determination of its pre-histories, Rifkin also seeks to chart the way the writing of history is always inflected by the particular historical and material conditions of its production. In his introduction, he offers a critique of Walter Benjamin's canonic work *Paris, Capitale*, arguing that the logic of synthesis that informs Benjamin's dialectical image of Paris ultimately co-exists too comfortably with its objects. For Rifkin, Benjamin's text displays a tendency to substitute names for structures and 'to make names stand in for process'. It is this excess in naming, this absorbing and endless process of making nuanced distinctions between components, that ultimately implicates it within the logic it seeks to analyse, resulting in the disarming of the moment of critique, undone by the accumulation of 'new data from the inexaustible city that will undo each theoretical discovery and prepare its next development'.[11] Hence the process of de-mystifying Paris is ironically turned into a part of its allure and mystery; the noun Benjamin in turn becoming 'just another name for the anomie of modernity, or of its equivocal pleasures'.

In the book's first chapter, Benjamin's text is juxtaposed against Marcel Carné's epic

film, *Les Enfants du paradis*, and Rifkin argues that both are animated by a nostalgic atavism in which a misrecognized present is projected onto a past that is thereby reconstituted as the mythical origins of modernity.[12] Critiques of Benjamin — an author whose insights nevertheless inform many of Rifkin's own observations — introduce themes which Rifkin goes on to explore in detail in a number of contexts. *Street Noises* uncovers a core structure of nostalgic atavism that pervades many of the characteristic writings on Parisian culture in the period.

The combination of the disparate elements and shifting imbrications of urban subjectivity — the 'frenzied cycling' of identity and commodity — has long been taken as the epigone of modernity, a modernity which from Baudelaire on has centred on the figure of the flâneur/city poet. It is to this expert ethnocentric perception of the literary professional, dating back to Suè and even Balzac, armed with a heritage of skills to master the extrinsic ebb and flow of the city, that many of *Street Noises'* observations are addressed. Rifkin traces the persistence and flourishing of this 'compelling vision' as an 'epiphenomenon of an altogether other modern'. For in the 1920s and 1930s this nineteenth-century literary heritage was reworked through the new technologies of the gramophone, radio and cinema that matured along with the establishment of a turn-of-the-century literary bohemia working across a disparate range of the media of mass culture. As the writers of the Académie Goncourt, whose luminaries included Lucien Descaves, André Warnod, André Billy, Pierre MacOrlan and Francis Carco, drew upon the tropes of Zola's and Baudelaire's Paris, that viewpoint was made over into the linguistic apparatus of a new literary formation that was deeply narcissistic and misogynistic; a culture spawning omniscient city connoisseurs for whom social difference offered no barrier. These writers were at home both in the 'city of lights' and the 'city of shadows', in the *bas fonds* and *beaux quartiers*; they were professionals well versed in the detection of the *faux-semblant* and skilled in initiating the 'knowing reader' into the city's 'deepest' secrets. As Rifkin shows, they are as entranced by the act of revelation as by what is revealed.

The critique of the flâneur/city poet is most emphatically taken up in a chapter entitled 'Some snapshots', which analyses the codes and dialogics of the 'sight-plans' and 'sound-plans' of the city, primarily in relation to the Académie Goncourt, the figure of the detective, the culture industry and the press. In this chapter Rifkin points to the ways in which the new technologies provide a crucial set of transformations concerning the nature of perception, of seeing and hearing, arguing that through radio a new relation between attention and inattention ensues, in which hearing becomes 'voluntary' and 'authored'. Beyond this, Rifkin argues, the intervention of this literary bohemia within the new technologies of mass culture had the effect of entrenching a 'city mnemonic' — the term he uses to invoke the repertoire of pre-coded tropes, metaphors and metonymic connections which characteristically structure the representation of Paris — that privileged the known and the fixed over the unknown, the unexpected and the instantaneous, thereby ironically effecting an atrophying of the language for mapping out the city's differences.

Taking the 'snapshot' as a paradigm for the illusion of disinterestedness that constitutes a prevailing condition of this form of urban subjectivity, he analyses the processes of translation through which the 'random' collection of Parisian sights and sounds is made to yield meanings which give form to the city and which provide a means of establishing and crossing the parameters of the self and other.[13] Inverting the received wisdom of theories of 'the gaze', he argues that the author's 'glance' becomes the unifying principle of the heterogeneity of the city spectacle: 'The poet in constructing images out of the materials of the glance, gives them permanence and monumentality — qualities that alone guarantee him possession of himself: a self-possession that achieves itself

through the perfect recognition and fixing of the ephemeral.' (p. 98) The seizing and fixing of ephemera therefore takes on a compulsive and narcissistic character, in which the city poet attempts to 'articulate the margins from within the centre of its self-consciousness'. In this equation 'Paris' is a sign that invokes a special kind of masculine self-expression, the signifier that secures his bonding with 'the people'. Invariably, in the writings Rifkin discusses, this amounts to little more than a self-serving posture that merges poverty, exploitation and misery into a 'single state of nostalgic grace'. Against the 'snapshot' paradigm of the flâneur, Rifkin juxtaposes the 'weaving together of glances' of the photomontage *mise-en-page* of the *Détective*. If this *mise-en-page* of the *Détective* potentially opened up a space which empowered the reader, a space of irony, textualism and polysemy, that space was inevitably hemmed in by the framing ideological codes which prefigure the act of reading and thus we might ask upon which conditions and from what perspective such a possibility is realizable and whether such reading constitutes, as Bourdieu has argued, no more than the unwitting re-assertion of the authority of the intellectual at the heart of the popular.[14]

The critique that gradually unfolds within *Street Noises* revolves around the wider implications of issues about reflexivity, immanence, iteration, representation and meta-language, issues that in recent critical debates have become central preoccupations in the theorization of the question of pleasure.[15] These are issues that register themselves on the strategies of writing that Rifkin adopts both to grasp the motions of the figural and linguistic histories of Paris and to undermine any master viewpoint. *Street Noises* resolutely deploys an elliptical and montage form which maximally brings together conjugations of difference and identity. It is a many-layered text that lends itself straightforwardly neither to classification nor to paraphase, but demands to be read on its own terms, the better to draw our attention to the logics and cultural habits which intersect and unify the heterogeneity of the 'urban spectacle', logics which might escape a more conventional analysis. These strategies are, however, not without their perils. Occasionally, as readers wander through its labyrinthine passages, they may feel that they have not only momentarily lost their guide but also their bearings. The text rewards the patience of its readers with reflections that are both genuinely original and incisive.[16] By virtue of these strategies *Street Noises* signals its rupture with the standard narratives of Parisian culture and modernity as much by the form of its analysis as by what is literally stated. It is therefore a book that is bound to fuel the long-standing controversies about the relationship of deconstruction and psychoanalysis to history. Whether one accepts Rifkin's arguments as definitive or provisional, it is a book that no one working in the field should ignore.

<div align="right">

Jon Kear
University of Kent

</div>

Notes

1 Julian Green, *Paris*, Paris, 1984, p. 11.
2 See Paul De Man, *Blindness and Insight: Essays in the Rhetoric of Contemporary Criticism*, 2nd ed., London, 1983.
3 It is one of the book's most interesting arguments, one that takes the form of an inversion of received wisdom, that the common realization of the experience of the city in such popular materials frames as well

as is framed by the discourses of high culture.
4 Similarly, we end, as the final chapter makes plain, only in 'the form of a conclusion', a conclusion which looks toward the present.
5 See P. Macherey and E. Balibar, *A Theory of Literary Production*, London, 1966.
6 As Rifkin remarks these mythologies are 'rooted in the criss-crossings of different forms of social objectification' whose habitual forms

of expression he argues are made synonymous with the substance of pleasure and identity.

7 Adrian Rifkin, 'Moments musical', *Yale French Studies*, vol. 73, 1987, p. 133.

8 On the Zone and the fleamarkets see A. Rifkin, 'Moments musical', op. cit. pp. 121–55. For a sample of the literature on the Zone see L. Aressy and A. Parménie, *La Cité des épauves*, Paris, 1943; L. Larguier, *Marchés et foires de Paris*, Paris 1953; A. Warnod, *La Brocante et les petits marchés de Paris*, Paris, 1914; W. Ronis, *Belleville-Ménilmontant*, with a preface by P. MacOrlan, Paris, 1954.

9 What, for instance, are we to make of the history of Aristide Bruant? In his lifetime Bruant was interpreted as a *succès de scandale*, as a parasite off the misery of the working class, or as the true heir to François Villon. The authenticity of his claim to represent the true voice of the street, was a claim to represent 'the people whose face is both that of the Communard and the *poisse*, whose complaint can lead either to a Blanqui or to a Boulanger, whose poverty is "timelessly old" but whose misery is that of the "contemporary depths". (*Street Noises*, p. 181).

10 Rifkin is interested here in the way the mechanisms of policing 'produce' that which they are in the business of monitoring, and also the manner in which that monitoring falters amid the burgeoning commodification of 'illicit pleasure'.

11 This critique of Benjamin's philological method derives ultimately from Adorno, who responded to Benjamin by questioning 'whether such ideas need to be as immured behind impenetrable layers of material as your ascetic discipline demands'. See F. Jameson (ed.), *Aesthetics and Politics*, London, 1977, pp. 110–37.

12 As Rifkin remarks, the postponed appearance of *Les Enfants du paradis* in 1945 if anything made it more relevant to the 'Vichy mentality', which saw cabaret singers like Piaf attempt to escape the realist song with its 'dirty pavements seething with prostitutes' to sing of 'simple loves, health and the joy of living ... the sunshine and Paris' (p. 33).

13 On questions of ideology as systems of representation, and the utilization of a notion of ideology informed by Lacanian psychoanalysis, see L. Althusser, *Lenin and Philosophy and other essays*, trans. B. Brewster, New York, 1978 and J. Kavanagh, 'Ideology', in F. Lentricchia *et al.* (eds.), *Critical Times for Literary Study*, Chicago, 1990.

14 On this see P. Bourdieu 'The Aristocracy of culture' in *Media, Culture and Society*, vol. 2, no. 2, 1980. As Bourdieu has written: 'The desire to enter into the game ... is based on a form of *investment*, a sort of deliberate "naïvety", ingenuousness, good-natured credulity ... which tends to accept formal experiments and specifically artistic effects only to the extent that they can be forgotten and do not get in the way of the substance of the work.'

15 These questions have become emphatic aspects of recent critical debates, especially in respect of the theorizing of the formation and regulation of pleasure to which the text's subtitle alludes. Indeed, though Rifkin's position to his material is obviously informed by the legacy of Foucault and the notion of *différence* elaborated by Derrida, reading through *Street Noises* it is the problematic legacy of Barthes which might seem most striking to the reader, occasionally permeating the language and concerns of the text. For indeed, it was the 'late' Barthes who perhaps most forcefully raised the issue of pleasure within cultural studies in terms of both the question of the idea of pleasure itself as a field of inquiry and the relation of pleasure to ideology. See Roland Barthes, *The Pleasure of the Text*, London, 1976. This ultimately culminated in what Colin Mercer has termed Barthes's 'almost falstaffian expeditions in search of a "salutary" cultural hedonism that would constitute the "other" or "outside" of moral, political, economic and legislative order'. (C. Mercer, 'A Poverty of desire: Pleasure and popular politics' in *Formations of Pleasure*, London, 1983, pp. 84–100). The ambivalent question which lurks within *Street Noises* is how to rescue that legacy of Barthes for an historical analysis of cultural forms. Rifkin intrepidly stalks a path between conjuring something of the disarming 'semiotic paradise' of Paris in the 1930s before the austerities of the Occupation and immediate post-war years, whilst resisting the temptation to collapse this into a textualism that avoids reference to the way in which such pleasures are codified, reconstructed, and commodified through the mechanisms of an ever-conscripting culture industry.

On the question of the theorization of pleasure in relation to gender, see, among others: L. Mulvey, 'Visual Pleasure and Narrative Cinema', *Screen*, vol. 16, no. 3, Autumn 1976; Cora Kaplan, 'Wild Nights Pleasure/Sexuality/Feminism', *Formations of Pleasure*, op. cit., pp. 15–35. See also N. Green, *The Spectacle of Nature*, Manchester, 1990, which makes an interesting comparison point in these debates.

16 Unfortunately, many obfuscations arise from the appalling proliferation of errors in the text, which include not merely mispellings and misdatings, but even passages that seem to contain both original and revised phrasings.

Story of the Eye

Mark Durden

Downcast Eyes, The Denigration of Vision in Twentieth-Century French Thought by *Martin Jay*, Berkeley, Los Angeles and London: University of California Press, 1993, 632 pp., £25.00

Western culture's domination by an ocularcentric paradigm — a vision-centred interpretation of knowledge, truth and reality — is under scrutiny. A batch of books have recently begun severely to trouble this hegemony of vision. Within art history, Norman Bryson in his *Vision and Painting* (1983) revealed the problematics of Gombrich's perceptualist account of art and looked to painting not as a record of perception, but as an art of signs. The book drew up a distinction between two conceptions of vision, the 'gaze' and the 'glance'; the former involved a look which forms part of perspectivalist, monocular way of seeing, a visual take which is disembodied, eternalized and de-eroticized, the latter a way of seeing linked to the corporeality and temporality of the body. While Bryson challenges the perceptualism of Gombrich, Rosalind Krauss, in *The Optical Unconscious* (1993), conducts a sustained critique of the pure opticality of (Greenbergian) modernism, bringing out a countertendency within the orthodox history of modernism. With a mix of writing, from the academic to the anecdotal. Krauss's book gave us the story of an insurrectionary corporealized notion of vision (akin to Bryson's conception of the 'glance') in works by Ernst, Duchamp, Giacometti through to Eva Hesse. Vision itself was the subject of Jonathan Crary's *Techniques of The Observer* (1992), which provided a radical rethinking of vision's role in modernity, addressing an epistemic shift involving the subjectivization of vision in the nineteenth century, its relocation in the physiology of the body.

Nothing before, however, attempts such an ambitious project as Martin Jay's book on vision, *Downcast Eyes, The Denigration of Vision in Twentieth-Century French Thought*. It is a massive book, running to over 600 pages. Its subject is what Jay calls the 'ocularphobic discourse which has seeped into the pores of French intellectual life'; an anti-visual discourse, which is seen as a 'pervasive, but generally ignored phenomenon of twentieth-century Western thought', and one which is seen to be 'most prevalent and multifarious' in France (p.15). Encyclopedic, the book is refreshingly lucid, and establishes an engaging 'story of the eye'. We move from Greek approaches to vision, to Cartesian philosophy's hold on France's major thinkers, to a discussion of the accent on spectacle and theatre at the court of Louis XIV, through to a loss in the faith of the ocular with Diderot's claim that touch was as potent a source of knowledge as vision. But it is not until Henri Bergson in the late nineteenth century that the crisis in faith in the eye really begins. After a discussion of Bergson, the book then proceeds to provide us with a study of hostility to visual primacy in twentieth-century French thought: the work of Bataille, Breton, Sartre, Merleau-Ponty, Althusser, Lacan, Foucault, Debord, Barthes, Metz, Derrida, Irigaray, Levinas and Lyotard.

The length of the list is enough to make clear that despite its size, this book is not going to offer particularly detailed readings. It can only provide what Jay himself calls 'a synoptic survey', with a lot left for us to follow up through references in the footnotes. And as he also makes clear, such an overview, with its totalizing vantage point, reveals an Enlightenment faith, a paradox when the book's very point of focus is an anti-Enlightenment impulse.

For Jay, the camera was a key instrument in the denigration of vision. He follows

Crary's thesis with respect to photography. He does not see it as part of a linear technological narrative from the camera obscura. The camera, rather than validating the scopic regime of the camera obscura, instead troubles the security of vision: Jay notes, among other things, the readiness with which photography deceived the eyes through retouched and composite images, and how Muybridge and Marey's chronophotography denaturalized conventional visual experience.

Jay gives us a summary of the changes Paris went through in the nineteenth century: the Haussmannization of Paris, the rectilinearity of the new boulevards which rendered the city less obscure, less opaque — Paris was largely a medieval city until the Second Empire rebuilding project. But what might appear as 'the perfect urban form for a Cartesian perspectivalist scopic regime' (p. 117), is instead involved with the introduction of uncertainties about truths and illusions conveyed by the eyes. Jay stresses the disorienting effect set up by the process of demolition and reconstruction, and points out the optical desire set up by new department stores which lined many of the sidewalks in the 1860s. Death itself even became available as a popular spectacle for the masses in Paris, the city's morgue having glass display windows.

Crary's account of nineteenth-century vision is important to Jay's thesis: the account of a shift away from geometricalized laws of optics and the mechanical transmission of light to the physical dimensions of human sight, as the visible becomes lodged in the unstable physiology and temporality of the human body. This leads Jay to a discussion of the corporealized vision reflected in Impressionist painting: these artists' emphasis 'on the fleeting, temporalised, evanescent glance meant they retained an awareness of the corporeally situated quality of vision, which high modernism sometimes forgot.' (p. 115) His following discussion of Duchamp's restoration of the desiring body in vision has a lot in common with Krauss's account of his corporealizing vision in *The Optical Unconscious*. Such points realize the problems of such a broad-ranging and all-encompassing book, the tendency to give us little more than résumés of existing interpretations. He nevertheless goes on to provide a useful discussion of Proust and the recovery of experienced time, '*durée*', by Henri Bergson. Bergson disputed the nobility of sight with the body not as an object of contemplation, but the ground of our acting in the world. Jay draws relationships not only between Proust and Bergson but also with Cézanne, whose 'carefully constructed works can be understood as an attempt less to catch flux on the canvas than to re-animate in the beholder the experience of the artist's own endured time.' (p. 205) Cézanne's paintings realize Bergson's insistence on the 'equaprimordiality of the senses in the apprehension of the world'.

The following chapter offers the clearest instance of vision being attacked: Surrealism's subjection of the noblest of the senses to 'explicit rituals of violent degradation'. Jay sees World War I as having had a decisive impact on vision. The western front's trench warfare created a bewildering landscape of indistinguishable shadowy shapes, 'more visually disorienting than those produced by such nineteenth-century technical innovations as the railroad, camera or the cinema' (p. 212). War set up the experience of a decomposition of spatial order, the practical collapse of a shared perspective, and here it provides the context for a discussion of Bataille and the Surrealists, all affected by the experience of the war. Their art does not just show an anxious vision which reproduces the trauma of war, but 'an anxiety about vision itself'. The ocular iconography of the Surrealists, the motif of the eye, from Redon's eyes as balloons through to de Chirico, Ernst and Dalí, reveals eyes which are mostly transfigured, mutilated. But it is in fiction, in Bataille's *Story of the Eye*, that we find 'the most ignoble eye imaginable'. Bataille's story involves not just acts of ennucleations, but gestures in which the eye is thrust back into the body through anal and vaginal orifices. Bataille's paradigmatic gestures of the denigration of vision are discussed in relation to the infamous visualization

120

of denigration, the slitting of the eye in Bunuel's film *Un chien andalou*, a cutting-up of the eye which is to be set against the 'serene dissections' of the *oeil de boeuf* in Descartes's *Dioptrique*, the 'founding document of Cartesian perspectivalist tradition'.

But Jay's concern with an anti-Enlightenment impulse never goes so far as to adhere to a celebration of the violence of Batailleian 'informe'; as he said in an earlier essay, which sketched out some of the concerns enlarged upon and developed in *Downcast Eyes*: 'vision hostage to desire is not necessarily always better than casting a cold eye.'[1] One begins to get a sense of Jay's position in his chapter on Sartre and Merleau-Ponty. The philosophers' decidedly different approaches to vision rests on two visual modes, defined by David Michael Levin as the 'assertoric' and 'aletheic' gaze. The former is 'abstracted and monocular, inflexible, ego-logical and exclusionary', and could be likened to Bryson's 'gaze'; the latter is 'multiple, aware of its context, inclusionary, horizontal and caring', more akin to Bryson's 'glance'. This theme of two gazes is a key to Jay's own approach to vision. It occurs in his discussion of Levinas in which he calls attention to a caring redemptive conception of vision. In his discussion of Sartre, who conceives of vision only in terms of the 'assertoric' gaze, Jay draws out an 'obsessive hostility to vision'. The career of Sartre gives us 'the quintessential articulation of the demonisation of the eye'. Vision is crucial to *Being and Nothingness*, where he emphasized the hostile contest of wills between competing subjects. Sartre's conception of the gaze is related to a fundamental struggle for power, what Jay calls a 'sado-masochistic dialectic of the look'. The 7,000 references to the look in Sartre's complete body of writings reveal a hostility to any redemptive ('aletheic') notion of vision, precisely the kind of vision we find in Merleau-Ponty. Sartre's 'dual of wounding gazes' opposed the conception of vision in *The Phenomenology of Perception* where we can find a far more hopeful account of vision's role 'in the nurturance of human freedom'. Merleau-Ponty is also important because of the way in which he stressed that sight was imbricated with the other senses in order for us to make sense of our experience of the world. While he refused to degrade vision and connect it with allegedly baser human functions like Bataille, he sought to level the traditional sensual hierarchy and question the elevation of sight above the other senses.

The chapter on Lacan and Althusser is weighted more to the former than the latter, beginning with an account of the optical origins of psychoanalysis with the study of hysteria 'in the theatricalised amphitheater and photographic studio of Charcot's clinic at Salpêtrière'. Freud began by being aroused by what he witnessed there. But he came to be distanced from Charcot's ocularcentric method as he became concerned with the interpretation of verbally reproduced phenomena. Jay points out how Freud's use of the couch was a way to avoid direct eye contact between analyst and analysand. In his discussion of Lacan, Jay connects his account of the 'mirror stage' to the paranoid psychosis shown in the infamous case involving vision and violence which Lacan wrote up in the Surrealist journal, *Minotaure*: the case of the two Papin sisters who tore out their servants' eyes on returning to find their house in darkness. Much time is spent unpacking Lacan's later notion of the gaze, his critique of the visual constitution of the self, and the notion of the desiring subject whose primordial lack will never be filled, a lack symbolized by, among others, the anamorphosed skull in Holbein's painting *The Ambassadors*. The brief passage on Althusser stresses how he showed ideology was involved not in distortions in vision (Marx's famous camera obscura metaphor), but distortions in language. Jay also considers Althusser's autobiographical confessions which were published two years after his death in 1992 and twelve years after he was incarcerated in a mental institution for the murder of his wife. He calls attention to the way in which his privileging of the eye in place of touch played a part in his psychologically tormented life.

His discussion of Foucault and Debord fits well with the theme of the denigration of vision, Foucault with his strictures against the medical gaze and panoptic surveillance and Debord with his contrast between lived, temporally meaningful experience and the dead spatialized images of society's spectacle. Once you have a paradigm everything is pulled in to fit it. While the discussion of Foucault and Debord is appropriate, vision being clearly problematic to both, uncertainties begun with Jay's discussion of Barthes's *Camera Lucida*. Here he also looks at Christian Metz on film, though the intriguing title of the chapter, 'The Camera as Momento Mori', has more application to Barthes. While acknowledging Barthes's fascination with the visual, Jay's approach picks up on something Barthes said in an unpublished essay, 'Right in the Eyes', which, among other things, dealt with the photographs of Richard Avedon. Barthes expressed an anxiety about the gaze and Jay proceeds to try and find out what he meant by this. The conclusion he draws is interesting, but not entirely convincing. Photographs come to be involved with emotional trauma. This is to do with their ontology, they set up a new space–time category, involving both spatial immediacy and temporal anteriority. What Jay refers to as the 'aura of a lost past attached to all photographs' involves photography in a particular trauma for Barthes. *Camera Lucida*, Barthes's last book, is seen to possess a 'thanatology of vision' in its reflection on photography, marked by the pain of mourning the loss of his mother. Hoping to reunite with the maternal body of bliss, Barthes finds in photography only flat death 'resisting revitalisation of any kind.' This is a distinctive but somewhat perverse reading. To see Barthes's last book as part of the denigration of the eye plays down the 'blissful eroticism' he also speaks of in relationship to photography. It also does not address the evident import of the visual arts in Barthes's later writing: his essays on the graphic art of Erté and the painters Cy Twombly and Bernard Réquichot.

The critique of vision in French feminist theory, Irigaray in particular, is read in relation to Derrida's deconstruction. Reading feminism's critique of vision and phallocentricism through Derrida's critique of logocentricism leads to Jay's neologism: 'phallogocularcentricism'. His account of Derrida picks upon his refusal to purify language of its sensuous dimension and closes with Derrida's denigration of vision as a curator, when he selected paintings at the Louvre around the theme of blindness, *Mémoires d'aveugle (Memoirs of the Blind)*. Irigaray fits Jay's schema well with her (essentializing) account of the speciality of women's sexuality which is couched in antiocular terms: the stress on the temporal rhythms of the female body, on touch and fluidity (expressed by menstrual blood, milk and tears). Jay also gives us an interesting account of Irigaray's conflict with Lacan over vision: questioning the choice of Bernini's statue of an ecstatic St Theresa on the cover of *Encore Séminaire XX* and his personal ownership of Courbet's notorious painting of a vagina, *The Origin of the World*.

Jay's book closes with a discussion on postmodernism. Here he confronts certain difficulties. Postmodernism, as he acknowledges, can be seen as the triumph of the visual, the dominance of the simulacrum over what it purports to represent (as Baudrillard has pointed out). Jay, suspicious of this single perspective, then says how postmodernism has taught us that grand narratives (Lyotard) provide totalizing accounts of a world too complex to be reduced to a unified point of view. (In a book like Jay's this cannot be read without a certain irony.) This allows him to give us an account of postmodernism which more fully fits his antiocular thesis, and moreover enables the final coup of reading Lyotard — one who wrote with relish on visual themes: Cézanne, Duchamp, Barnet Newman, Daniel Buren (not Burin, as Jay calls him) — very much against the grain.

This final chapter begins with Levinas and Judaism. Levinas reflects the Jewish iconoclastic attitude toward visual representation. The discussion of Levinas takes up a theme earlier articulated in Jay's account of the importance of a reciprocal notion of

vision, the 'regard' in the gaze in Merleau-Ponty. Only with Levinas, care for the other involves the refusal to turn him or her into an object of visual knowledge. Regard in caring meant keeping the eyes shut: in Levinas's 'ethics of blindness' it was a summons to hear the other's call rather than seeing his or her visage that mattered.

Explaining Lyotard's denigration of vision, whose *Discours, figure* was, according to its author, written as a 'defence of the eye', Jay says how this defence of the eye was not readily comparable to those made by believers in empirical observation, or visionary illumination. Instead Lyotard's conception of vision is to see it as a source of disruptive energy, which 'resists recuperation into a harmonic intertwining in the flesh of the world.' Lyotard lays stress on figurality over discourse, the Id of desire, a primal phantasm that disrupts the intelligible, the imperialism of the textual. Jay discusses the incommensurability of language games with which Lyotard was fascinated and ends with his postmodern manifestation at the Centre Georges Pompidou in the spring of 1985, *Les Immatériaux*. The show linked Lyotard's ideas with new technologies: videos, holographs, satellites and computers. A labyrinth of language was set up, in which the spectator wandered through a maze of zones, from which earphones pumped a melange of texts, with no coherent narrative. The show for Jay signals a loss of 'any hope for clarity of meaning and transparency of understanding'. As Lyotard admitted, what we were left with was 'a mourning and melancholy for the lost illusions of modernism'.

At this point, Jay lands what he calls his 'high-flying balloon'. In his conclusion he is careful to point out that his interrogation of the eye is not simply to be seen as a metaphor for a counter-Enlightenment debunking of rational lucidity. Jay never gives up a certain faith in Enlightenment in this book. What the questions about the status of visuality in dominant cultural traditions of the West have done, is to weaken 'any residual belief in the claim that thought can be disentangled entirely from the sensual mediations through which it passes, or that language can be shorn entirely of its sensual metaphoricality' (p. 590). He regards his book as showing us the costs of assuming the eye to be a privileged medium of knowledge. He claims that the antidote to ocular-centrism is not blindness ('permanently downcast eyes are no solution to these and other dangers in visual experience'), but what he calls 'ocular eccentricity', and also (borrowing from Susan Buck-Morss) a 'dialectics of seeing', a multiplication of eyes, which precludes reification of scopic regimes. The story of the eye needs to be seen as a 'polyscopic narrative' and only then will we be less likely to be trapped in the evil empire of the gaze. This book marks an amazing and brilliant feat; it is a mammoth tome containing a wealth of information and does a lot to clarify difficult and less accessible writings, but it is not without its dangers of distortions; its all-encompassing thesis has the problem of stretching interpretations to fit the over-arching schema. In writing against the imperialism of the eye, Jay's text is not without the imperialism of its own master-narrative.

Mark Durden
Staffordshire University

Note

1 See Jay's 'Scopic Regimes of Modernity', in
 Hal Foster (ed.), *Vision and Visuality*, Seattle,
 1988, p. 19.

Plutôt La Vie
David Hopkins

Compulsive Beauty by *Hal Foster*, October Books, Cambridge, Mass. and London: The MIT Press, 1993, 313 pp., b. & w. illus., £22.50

Freud elaborated his notion of the death instinct in *Beyond the Pleasure Principle* of 1920. In this late, problematic revision of the theory of the drives. Thanatos was made to oppose Eros as part of a new dualism subsuming all the models of the instincts previously outlined. Whilst dialectically related to Eros (and particularly so in the form of sadism where the instinct is placed directly in the service of libidinal gratification), the death drive essentially represents the unconscious desire of living beings to return to a (prior) inorganic state (hence also the link to masochism). To this end, Hal Foster quotes Freud's pithy formulation, 'The aim of all life is death.' (p. 10) In the simplest terms, Foster's attractively produced book aims to locate this notion at the heart of Surrealism's project. In so doing, the book opposes previous readings of Surrealism which, in line with André Breton's own principles, upheld the liberatory and Utopian aspects of the movement. The book thus ties in with a trend in American Surrealist scholarship largely stemming from Rosalind Krauss, whose essays in *L'amour Fou: Photography and Surrealism* (1985) provided a powerful theoretical advocacy for a 'Bataillean' reading of Surrealist art as concerned with the transgressive blurring and dissolution of boundaries (between conscious and unconscious states, life and death) rather than the re-integrative resolution of contradictions in a higher 'surreality' espoused by Breton in the second Surrealist manifesto. Although Krauss made little of the death instinct, she did deploy Freud's linked notion of the 'uncanny' to elucidate aspects of Bellmer's imagery.[1] Foster borrows this usage from her; indeed, to the degree to which the concept rehearsed for Freud aspects of the fully fledged notion of the death drive,[2] it becomes, in Foster's hands, *the* driving force behind Surrealist art.

Basically, the notion of the uncanny anticipates the death drive in that it deals with an instinctual urge for repetition and the re-establishment of prior states. Uncanny experiences are characterized by the return of familiar phenomena made strange by repression, and are exemplified in such occurrences as a blurring of the real and the imagined, a confusion between animate and inanimate, and a replacement of physical reality by psychic reality ('a usurpation of the referent by the sign', in Foster's terms (p. 7). Such 'daemonic' experiences of estrangement or alienation hardly serve the 'pleasure principle' and, in arguing that many fundamental Surrealist obsessions are bound up with these states — the fascination with the disturbing fusion of animation and stasis in automata being one of many examples — Foster is concerned to establish that, in many ways, the 'thrust of Surrealism goes against its own ambition.' (p. 11) Freud had been compelled to adjust his thinking in relation to the primacy of the pleasure principle by instances of 'compulsive repetition' in, for example, the neuroses of World War I veterans. (There is a telling coincidence here with Breton's own experiences as a 'médecin auxiliaire' at Val-de Grâce at the end of the first world war. Breton also treated victims of war-induced trauma, which predisposed him towards psychoanalysis). The traumatic re-enactment of events in the dreams of these patients argued against the notion of dreams as (disguised) wish-fulfilments, and Freud came to see a peculiar process at work whereby unconscious attempts at 'preparing' the soldier subjects for the trauma of warfare were pathetically repeated even after the initial shocks had been experienced. Such processes seemed highly contradictory; on the one hand they served the self-protective interests

124

of the ego, on the other their compulsive nature seemed pledged to the dissolution of the subject, or rather its return to a point of origins or non-existence. Foster argues that the Surrealists themselves seem to have succumbed to this paradoxical conflation of affirmative and destructive impulses. For instance, in his novel *Nadja* (1928), Breton experiences various uncanny instances of 'objective chance' in which a variety of objects function as fetishistic substitutes for a 'lost object' (here, as elsewhere, Foster glosses Freud with reference to the Lacanian 'objet petit a'); hence Foster discusses several 'encounters' with gloves which function, for Breton, as symbols for castration and its disavowal. This compulsive need for symbolic substitutes in Breton is extended to his love relationships, pre-eminently in the person of Nadja herself. Initially, seeing her mental derangement as a potential accession to the 'marvellous', Breton eventually senses the negative or deathly side of his attraction (Nadja's condition leads her, on one occasion, to attempt to blind him with a kiss during a car journey in an attempt to 'extinguish' the couple), and thus turns to Suzanne Musard, his next lover. As Foster points out, 'this move hardly frees him of repetition, of desire as lack ... it is simply its next manifestation ... Suzanne Musard is soon associated with death and his *next* love object, Jacqueline Lamba, with love and life.' (p. 35)

Using such examples, Foster aims at exposing the self-deceptions of Bretonian Surrealism. He writes at one point:

> Surrealism may propose desire-as-excess but it discovers desire-as-lack, and this discovery deprives its project of any real closure. For any art as staked in such desire as is Surrealism, there can be no origin that grounds the subject and delivers the object: here this foundational ambition of modernism is frustrated from within. (p. 43)

He thus denigrates Surrealism's high ambitions (and thereby its appeal to any over-arching 'grand récit') at the same time as he (implicitly) endorses the anti-modernist impulse of the movement (this being linked at various instances in the book to the Bataillean detractors from the mainstream grouping). There is no doubting his polemical intention here. Given his commitment as a critic to exposing modernism's contradictions, Surrealism is an ideal object of study; its emphasis on subjectivity and sexuality constituted a 'return of the repressed' in the context of modernism's high-mindedness and vaunting of aesthetic 'purity'. However, the fact is that historians of modernism have paid greater attention than might be imagined to Surrealism and particularly to painting, William Rubin's monolithic *Dada and Surrealist Art* (1969) being the paradigmatic example. To counteract this, Foster, like Krauss before him, steers clear of painting, privileging photography (already theorized in relation to the deathly 'fixing' of experience in a future anterior mode and thus to the 'death principle' by Barthes in *Camera Lucida*) and Surrealist publications, at the expense of those aspects of Surrealist aesthetics which privilege expressivity or the hand-crafted (there are a few exceptions, notably discussions of De Chirico's and Ernst's paintings). At the same time, the hypocrisies within Surrealism which lay it open to modernist appropriation have to be accounted for, and this places Foster in a curious position. Surrealism may have been committed to psychoanalysis, but it lacked self-knowledge. Foster thus comes to see aspects of the movement as 'symptomatic'. He poses as the movement's analyst, keen to read into its symptoms the more pressing neuroses of current art theory and practice. Occasionally, he seems conscious of the dangers of his position, but this does not prevent him from making inflated claims for his methodology, elevating it to the level of a master interpretive key; at one point the uncanny becomes a 'principle of order that will clarify the disorder of surrealism' (p. xviii). Such pronouncements sit oddly alongside Foster's

endorsement of Bataillean dissolution and transgression.

What becomes evident from the above is the conflicted (to borrow a Foster usage) nature of his enterprise. Whilst the book purports to be an historical study, it is more properly a theoretical one — as Foster himself acknowledges at various points — and very often these modes are mixed in an exotic cocktail which, whilst exhilarating intellectually, is potentially confusing for the reader approaching the book on a more pragmatic level. (In this respect the book bears analogies with Krauss's recent *The Optical Unconscious* (1993).) If, as the author claims, he is providing a means of unravelling the symptomatology of Surrealism, he should be a little more forthright about the enormous selectivity involved in choosing which symptoms to analyse. If the book's central theme is the death impulse, why is there no mention of André Masson, whose works such as the *Massacres* of the early 1930s foreground the principle to a greater degree than those of any other Surrealist artist? (Presumably because these are examples of Surrealist drawing/painting, which have to be downplayed, given the book's critical allegiances). Furthermore, if the book's concern is the centrality of Freudian psychoanalysis for Surrealism, why does the author fail to acknowledge work already carried out in the field? Once again, a study of Masson (or, more specifically, his painting *Gradiva*, of 1939) in terms of the Eros/Thanatos opposition has been carried out by Whitney Chadwick.[3] Likewise, Elizabeth Legge's close analysis of Freudian themes in Ernst's work is not even footnoted in the relevant part of the book.[4]

Foster's theoretical glossing of historical data is more clearly demonstrated by the fact that, as he himself underlines at one point, Freud's texts on the death wish and the uncanny were not translated into French until 1927 and 1933 respectively. The Surrealists could therefore hardly have had access to such ideas in the formative years of the movement, although they may well have intuited Freud's contemporary preoccupations. (This in itself throws up enormous methodological difficulties which Foster avoids). Much of the book *reads*, however, as if the Surrealists were cognizant of such formulations. Foster is perhaps most successful when he is most direct about his polemical aims. He declares in the preface of the book that a motivating factor behind his re-examination of Surrealism was that the movement generated, almost as satellites to its artistic concerns, important innovations within the 'fundamental discourses of modernity — psychoanalysis, cultural Marxism and ethnology' (p.xiv), which were articulated influentially by Lacan, Benjamin and Bataille. Whilst these thinkers were only marginally involved with Surrealism, they were all deeply affected by it, and it is clearly their current importance to cultural theory which has fuelled Foster's turn to history. Foster's deployment of their insights is often exemplary. For example, in the latter half of the book he utilizes Benjamin's and Bloch's notion of the 'outmoded' (involving the use of obsolete cultural materials from emergent points of capitalism to undercut ideologies of 'progress' or 'improvement' inherent in its later manifestations) to examine the Surrealists' valorization of 'objets trouvés' culled from the Paris flea markets or of forgotten or anachronistic corners of the city due for redevelopment (here Foster appropriately comments on the Passage de l'Opéra section of Aragon's *Paysan de Paris*).

As already noted, the bulk of the book takes its impetus from the continuing vogue for Bataille, who is particularly invoked in the discussion of Bellmer, and in this respect — as was made clear at the ICA Conference on Foster's book[5] — there are tendencies within current (American) art practice which are also at stake. Broadly speaking, these tendencies can be grouped under the rubric of 'abjection', although the term has itself become debased, denoting the 'excremental' subject matter of some recent art (matter being the operative word) rather than any strict allegiance to Kristeva's theoretical elaboration of the notion in *Powers of Horror*. Recently works such as the

sculpture/installations of Mike Kelly have been seen as embodying the concept, eliciting the amusing 'scatterological' coinage in a recent 'October' round table[6]; a term which seemingly reprises the 'anti-form' aesthetic elaborated by Robert Morris in counterpoint to high Minimalism. Foster's oblique references to similar tendencies in *Compulsive Beauty* circle around notions of 'desublimation' in relation to the Bataillean critique of idealist (Bretonian) Surrealism, or to the notion of the (structurally) 'heterological' or diffusive as opposed to the integrative or (psychically) resolved. The author seemingly embraces a Bataillean aesthetic of the 'informe' and this leads to a fair degree of Breton-bashing as implied earlier. At times this seems somewhat gratuitous. Breton's drive towards the resolution of dualities — which, as Foster shrewdly comments, hardly squares with Freudian/Lacanian accounts of split subjectivity — is dismissed as merely 'compensatory', and his interests in Fourier, androgyny and analogical thought are deemed 'excessive' (p. 228, n. 56). The notorious instance of Breton's declaration of homophobia in the 'Recherches sur la sexualité' is wheeled out as an instance of his prudery, but it has to be acknowledged that Breton was prepared to talk openly about subjects such as sodomy and masturbation which suggests he was not exactly the archetype of repression. If Breton's rather pious attempts to place Surrealist dialectics at the service of Marxism are to be rubbished, one wonders what Bataillean desublimation in the service of 'base materialism' could really amount to. This is not exactly clarified. As quoted by Foster, Bataille claimed that 'The final aim of eroticism is fusion, all barriers gone.' (p. 114) Ultimately, of course, this desired fusion points towards non-being, the guiding principle behind Foster's project. So where does this leave us?

Perhaps the virtues of a Bataillean, desublimatory reading of Surrealist practice are best exemplified in Foster's analysis of Bellmer, which is one of the most satisfying, if disturbing, aspects of the book. Foster frequently alludes to the work that needs to be done on Surrealist constructions of masculinity; for instance, in relation to Breton's homophobia, mentioned above, he asserts that more research needs to be carried out on the 'homosocial' basis of early twentieth-century avant-garde formations. This is a valuable suggestion. However, he himself only directly addresses the topic of masculinity in the discussion of Bellmer. Whilst he admits that the sadistic dismembering of the female body in the artist's 'poupées' has, in broad terms, to be seen as misogynistic, he puts his weight behind a more challenging theory whereby the dolls are to be taken as self-reflexive critiques of male sexuality, deconstructing its mechanisms at the same time as they enact its most disturbing fantasies. This argument follows on from Krauss's attempt, in *L'amour Fou: Photography and Surrealism*, to suggest that (female) gender in Surrealist photography is overtly placed 'under construction' rather than naturalized.[7] However, Foster's point is a little more complex. Employing Theweleit's thesis on the construction of male Fascist subjectivity,[8] Foster argues that the 'poupées' oscillate between sadistic and masochistic positions; they encode not only aggressive masculine fantasies, but also the potential fragmentation of the (Fascist) subject. He sees the combination of body and weaponry imagery in a work such as *Machine Gunneress* (1937) as pledged to undercutting the authority of Bellmer's (Nazi) father and, by extension, the German Fascist state. This is an ingenious utilization of Theweleit's account of the Freikorps' obsessive concern with both fantasizing and guarding against the body's dissolution through an excessive or hysterical armouring, but it is also worrying. The violence done to the female body in the course of such projections cannot be so easily theorized away and, as Foster rather obscurely comments 'there may be an appropriation around the position of the masochistic.' (p. 122) Foster has made similar points elsewhere in relation to Ernst.[9] There, it seems to me, he is much more convincing, given that the mechanized bodies at issue are gendered as male.

It is with the relatively short discussion of Ernst in *Compulsive Beauty* that some

of the book's shortcomings stand revealed. This discussion occurs in a chapter dedicated to the uncanny as evoked by traumatic scenes of primal fantasy; the fantasies being Freud's three fundamental psychic 'triggers': seduction, the primal scene proper and castration. De Chirico and Giacometti are dealt with in terms of the primacy of seduction and castration fantasies respectively, and here Foster as analyst seems very convincing in explaining the 'crises' in their careers — namely, de Chirico's lapse into 'deathly repetition' after 1917 and Giacometti's abandonment of the Surrealist project in favour of obsessive mimesis after 1935 — as outcomes of their inability adequately to resolve psychic tensions arising from trauma. With Ernst, however, Foster's probing of symptoms seems inappropriate. There is certainly a sense in which Ernst's constant recourse to fantasies of the primal scene, particularly in his writings, would appear to encode an ambivalent attitude towards his father (often a passive homosexual position), itself related to fantasies of the phallic mother, which leads to a constant shifting from active to passive states in Ernst's aesthetic procedures, to say nothing of a general troubling of the notion of identity. Beyond this, however, Foster's reading of the artist seems too restrictedly psychoanalytical in itself to encompass the remarkable referentiality of the Ernstian imagination, both psychoanalytic and otherwise. If a Freudian model were to be applied wholesale to Ernst, it would surely have to be that of 'over-determination', despite the burgeoning literature keying various works to specific case histories. More than any other Surrealist artist, Ernst consciously employed disparate Freudian motifs, often playing them off against each other and thus ironizing and complicating the apparent autobiographical dimension of the works. Frequently he actually pitted psychoanalysis against other belief systems, thereby relativizing it and exposing its historical contingency.[10] To talk of Ernst's works of the 1930s and '40s as 'paranoid fantasies' or 'delusions of grandeur', traceable to originary trauma, as Foster does, seems insensitive to the self-reflexivity of Ernst's work. Outside psychoanalysis, Foster makes no mention of other sources, yet it has been shown that Ernst often correlated psychoanalytical and alchemical motifs in his works, thereby setting up analogies between the practices.[11] One imagines that hermeticism would be a taboo subject for Foster, committed as he is to a materialist reading of Surrealism. (In this sense, of course, he follows Benjamin, who relished the 'profane illumination' offered by the movement.)[12] However, his brief mention of the topic (one paragraph) hardly does justice to the fact that, for the Surrealists themselves, hermeticism was at least as important a resource as psychoanalysis. All of this suggests that one challenge for Surrealist scholarship would be to define the extent to which the sheer multiplicity of reference in the works compromises any possibility of easily unravelling 'unconscious' symptoms. Foster's book barely acknowledges such a problem, and this is surely an outcome of the prioritization of theory over and above issues of historical exactitude.

As a whole, Foster's book undoubtedly succeeds in opening up areas of debate and points towards new areas of research. The latter half of the book, which deploys the notion of the uncanny to show how Surrealism dealt with 'the shocks of industrial capitalism as well as the traumas of individual experience' (p. 126) charts relatively unexplored terrain. Throughout the book, suggestive points often occur as asides to the overall argument. For instance, there is a disappointingly brief discussion of the way in which representation 'returns uncannily as simulation' in Surrealist art (on pp. 96–8), which extends Foucault's study on Magritte in a fascinating way. However, historical blind spots do sometimes lead to rather arid readings of actual works of art. For example, to use the example of Ernst again, Foster at one point discusses *The Master's Bedroom* (1920), also the subject of an important essay by Krauss,[13] in terms of his thesis on the centrality of the primal scene for Ernst. This misses the wit of the work. The diminishing perspective, the picture on the wall, the red coverlet on the tiny bed, the

© Association of Art Historians 1995

title itself, all point to this collage/overpainting being a reworking of Van Gogh's *Bedroom at Arles*. The dislocations of scale are therefore as ascribable to an underhand joke at the expense of Van Gogh's psychosis as they are to the symptomatic effects of trauma, as Foster rather drily asserts. Generally speaking, there is little of Surrealism's 'humour noir' in this book and, although the author appears sympathetic towards the subversive or transgressive impulses of the movement, his neat categorizations tend to deprive it of whatever 'convulsive beauty' it might retain. In the face of such a sophisticated piece of deconstruction invoking the death wish, one feels inclined to quote the much-maligned Breton: 'Since words have become over-rife / Rather life.'[14]

David Hopkins
Edinburgh College of Art

Notes

1 R. Krauss, 'Corpus Delicti', *L'Amour Fou: Photography and Surrealism*, New York, 1985, pp. 82–6.
2 'The Uncanny' was published in 1919 (in *Imago*, 5), a year before the publication of *Beyond the Pleasure Principle*.
3 W. Chadwick, 'Masson's *Gradiva*: The Metamorphosis of a Surrealist myth', *Art Bulletin*, vol. 52, no. 4, December 1970.
4 E. Legge, *Max Ernst: The Psychoanalytic Sources*, UMI Research Press, 1989.
5 ICA, London, 30 April 1994.
6 H. Foster *et al.*, 'The Politics of the Signifier II: A Conversation on the 'Informe' and the 'Abject', *October*, no. 67, Winter 1994. 'Scatterological' appears to be Foster's coinage.
7 'Corpus Delicti', op. cit., p. 95.
8 K. Theweleit: *Male Fantasies*, 2 vols., trans. S. Conway, E. Carter and C. Turner, Minneapolis, 1987–89.
9 H. Foster: 'Armour Fou', *October*, no. 56,

Spring 1991, pp. 64–97.
10 For accounts of this layering of reference in Ernst see E. Legge: 'Max Ernst's Oedipus Rex and the Implicit Sphinx', *Arts Magazine*, vol. 61, no. 1, Sept. 1986 and D. Hopkins, 'Hermetic and philosophical themes in Max Ernst's *Vox Angelica* and related works', *Burlington Magazine*, vol. 134, no. 1076, Nov. 1992.
11 D. Hopkins, 'Max Ernst's *La Toilette de la Mariée*', *Burlington Magazine*, vol. 133, no. 1057, April 1991.
12 W. Benjamin: 'Surrealism: The Last Snapshot of the European Intelligentsia' (1929) in P. Demetz (ed.), *Reflections*, trans. E. Jephcott, New York, 1978.
13 R. Krauss, 'The Master's Bedroom', *Representations*, pt. 28, 1989, pp. 55–76.
14 A. Breton: 'Plutôt la vie', trans. Kenneth White, *Selected Poems*, London, 1969.

A Long Courtship
David Howarth

History and its Images by *Francis Haskell*, New Haven and London: Yale University Press, 1993, 558 pp., 21 col. plates, 242 b. & w. illus., £29.95

In the Preface to this book it is stated that the intention is to trace 'the impact of the image on the historical imagination'. This is done by considering the slow, halting and often interrupted process whereby historians of the Occident came to value the images of western Europe as a means of interpreting the past, or even went beyond that to proclaim with the French historian Hippolyte Taine the wish to write a 'a history making use of paintings rather than literary sources as documents' (p. 9). Answers are suggested as to why historians were taught to read medieval script but not to look at pictures, took so long to see the Marciana in Venice, that great Renaissance Library, as perhaps

a more eloquent testament to historical change than the charters which they so painfully transcribed within. But it is not a one-way process. In discussing the distinguished eighteenth-century Ferrarese antiquarian and historian Leopoldo Cicognara, Haskell suggested that his contribution to the process of bringing historians and art together was to make art historians appreciate how much they could benefit 'from a thoughtful understanding of conventional history' (p. 200): though, as the author notes, the opposite process was still to happen; at the end of the eighteenth century when Cicognara was working, historians were not yet ready to use images in the writing of history. This is abundantly clear from Gibbon who managed to write his *Decline and Fall of the Roman Empire*, the first volume of which appeared in 1776, without referring once to the artefacts of antiquity. And this, despite the obvious susceptibility of the author to things of the eye; a responsiveness which runs like an underground spring below the surface of the *Autobiography*. Evidently historians found it difficult to visualize their imaginations. Was this the case with writers in the modern sense? Was Conan Doyle unusual in ending 'The Giant Maximin' from his *Tales of Long Ago*, in a way which Gibbon could not have comprehended:

> I sit in my study, and upon the table sits a denarius of Maximin, . . . In the centre is the impress of a great craggy head, a massive jaw, a rude fighting face, a contracted forehead. For all the pompous role of titles it is a peasant's face, and I see him not as the Emperor of Rome, but as the great Thracian boor who strode down the hill-side on that far-distant summer day when the eagles beckoned him to Rome.

Gibbon knew his coins though he did not use them as currency in his history. But it is with coins, or more precisely with numismatics, that the book begins. Here it is pointed out that publications of the sixteenth century, often beautiful folio volumes, used coins as illustrations though not as illustrative of the text. They seem to have had as much relevance to the argument of a history book, as jewels on the covers of a Carolingian Gospel. They were mere embellishment. Enea Vico and Fulvio Orsini are singled out as the two most distinguished numismatists; the latter because he was the first to draw not merely on coins and medals, but on what may be termed the *impedimenta* of the classical world as it had come down to late sixteenth-century Rome. Orsini created a synoptic interpretation of the past; an interpretation based not only on coins but epigraphy, statues and busts — complete or incomplete — it did not matter. What did matter was that Orsini was the first to take them together because he was the first to see that they provided a more rounded interpretation of the past than was the case if, as had happened before, each aspect of civilization was examined separately, if not hermetically. Within the context of late Renaissance numismatics, it might have been useful to mention Francis Junius's *De Pictura Veterum*. There is, of course, a disincentive because — as its critics have pointed out since its publication in 1637 — it has no illustrations. Nevertheless, Junius devoted much thought in the book to the coins of antiquity and anticipated some of the historians Haskell writes about, in proclaiming that the moral state of society could be gauged by the artistic quality of its coinage; when the Romans began to produce bad coins we can be sure that their morals were appalling, or so Junius would have us believe.

Coins lead on to the larger issue of historical portraiture. Less space is devoted to the cult of the emblem book than one might have expected. Although part of the point of emblems was that they were timeless, non-specific and allegorical, nevertheless the intensity with which they absorbed a literate public in the late sixteenth century may have made people rather more aware of the study of artefacts. That in itself surely

contributed to a growing awareness of the physical remains of history.

The starting point for Haskell's discussion of the 'historical' portrait as a moral exemplum is the immensely influential collection of *uomini illustri* which Paolo Giovio collected at his villa at Como, on land that had once belonged to Pliny the Younger. This enterprise, and enterprise is surely the word as he seems to have expended huge energies in pursuit of a prize, was to have the effect of taking the portrait as something the historian should consider, out of the confined space of the medal cabinet and into the more public and political sphere of the Long Gallery. However, we are still very far from exacting standards of historical integrity since, as is pointed out: ' . . . despite the diligence of his researches and his refusal to countenance outright fabrications, Giovio must clearly have known that many of his "portraits" were not exact likenesses but were images which had been made to correspond to impressions derived from a knowledge of the sitter's life and actions.' (p. 48) Seen in a certain light, the creation of this collection exemplified the belief that the best way to know a man was to know his actions. Giovio's museum created a mesmeric fascination for the portrait; but the methodology of historians remained untouched by the fashion for the 'Gallery of Worthies', that legacy of the Italian antiquarian. Take, for example, the Earl of Clarendon, who wrote the greatest of all accounts of the English Civil War on the basis of the personalities involved, many of whose faces he had studied in animation, without reference to the visual *evidence* provided by their portraits. This is all the more intriguing since Clarendon had arguably the best portrait collection in England after the Restoration. Significantly, however, Clarendon's history was much used in the eighteenth century as an extra-illustrated or grangerized text.[1]

Before turning to the age of Enlightenment which Haskell sees as the period when art and history sat down at the same table, it may be worth considering certain aspects of seventeenth-century culture to suggest that more cognizance of visual objects as historical records may have been taken than is allowed. John White was the official artist attached to Raleigh's 1585 Virginia expedition and he then produced his celebrated watercolours of the Carolina Algonquian Indians which later accompanied Thomas Harriot's *A briefe and true report of the new found land of Virginia* (1590). That was a book of immense significance to the growth of an interest in the new continent and although what text and illustration tells us belongs more to the realm of ethnography and sociology than to history, it may be that illustration and history writing in the late sixteenth century was more closely allied than we can now appreciate. For instance, it would be fascinating to know what was made of the fifteen volumes of drawings of Mexico created by a team of artists under Fernando Hernandez, for Philip II in the 1570s, which were lost in a fire at the Escorial in 1671. These were perhaps part of the same impulse which had sent Joris Hoefnagel round Europe recording the appearance of the principal cities. I wonder then whether the expansion of Europe — the encounter, followed by the destruction of alien cultures — induced men to consider artefacts as historical evidence; particularly those writing about the New World.

Haskell concentrates upon written evidence of an awareness of art and visual information and not on the vast field of those who collected things from the past. However, what about a figure such as Sir Robert Cotton, who maintained a European correspondence in the first thirty years of the seventeenth century? He combined a museum of historical relics, including such curiosities as what Cotton proudly proclaimed to be the cranium of Thomas à Becket, with the best archival library in England. The Cotton Library was the British Museum before its foundation, and for his part, Cotton saw artefact and document as two sides of a diptych. His contemporaries talked of the library in Westminster as Helikon's Fountain. No historian could afford to ignore this repository of document and artefact alike, and thus, at the least, it would seem that

the mental set of the Jacobean antiquarian would have been modified by the indivisibility of the written word and the seen object. Cotton's legacy was a cast of mind which led to the distinguished contribution made to an understanding of cultural history by the Society of Antiquaries in Augustan England. Haskell makes no reference to its collection of medieval imagery, original and reproduction, which is perhaps somewhat surprising. For instance, what little is known today about the frescoes in the royal palaces of England in the Middle Ages has largely come down to us from watercolour records made for the Antiquaries. It is surely the case that these partial records were used to interpret history. In this connection it might too have been valuable to raise the question of when does an antiquarian become an historian — something central to the purpose of the book.

The central section of the book is devoted to the eighteenth century, when it is demonstrated that historians from Edinburgh to Naples began to appreciate the immense potential visual evidence had for their studies. Voltaire is singled out for special emphasis. Although he paid little attention to works of art in his history writing, he was contemptuous of the trivial incidents of military victories and the largely destructive actions of princes. His insistence that what mattered in history were the humane achievements of civilized people, did much to induce a new respect for painting and the sister arts. Voltaire claimed the arts for liberalism: though as Haskell demonstrates later, they were going to have more sinister suitors, who would woo them in the name of a belligerent and repellent notion of racial superiority.

One of the most compelling sections of the book is the consideration of the 'discovery' of the Bayeux Tapestry. This, the largest of all medieval chronicles, had attracted considerable interest among French antiquarians in the late seventeenth century. But it was not until 1724, when Antoine Lancelot turned his attention to it, alerted by his encounter with some incomplete visual records made for the distinguished French civil servant Nicolas-Joseph Foucault, that it came to be considered as a *Gesta Normanorum*. Lancelot, dependent as he was on the Foucault watercolours, did not even know what he was looking at. He thought the illustrations probably represented reliefs from the tomb of William the Conqueror in Caen, which he believed had been destroyed by the Huguenots in 1562. But perhaps for the very reason that he was an historian not an art historian, this did not matter. He pondered defective inscriptions and considered minute questions of detail within the illustrations, to explore the still controversial question as to what rights, if any, William actually had to succeed Edward the Confessor to the English throne; in other words, to square up to the central issue of whether William came as a thief on a kingly scale, or to claim what was legally his.

Lancelot's generosity as a scholar involved Montfaucon and he provided his own brilliant thoughts on the questions of stylistic formulae in those reproductions of the tapestry. Montfaucon showed what was then a unique capacity to discount formulaic conventions of medieval art in understanding what was going on. As Haskell points out: 'Montfaucon recognised that despite the scene that shows Harold and one of his companions half-kneeling outside the church at Bosham, "no doubt they actually went into the church to say their prayers. But the artist placed them outside as otherwise he would not have been able to let them be seen." ' (p. 140) The larger significance of this compelling and exciting facet of the book is summarized by Haskell thus: 'For the very first time it appeared that a historical problem of real importance had been solved on the basis of an image, and that the visual had taken place over the literary.'

The Bayeux Tapestry can be categorized as an aspect of the decorative arts and Haskell demonstrates how historians could use pebbles to construct temples dedicated to the greatness of nations. In chapter 13, entitled 'The Deceptive Evidence of Art', there is an absorbing analysis of work which stemmed indirectly from the inauguration of the Academie Celtique in 1805, itself an offshoot of patriotic nationalism stimulated

132

ultimately by the release provided by the French Revolution. Perhaps the most absorbing demonstration of how a study of the minor arts of France could be used to measure the nature and tempo of the Revolution itself was provided by Champfleury in his painstaking study of what he liked to think of as 'faience parlante'. Champfleury made an inventory of ceramics which displayed patriotic inscriptions, symbols and the names of Revolutionary heroes, by searching through rat-infested barns in pursuit of utility wares produced in primitive localities. It was a kind of MORI poll conducted on the assumption that the moving force of political life is the personalities of the main players: one needed only to count up the number of plates inscribed with the name 'Mirabeau' to appreciate that 'this orator ... remained a principle as far as the people were concerned'. (Champfleury, p. 379) It is a nice question as to whether the wares or the scholar himself were the more naïve, but what is certain is that Champfleury's researches had implications beyond the modest scope of his material. What he was doing has connections with the rise of 'Realism' in France, not least because of its politically engaged nature. His admiration for art produced by the people for the people also seems to anticipate William Morris's interest in craftsmanship and Vaughan Williams's rural idylls in pursuit of the fast-vanishing tradition of English folk songs at the turn of this century.

Connected with the work of Champfleury, if only because of its association with the French Revolution, is the attitude historians have taken to the work of Jacques-Louis David. This forms a major part of the subsequent chapter entitled 'Art as Prophecy'. Here Haskell turns over the old chestnut of the extent to which a significant change of style can be taken to presage changes in society at large. It was an issue which had begun to circulate particularly in Germany as a result of the publication of Schiller's poem *Die Kunstler* in March 1789, and it was one which was most intensely focused in the merciless clarity of David's paintings: 'It is certain ... that the pictures painted by David between 1785 and 1789 have, more than any other single works of art, been responsible for implanting into historical thought the idea that a major shift in artistic style can indicate — must indicate? — a forthcoming upheaval in society in general or even in the very stability of the world.' (p. 400)

Much of this is inevitably familar since it has long been something of a *cause célèbre*, but Haskell might have approached this material in a fresher way had he taken up again where he had left Burckhardt earlier. Burckhardt was naturally aware of these issues and yet, in *The Civilisation of the Renaissance in Italy*, he specifically refutes the idea of the artist and his artefact as prophet; 'he tends to downgrade their significance for the cultural historian by pointing out that changes in them are always long preceded by those that occur in other forms of culture.' (p. 336)

Haskell has chosen not to take up the opportunity of a dialogue between historians whose response to visual evidence forms the theme of this book. This is understandable given the variety of period and personality covered. By not looking over his shoulder more than is necessary for coherence, he has managed to convey with exemplary clarity an astonishing range of approaches to the relationship between art and history. Consequently many stars have been fixed in the firmament. Nevertheless the absence of a cross-referential framework tends to make the book a series of essays: some seen almost to stand on their own. Perhaps the most satisfying and certainly the most self-contained, is the last. This is entitled 'Huizinga and the "Flemish Renaissance" '. Here, in sixty pages, we are not only treated to an introduction to a specific historical method or prejudice, but to a moving intellectual biography of great distinction and attraction. The respect and affection shown by Haskell for his subject reminds us of a great apologia for an art historian, E.H. Gombrich's study of Aby Warburg. However, the vividness with which Haskell paints his sitter is all the more remarkable since it was done without any sittings.

History and its Images shows us that historians took a long time to use images and even when they did so, this often led to greater obscurity. What is however clear for us is the importance of this book in demonstrating how the habit of looking was gradually absorbed into the heart of humanist studies. Haskell suggests that the visual arts had become an acceptable frame of reference for the cultural historian at the turn of the eighteenth and nineteenth centuries: just the moment when art history first became enshrined as an academic discipline within German-speaking universities. Was this coincidence or is there a causal connection? That is just one of the large issues which this book provokes.

David Howarth
The University of Edinburgh

Note

1 See M. Pointon, *Hanging the Head*, New Haven and London, 1993, pp. 72–7. I am indebted to Malcolm Baker for this observation.

Art History ISSN 0141-6790 Vol. 18 No. 1 March 1995 pp. 135–148

SHORTER REVIEWS

Modernity in Asian Art, ed. *John Clark*, Broadway NSW: University of Sydney East Asian Studies Number 7, Wild Peony, 1993, 236 pp., 167 b. & w. illus. Aus$37.00

This volume of seventeen papers stems from a conference on *Modernism and Post-Modernism in Asian Art*, held in Canberra in 1991. In addition to John Clark's admirable introduction, which sets the tone for the entire project in its attempt to problematize the simplistic opposition of 'modernity' to 'tradition' which has bedevilled so much writing on Asian art in the twentieth century, there are papers (five of them) dealing with painting and sculpture produced in China (including Taiwan), three on Indonesia, two each on Thailand and Japan, and a single one each on India, the Philippines, Korea and Malaysia, covering the whole period from 1900 to the present. Into a field which thankfully lacks an accepted master narrative, an agreed canon of significant works or major artists, and a body of normative critical literature, this volume inserts an unprecedented quantity of important new material which will demand engagement in the future.

The question is: demand engagement from whom? The preface by Virginia Spate of the Power Institute of Fine Art, University of Sydney, speaks directly of the disturbance she felt as a scholar of European modernism, on discovering the existence of vast areas of work done in Asia which she would feel more comfortable ignoring. It is very much to be hoped that Spate's unease will come to be shared, and that the publication of this volume in a series devoted to 'East Asian Studies', together with the fact of its being reviewed by those identified as 'Asian specialists', will not draw it back into the vast gravitational field of a marginalized orientalism, where it can be ignored. The problems it poses deserve a better response than that.

Not that all the contributions escape that field themselves, or appear fully to grasp the implications of Clark's characteristically closely argued introduction. Some are still stuck in a teleology of modernism as the artistic superstructure accompanying the rise of a totalized bourgeoisie. Some still seek the explanation of individual artworks as being 'ultimately rooted in an Oriental philosophical attitude towards nature, life and death', or believe in the existence of 'Far Eastern sensibilities'. Some still see modernity and Westernization as the same thing, having overlooked the fact, pointed out in Astri Wright's useful contribution on 'Artist Roles and Meanings in Modern Indonesian painting', that 'not all of the stylistic elements that look modern to a Western eye were new for Indonesians.' Some statements about contemporary practice have already been overtaken by events, as when Ellen Johnson Laing argues that there is no evidence of the appropriation of popular culture in Chinese painting, ignoring the work of Guan Wei, or the blandly fashionable 'political pop' of Yu Youhan.

Such mis-steps do not negate the value of this volume as an intervention in current debate. All the papers contain valuable material not readily accessible elsewhere, and many of them add subtle and powerful critical readings of this material. For example, Ralph Croizier on the Post-Impressionist 'Storm Society' in early 1930s Shanghai successfully resurrects an entire silenced milieu of artistic creation and aesthetic polemic in circumstances of intense economic and political change.

Similarly, it is pointless to argue that a broader regard for the visual culture of graphics, advertising or book design would enrich papers sometimes too narrowly focused

on small groups of artists, that there is very little attention paid to gender, and that some areas of Asia with thriving modernist art histories, such as Vietnam, are not covered. The illustrations are small, and in many cases reproduce lost originals from periodicals which were poorly printed in the first place. The information given about them is often exiguous. But none of these flaws should let the basic question be brushed aside. Anyone who still feels that Pang Xunqin is 'derivative', while Picasso is a creative appropriator, should read this book and certainly *ought* to be made to feel uncomfortable by it.

<div align="right">

Craig Clunas
University of Sussex

</div>

Tekstura: Russian Essays on Visual Culture, ed. and trans. *Alla Efimova* and *Lev Manovich* with a Foreword by *Stephen Bann*, Chicago and London: The University of Chicago Press, 1993, 231 pp., 18 b. & w. illus., £10.25

Tekstura is an anthology of thirteen essays by Russian-language writers on various aspects of visual culture, primarily Russian and Soviet. Most are published here for the first time in English translation. With three exceptions — essays by Mikhail Bakhtin, V.N. Voloshinov and Sergei Eisenstein — they were written over the past twenty years. The anthology can potentially contribute to a study of the intellectual roots of Soviet liberalization in the late 1980s. It demonstrates that, however stagnant the Soviet economy may have been under Brezhnev, intellectual life was in ferment. As such it begins to fill some important gaps in the anglophone world's perception of twentieth-century Russian culture, too long dazzled, as Stephen Bann notes in his Foreword (p.XII), by the historical avant garde. The absence from this collection of any essay written by a woman (excluding the editors' introduction), or addressing questions of gender, while regrettable, should be put down less to editorial bias than to the gender relations prevailing in recent Soviet culture.

The declared aim of the editors/translators is dual: to offer an appraisal of the Russian and Soviet visual heritage; and to present new theoretical approaches to the problems of visual culture that 'rely on philosophical concepts and categories specific to the Russian tradition.' (p.XIX) Rather than a coherent tradition, however, it is the methodological heterogeneity and the breadth of the subject matter classed as visual culture — ranging from painting and film to mass celebrations and urban refuse — that will most strike the reader. If a unifying thread is to be found it is the conviction, expounded by Voloshinov, that all material things are capable of becoming signs and thus lend themselves to ideological analysis. The continuity of this intellectual 'tradition' to the present day is established across formalist film director Sergei Eisenstein's investigation of pictorial structure, through more recent work inspired by the Moscow-Tartu school of semiotics, to the intellectual context of Moscow Conceptualism.

Moscow Conceptualism, the category of contemporary Russian art that has attained greatest international recognition since the late 1980s, developed in the Brezhnev years at the interface between the visual and the verbal. The art of its most prominent exponent, Ilya Kabakov, is illuminated here by two complementary essays: Mikhail Epshtein's meditations on a 'Lyrical Museum' composed of personal things devoid of universal public significance; and Alexander Rappaport's consideration of the installation *The Ropes* (1985).

While the semiological tendency is arguably the most vital and distinctive, it represents only one aspect of Russian culture of the past twenty years. Indeed, one contribution

appears to have strayed into the anthology from the alien realm of meticulously documented but ideologically orthodox socio-historical research. This is Grigory Sternin's fascinating essay on the awkward question of public taste and the growing gulf between art and society in Russia at the turn of the century. Many of the essays were written from the nonconformist margins of Soviet culture, or, like Boris Groys's provocative 'Stalinism as Aesthetic Phenomenon', in emigration. But Sternin was a respected member of the Soviet art-historical establishment, albeit on its liberal wing. *Tekstura*'s potential to provide non-specialists with insights into recent Russian cultural thought is limited by the lack of contextual information concerning the social positioning of the authors and the nature of the original place of publication (official, samizdat, emigré, etc.). In their selection the editors have consciously set out to 'erase boundaries between high and low, official and dissident, avant garde and socialist realism' (jacket text). While this refusal to differentiate has the merit of allowing continuities to be recognized, it risks ahistorically distorting the significance of the texts. As the old distinctions fade into history, is it not important to preserve an understanding of how a writer or artist was situated in relation to power and how this inflected what was said, how, and to whom?

Susan E. Reid
University of Northumbria at Newcastle

Landscape and Power, edited by *W. J. T. Mitchell*, Chicago: The University of Chicago Press, 1994, 248 pp., 72 b. & w. illus., £33.95

The landscapes discussed in this varied collection of essays divide between a number of subjects which include what might be considered the 'new' tradition of re-reading eighteenth- and early nineteenth-century British landscape discourse; essays which address appropriations of the natural in order to naturalize the effects of colonialism; and work which explores the ways in which images of land address a range of possible constituent audiences. They are jointly concerned with power ideologically inherent in all aspects of landscape, and how representations of landscape deal or fail to deal with power. In this sense what has become known as 'landscape' in traditional art history is dramatically enlivened, and representation is seen to be an active force in naturalizing kinds of power, especially the power of colonial forces. *Landscape and Power* can be read as a critical extension of John Barrell's and Ann Bermingham's earlier work, and also as a criticism of classic works which consider an art-historical landscape remote from social practice.

Within the first page of Ann Jensen Adams's 'Competing Communities in the "Great Bog of Europe": Identity and Seventeenth-Century Dutch Landscape Painting', the myth of faithful transcription in Dutch landscape painting is punctured. Paintings were sometimes constructed by rearranging features, or by creating elevated positions in order better to represent the new nation created by civil engineering. Though interestingly, tensions towards modernity can be traced in the representation of transport, often anachronistically portrayed as river-based. At a time of political, economic and religious upheaval, where relationships and bonds were constantly challenged by contemporary developments, landscape representation offered a kind of control and image otherwise unavailable.

In 'Territorial Photography', Joel Snyder examines the photographs of Timothy H. O'Sullivan and Carelton Watkins and explores the kinds of images and audiences involved

at this early stage of 'photography' (the 1860s). Whereas Watkins seems to be responding to a landscape already confirmed in its being, O'Sullivan presents a land that is *unpresentable*, one that refuses easy consumption and is *not*, Snyder suggests, the easy or uncomplicated domain of a prospective colonizing population.

David Bunn describes the manoeuvres inherent in naturalizing a colonial presence in a land far removed from the familiar. In one remarkable illustration, a colonial figure gesticulates across a clearly tropical land, which by sleight of hand is very nearly reduced and transformed into a reassuringly familiar parkland scene. Bunn thankfully remains alive to a 'plurality of determining systems' and is not as severely reductive as the essayists that deal with the more traditional arena of eighteenth- and early nineteenth-century British landscape. Here, analysis tends to be restricted in order to embellish a very deliberate, often overbearing 'political' viewpoint (for instance, Ann Bermingham's rather mono-dimensional reading of *Northanger Abbey*). Mitchell's own essay combines a thoughtful criticism of Clark's *Landscape into Art* with a concern for the perception of landscape framed by a complex colonialism. Landscape can, he suggests, more usefully be seen 'as something like the "dreamwork" of imperialism'. His introductory nine theses on landscape, like some of the essays, point to difficulties that, though deserving of attention, can only be briefly dealt with at essay length. Given these restrictions, *Landscape and Power* can be seen as setting out important agendas for work in progress and could be of interest to a large audience.

Nicholas Jagger
University of Leeds

The Politics of Picturesque: Literature, Landscape and Aesthetics since 1770, ed. *Stephen Copley* and *Peter Garside*, Cambridge and New York: Cambridge University Press, 1994, 318 pp., 25 b. & w. illus., £35.00

The Picturesque has of late become a veritable industry, with explorations of issues stretching way beyond the initial (deemed by now simplistic) concerns of looking at landscape. Books such as S.K. Robinson's *Inquiry into the Picturesque* (1991), reviewed previously in these pages, have suggested the complexity of the Picturesque and also its intractability — that while purporting to be a system, it may in fact embody lack of system, and that it was anyway given widely different interpretations at the time. This volume looks at a number of facets of the subject, some with no obvious immediate connection, such as a Los Angeles department store in the 1920s. The authors of the twelve essays approach their topics from various angles but most essays are informed by a critique of the elitist and sometimes sexist nature of Picturesque assumptions and of the practitioners of the Picturesque, whether landowners or tourists, who tended not to wish to be too closely involved with the 'real' life going on in the mines and elsewhere, often in appalling conditions.

The essays cover the topics of estate management, ruins, mines, women's fashion and fiction, portrayal of 'picturesque' figures such as gypsies, explorers, the sublime, agrarianism, Chartism and architecture and life in Victorian London. Social, psychoanalytical, political and feminist investigation is brought to bear on a way of thinking that had repercussions far beyond its originally conceived sphere of interest. Many contradictions are thrown up: Gilpin's lack of consistency is well established, but ambiguities and ambivalences are found too in the arguments and practice of Price and Payne Knight.

138

Taken as a whole, the collection conveys a sense of enormous change sweeping the country in the late eighteenth and early nineteenth centuries, a change of sensibility and in seeing the new and (to some) frightening world that was emerging in the almost simultaneous movements of the Industrial Revolution and Romanticism, with their social and political consequences, and threats to order and control. The Picturesque was only a small part of this world yet it provides a frame of reference (perhaps a Claude glass) for exploring and explaining the way in which these upheavals were observed.

The volume is a valuable contribution to our understanding of this seemingly inexhaustible subject. For the art historian there is a certain amount of visual material, including tellingly contrasted depictions of Rievaulx Abbey and different artists' interpretations of the gypsy Meg Merrilies in Scott's *Guy Mannering*, but in general the issues raised will be relevant and common to students of several of the arts, and the insights provided will be of application to many areas of social or cultural history.

<div align="right">

Michael Symes
Birkbeck College,
University of London

</div>

Prospects, thresholds, interiors. Watercolours from the National Collection at the Victoria and Albert Museum by *Lewis Johnson*, Cambridge and New York: Cambridge University Press, 1994, 250 pp., 16 col. plates, 100 b. & w. illus., £45.00 hdbk, £19.95 pbk

There is a dearth of interesting writing on British watercolour. The last eighteen months or so have seen an extraordinary glut of publications of museum collections from Birmingham, Leeds, the Whitworth in Manchester, Oldham, Newcastle, Edinburgh and Cambridge and, in addition, the weighty catalogue of the Royal Academy's 1993 exhibition, *The Great Age of British Watercolours*. All adopt more or less the same model of an historical survey followed by entries on individual works (Mungo Campbell's *The Line of Tradition* for the National Gallery of Scotland is a refreshing variant with a well-informed, discursive text). Critical examination of the inherited tradition of writing on the subject is little in evidence. One can sympathize, then, with the decision of the V & A to look beyond its own curatorial ranks and commission a catalogue from a new author which might overcome some of the inbreeding which weakens the other recent examples. Lewis Johnson is nothing if not critical; regrettably, he pursues his task of undermining conventional theory with such energetic fervour that he appears unaware that his own newly constructed edifice also threatens to collapse on top of him.

In format, he adheres to the convention: after an introduction, the one hundred 'watercolours' (which include works in oil, tempera and gouache) are discussed individually, grouped in ten sections. As the book's title suggests, an attempt is made to move away from landscape as the predominant mode of watercolour painting and to find space for figures, still life and interiors; the time span, too, is wide, covering the period roughly 1750–1950. In the introduction, Johnson turns his attention away from the works themselves, to consider ways in which their histories have served the ideological agendas of individuals, or whole generations (the two are not always clearly distinguished). When it comes to the catalogue, there are no texts heading each section, and much of Johnson's revisionist argument is dissipated. The photocopied sheets available free to visitors to the exhibition provided much-needed assistance in this respect, but are absent from the publication. His 'brief essays' adopt a variety of interpretive approaches, often obtuse and highly subjective, their detailed readings unrelated to the

central thesis of the introduction. All this might be preferable to the bland fare usually served up in watercolour catalogues, were it not that the author is all too often almost dismissive of the historical processes which created the specific images he is discussing. He thus has no time to question the attribution of the doubtful Alexander Cozens (cat.18), to sift observation from invention in William Alexander's view of the Emperor of China's garden (cat.53), to see that the pavement level view of Paris by Girtin could never have been intended for a panorama (cat.36, discussed in Susan Morris's all-to-brief catalogue for the Yale Centre for British Art, New Haven in 1986), to unscramble a garbled quotation from William Morris (cat.88) or to correct the misquoted title of Bawden's 'Christ! I have been a many times to church' (cat.97).

The targets of Johnson's salvos are certainly wide-ranging, from tourism and racism to hermaphroditism and nappy-changing, even if his grapeshot too often falls short. How exactly *did* Paul Sandby become 'the father of English watercolour' when much of his more considered, imaginative work was in gouache? To what extent *did* the curators of the National Collection early in this century view their role as political? This last issue is especially intriguing, as the designation of 'National Collection' was all but forgotten during those very fifty years when the foundations of a modern, scholarly approach to the study of watercolour were being laid. Any clash with the newly founded National Gallery of British Art at the Tate was avoided and the curators left free to pursue priorities elsewhere. Yet as Johnson's catalogue does not publish the means of acquisition (to distinguish purchases from donations), only the date, nor look into any surviving museum files, this vast chamber of research is passed by, door ajar, without so much as a peep inside.

If the V&A is seriously committed to accessibility and scholarship, it will need to question whether this publication fulfils these aims; with its measly selection of sixteen colour plates, even for visual interest it leaves much to be desired.

<div style="text-align: right">

Timothy Wilcox
Hove Museum & Art Gallery

</div>

Poussin's Paintings: A Study in Art-Historical Methodology, by *David Carrier*, University Park, Penn.: The Pennsylvania State University Press, 1993, 294 pp, 60 b. & w. illus., £31.50

In 1966 Anthony Blunt included 1,444 bibliographic items in his monograph and *catalogue raisonné* on Nicholas Poussin. Since then, and especially more recently — perhaps in anticipation of the many celebrations honouring the artist this year — the Poussin industry has been full-bore with the publication of dissertations, monographs and exhibition catalogues. A recent addition is David Carrier's *Poussin's Paintings: A Study in Art Historical Methodology*. Written from the voice of a philosopher — or an art writer as Carrier would have it — the essays in this book succeed in establishing new ways to discuss Poussin's paintings. Given the weight of publications on the artist, this has not been an easy task. Still, Carrier achieves his aim by pointing out that Poussin scholarship to date, whose narrative conventions are contradictory or consist largely of recurring clichés, has limited the discussion on the artist's paintings. What has been intentionally avoided, considered insignificant, or merely overlooked, as well as what we may have recognized intuitively, but never had quite the means of drawing them to the forefront of the discussion, are issues that Carrier addresses. His intention is not to return to see Poussin's works as they were seen in his time, since there can be no

such neutral views, but simply to read Poussin's paintings in a new light. As Carrier states: 'When clichés are well entrenched, it becomes difficult to avoid repeating them and to see paintings in a new way. The most a writer may do, I think, is to deviate from such a powerful tradition.' And that Carrier does.

His observations on Poussin's painting may not convince all his readers, but they certainly will compel them to consider the plausibility of new grounds of discussion. With an intentionally fragmented prose of braided narratives, he brings meaning in Poussin's paintings to notions such as the nature of representation, near–far, the role of the senses, and the position of the viewer. He asks us to consider evaluating Poussin's paintings in light of their social contexts: Does the value of Poussin's paintings transcend the conditions of their production? Can we hate Poussin? Can we address Poussin's ideological constitution as a formative basis of his art? He also forces us to reflect on the nature of Poussin connoisseurship and then to reflect on the rules by which art historians have created narratives on Poussin's paintings.

Carrier's interest in opening up discussion of Poussin's paintings may also be the Achilles heel of his approach, Where, in fact, does one draw the line? But Carrier allays our fears of this, because, in the end, it really has little bearing, as each of our readings of Poussin's paintings will be, as Carrier points out, our own: 'How we see the work depends upon the personal point of view we bring to it.' Carrier's book may be singular among Poussin literature because it enables us to address it, as well as the artist's paintings, anew. After all, we do not discover what is in Poussin's paintings, we only create good interpretations of what is there. With such liberation that Carrier's approach offers, what a useful vademecum with which to manage the material about to appear throughout this coming year!

<div style="text-align: right">

Timothy J. Standring
University of Denver & Denver Art Museum

</div>

Prints and Engraved Illustration By and After Henry Fuseli by *D.H. Weinglass*, Aldershot: Scholar Press, 1994, 448 pp., 355 b. & w. illus., £55.00

The sight of the famous (replica) couch in Freud's consulting room in his house in the Berggasse, Vienna, is a focus of attention for visitors to this museum. Art historians will, however, take away a perhaps more powerful memory, that of the images that analysands could hardly avoid contemplating as they sat in the waiting room: Ingres's *Oedipus and the Sphinx* and Fuseli's *The Nightmare*. A quick run through the index to Weinglass's invaluable and exhaustive catalogue reveals no less than ten engravings after Fuseli's famous painting and as many as forty parodies, roughly a third of which are French in origin and many of which Weinglass illustrates. Whatever Freud's motives (conscious or otherwise) for placing these representations before the eyes of his visitors, in the case of the Fuseli at least, he chose an image that demonstrates the formidable power of reproducive engraving in the nineteenth century to disseminate and transmogrify imagery, breaking accepted categories, disrupting expectations and apparently endlessly replicating and subverting its models.

Weinglass is not interested in these processes and scholars concerned with transculturation should skip the introduction, where hierarchical distinctions between different categories of engravings prevail (Fuseli is a history painter who 'never dwindled into a mere book illustrator' and Stothard's productivity is described as 'uncommon but facile'), and go for the main text which is beautifully laid out, richly illustrated and

admirably scholarly. For those seeking evidence for the appearance of some of the many lost paintings of this versatile and widely read artist, reproductions of engravings after paintings (like *William Tell's Leap from the Boat* (1788–90) — a prime candidate in the competition for the origins of Superman or Batman), this book will be indispensable. Equally useful will be the catalogue entries, which comprise in many instances short essays on the engraving's production. Thus we learn that *The Nurse*, engraved by Moses Haughton after a pen and ink drawing by Fuseli was intended to illustrate William Roscoe's translation of Luigi Tansillo's poem in praise of mothers breastfeeding their children, but not used because Fuseli felt that the engraver 'travestied his figures'. When it comes to major collective publishing ventures in which Fuseli was involved, such as Macklin's British Poets, Boydell's Shakespeare Gallery and Sharpe's British Classics (not to mention Fuseli's own Milton Gallery), Weinglass transcribes, in each case, title page, list of contributors, and the main substance of the prospectus. This book, is, therefore, far more than simply a catalogue of prints and will prove an invaluable reference and teaching resource.

Prints . . . By and After Fuseli is dedicated to Gert Schiff, whose premature death robbed Fuseli enthusiasts of their most knowledgeable scholar. English audiences have long known Fuseli's work through Frederick Antal's pioneering *Fuseli Studies* (1956), Peter Tomory's popular survey of 1972, *The Life and Art of Henry Fuseli*, and the exhibition organized at the Tate Gallery by Gert Schiff in 1975. It is good to know that a new edition of Gert Schiff's magisterial, two-volume study of the artist in German, *Johann Heinrich Füssli* (Zürich and Munich, 1973), will shortly be published, updated and translated into English by Weinglass. Anecdotes about Fuseli (including many concerning the diverse variant anglicizations of his own Swiss name of Füssli — Tussle, Fussle, Fusseli, Fusely, Fuzelli, Fuzeli and his own Italianate 'Fuseli') abound in the annals of late eighteenth- and early nineteenth-century British art. Fuseli is one of those artists that is a slide librarian's nightmare; not only are there all the variant spellings of his name but you never really know whether he should be in the Swiss drawer or the English drawer. Weinglass's work will not solve those problems, but it is likely to lead to demands for a larger drawer.

<div style="text-align: right;">

Marcia Pointon
University of Manchester

</div>

John Singer Sargent by *Trevor Fairbrother*, New York: Harry N. Abrams, 1994, 157 pp., 51 col. plates, 49 b. & w. illus., £30.00

Trevor Fairbrother's study of Sargent is in many ways a conventional monograph, part of a series on American artists. It is welcome both because the literature on Sargent is slight, and because, within the confines of a book aimed at the general reader, he raises many interesting issues about Sargent. Among these is a consideration of Sargent's sexuality, long glossed over. Fairbrother considers Sargent's homosexuality, and the homoeroticism of many of his drawings, including drawings of the male nude serving as preparation for subsequent paintings of female figures. His brief but telling analysis of Sargent's drawings of the African-American Thomas E. McKeller is particularly interesting. McKeller was a bellman at a New York hotel whom Sargent persuaded to model for many of the figures in the rotunda of the Museum of Fine Arts in Boston. *Nude Study of Thomas E. McKeller* was a more private work, overtly homoerotic in its emphasis on the figure's open thighs and genitals. It makes a conjunction between

an Apollo-like figure and a slave. Fairbrother points out that Sargent was always fascinated by what he called 'aboriginals', and devoted hundreds of sketches to a range of such peoples. Such an interest in the Other, while common enough at this date, also suggests that Sargent acknowledged his own position of otherness, as an American who did not live in America, a famous and fabled painter of portraits of the wealthy and privileged who, while wealthy himself, was shy and withdrawn in society, and above all, as a repressed homosexual.

Sargent painted the rich and famous of Britain and America with huge success. His bravura technique ensured that even the most formulaic of his portraits have a certain dash and style, but many of them are superficial exercises in pleasing a patron. Some of these patrons were establishing themselves in the upper echelons of English society, among them several Jewish sitters, and Sargent became known as 'the painter of Jews'. This clearly relates to his interest in other peoples, but it is more than detached observation. His group of twelve portraits of Asher Wertheimer and his family was made over a period of ten years of close friendship, and combines penetrating observation with real affection.

One of the most interesting sections of this book is the last, 'Aftermath: Placing Sargent in the History of Art'. Unusually for this kind of monograph, here Fairbrother locates Sargent in terms of changing art-historical discourses. In the caption to one photograph by the fashion photographer Horst, setting two models of the early 1980s against a backdrop of Sargent's portrait of the Wyndham sisters, he unpicks some of the reasons for Sargent's appeal, and he is adroit throughout this brief text in suggesting in a few lines areas of further inquiry. This last section includes a summary of Sargent's status in the British art world at the turn of the century; the view taken of him by critics like Sickert, and above all, Roger Fry; his descent into almost total obscurity in the years after his death, and in the decades when modernism's sway was unchallenged; and the gradual resurgence of interest in him in the 1960s. Such a history helps to explain the paucity of critical material on Sargent, and provides a starting point for wider study.

Kathleen Adler
Birkbeck College, University of London

Kitaj: Pictures and Conversations by *Julián Ríos*, London: Hamish Hamilton, 1994, 278 pp., 273 b. & w. illus., £17.50

R B Kitaj: A Retrospective edited by *Richard Morphet*, London: Tate Gallery, 1994, 240 pp., 116 col. plates, 81 b. & w. illus., £25.00

There is an ever-growing literature on R.B. Kitaj. The publication of these two books in 1994 add to this. Julián Ríos's *Kitaj: Pictures and Conversation*[1] is reminiscent of an artist's sketch book in which pictures, drawn on thick creamy paper, have been punctuated with written notes. Ríos's text is bold and has at its heart the desire to let the pictures speak; to encourage conversations with the artist and images. Ríos writes with a vivid, graceful and generous eye, telling us that he wishes to engage with Kitaj's art neither as a critic nor as an art historian, but as a *writer*, by 'speaking with the painter and by trying to speak *with* his painting'. The text refuses, so it would seem, to *read* the paintings or indeed even to *explain* them: rather Ríos intends 'to see between the lines and to read between the images', perhaps, I dare say, even to *rewrite* them.

The Tate Gallery catalogue, a lavish and glossy publication, has a somewhat different mission. It promises scholarship and is more conservative in conception. Regrettably,

it wearily follows what has become the routine formula of essays which sketch out the artist's life, ideas and work. It features texts by Richard Morphet and Richard Wollheim, together with an interview, 'Prefaces' and catalogue notes provided by Kitaj himself. Also included is a Chronology, compiled by Joanne Northey, and a selected Bibliography, put together by Krzysztof Z. Cieszkowski, in consultation with the artist: indeed, the vast, if not exhaustive, bibliography should ensure the usefulness and durability of the publication. The catalogue bulges with illustrations of which the colour plates unfortunately are of a lamentably poor quality, thereby distorting our memory of the paintings.

While the form and probable use of each book is radically different, each, in my view, is disappointing and for similar reasons. It is striking that in both the authority, the power of legislating the meaning of a picture, is handed back, again and again, to the artist Kitaj. The potential dialogue presupposed by Ríos's book gets subverted to form a series of interviews which re-inscribe the artist as the sole authentic voice, rather than one of the many who may *listen* patiently and let the work itself provoke. This particular text, which could have acted as an intelligent corrective to some of the excesses of the death-of-the-author script, merely reinforces Kitaj's legislative authority. It slips, against itself, into the all too familiar mode of the artist, rather than the work itself, as the defining Subject of the text.

Artistic personality also provides the focus for the carefully crafted essay, 'Kitaj: Recollections and Reflections', written by Wollheim in the Tate publication. The key to unlock the meaning of the work is Kitaj himself. Described as a romantic artist, he is situated in the nineteenth century by an eloquent, if not entirely convincing, anecdotal reference to Ruskin. Isolated and differentiated from his contempories, the author details Kitaj's life as a series of artistic rituals whose work, interpreted as 'material fragments', is opposed irreconcilably to what Wollheim sees as that other trajectory of modernist art, conceptualism. The concluding remarks of this essay, which suggest what may bind a painting with a painter, a work with a life, are tantalizing. Refusing the sentimentality of the rest of the text, this ending gives a telling glimpse into the making of an image, into painting-as-painting, which the biographical reflections never begin to address. Furthermore, the inclusion of Kitaj's 'Prefaces', together with Morphet's interview with Kitaj and essay, 'The Art of R.B. Kitaj: "to thine own self be true" ', in their effects serve to reify intentionality.

It does matter what the artist intends and thinks, but his view is just one of the many responses available to the work. Kitaj himself surrounds his images with words: labels abound, Prefaces, *Diaspora Manifesto* (published in 1989), Jewish identity, and provide the structure for much of the thinking informing these two publications. The pictures then — seemingly inevitably — are read unproblematically through the sign, Kitaj.

Kitaj's project is in part to create anew a narrative painting which is informed by the rigours of modernism. His pictures initiate a game between signs. They offer sites of open readings in which visual clues may be both revealing and misleading. The impossibility of fixing a single meaning seems to be a source of anxiety for Kitaj and for his commentators, but it may well be that it is in the condition of provisionality that the importance, the ethics, of his art may be said to lie. Kitaj's own insistent attempts to pin down the meaning — despite, for example, Ríos's claim that Kitaj finds 'particularly stimulating . . . the provisionality of every reading' — works in both books as a controlling device painfully evoking something like terror at the prospect of the art being *misread*. I should remark here, that this is not simply Kitaj's personal problem and is a much wider cultural issue. It could be also that current critical emphasis on *reading* pictures contributes to this dilemma. What I am asking for is a space in the texts where meanings are not already foreclosed.

The Kitaj literature is in danger of entirely reducing his art to extra-painterly content: of turning an image into *this* text only. It does not seem permissible for Ríos (and for me) to expect to converse with the pictures *as* pictures, to write them *as* pictures — with all that literature, with all that art history, those themes, the people-of-the-book, the artist-in-exile. The reflective act of interpretation always entails rewriting, altering the work of art, and is a risky business. Interpreting visual culture can be understood as analogous with translation, a point to which Ríos alludes in his Preface. It is disappointing that neither publication takes the risks inspired by Kitaj's unsettling and provocative art: rather than living with 'pro-visionality', both texts end up by giving themselves over to the lure of certainty.

Juliet Steyn
Kent Institute of Art & Design, Canterbury

Note

1 The book was first published in Spanish as
Impresiones de Kitaj (La Novela Pintada),
Madrid: Mondadori, Espana, 1989.

Howard Hodgkin by *Andrew Graham-Dixon*, London: Thames and Hudson, 1994, 192 pp., 96 col. plates, 18 b. & w. illus., £24.95

Andrew Graham-Dixon's monograph on Howard Hodgkin is the first on this leading British artist. The text eschews a chronological and biographical approach in favour of a series of fourteen thematic essays. These set out to convey the formal and conceptual complexities of Hodgkin's painting, which hovers between abstraction and figuration.

Graham-Dixon rightly emphasizes the powerful emotional and autobiographical issues invested in the work, and Hodgkin's concern to 'describe' the relationships between people and the environments in which they live. Hodgkin mostly uses wood as a surface, enclosing his imagery in a painted border. The scale is usually small too. This gives the images the physicality which Hodgkin wishes them to possess, and reminds us that the artist is also a serious collector. While difficult to decipher in many ways, Hodgkin's paintings also possess characteristics that make them very approachable, most notably their intense, exuberant, overloaded colour and their vocabulary of autograph marks — blobs and splodges of oil paint that defy reticent 'good taste'.

Graham-Dixon says 'there are a lot of pictures about fucking'. In *Waking up in Naples* he draws our attention to the use of bare wood at the bottom of the picture to suggest a back of human flesh. The cover of the book shows a detail from *In a Hot Country*, a deep rose arrow, the 'most blatant piece of painter's code in Hodgkin's art'. But unless pointed out, the erotic content is not overt; it seems much more to do with sensuality and mood. Elsewhere Graham-Dixon extols Hodgkin's paintings precisely because they defy exact definition.

As the number of chapters related to travel demonstrates Hodgkin is not simply a painter of (haute) bourgeois interiors. He has travelled extensively, and many of his paintings invoke an elusive memory of these places. The titles of many of the paintings 'add up to a kind of haphazard itinerary, the diary of a life seen as a journey.' The richest source of inspiration has been India. Graham-Dixon rejects as glib the countless references and comparisons made between Hodgkin's painting and Indian art. He points out that

in his collection of Indian miniatures, mainly of the Kota, Mughal and Rajput schools, Hodgkin has been drawn to large-scale examples, and these are usually drawings where colour is hardly dominant. Graham-Dixon suggests that it is the experience of being in India rather than Indian art itself that is really essential to Hodgkin's development as an artist. Nevertheless, it is not enough to see the relationship as 'an affinity that is really a shared faith in painting simply and confidently to create its own world'. Surely it is also about 'an unusual sense of surface, a high degree of pictorial density and diversity, decorative vitality with assertion of subject',[1] as Richard Morphet noted in 1975.

Another key influence is Vuillard who, as a member of the Nabis, moved from the natural world of Impressionism into the mysterious atmosphere of the domestic interior. While Graham-Dixon locates Hodgkin's work within this Intimist ambience, he is at pains to stress Hodgkin's originality, without the striving for superficial novelty and the spurious support of 'theory' that features so largely in contemporary art.

Graham-Dixon is right to detach Hodgkin from the so-called School of London; Freud, Auerbach and Kossoff are singularly unresponsive to colour. But his claim that Hodgkin's painting is 'art's revenge upon the intellect', inverting Susan Sontag's description of interpretation as the revenge of the intellect upon art, is problematic. Hodgkin may dislike the need for words to come between the picture and the spectator, but the importance he attaches to words is evident in his resonant titles.

Inevitably, Graham-Dixon's monograph is as much about the mystique of art as it is about the work of Howard Hodgkin. He talks about the shamanistic role of art and the 'occult power of painting' which 'transforms the mundane'. So this is not a book that will find favour with historians who see their role as dismantlers of the highly privileged status of art and the ideologies which sustain it. But Graham-Dixon makes no excuses for his intense admiration for Hodgkin's work. No advocate of critical distance, he implicitly supports the concept of art detached from history, and succeeds because he focuses entirely on the paintings themselves.

Bette Spektorov
Middlesex University

Note

1 Richard Morphet, *Howard Hodgkin: Forty-five Paintings* (Arts Council, London, 1975).

The Materials of Sculpture by *Nicholas Penny*, New Haven and London: Yale University Press, 1993, 318 pp., 230 b. & w. illus., £35.00

Our knowledge of classical sculpture would be greatly diminished had it not been for the writings of Pliny the Elder. In his *Natural History*, he incorporated extended discussions of famous artists in accounts of the properties of metals and minerals. The association is interesting because such lateral thinking is unexpected now, and yet the relationship between an artefact and its medium remained a focal point in discussions of art down to the Renaissance. Paul the Silentiary wrote a poem on the marbles of Santa Sofia in the sixth century, and the first published description of San Marco in Venice, Pietro Contarini's *Argoa Voluptas* of *c.* 1541, concentrated on its rare marbles

146

rather than the mosaics. The Medici grand dukes expended time and money over generations to assemble the precious stones that embellish their mausoleum in San Lorenzo although few visitors today give them more than a cursory glance.

Clearly, we have lost much of the sensitivity of our ancestors towards the numinous qualities of stone and metal, and Nicholas Penny's *The Materials of Sculpture* comes as a timely reminder of the way in which a medium defines a work of art. The text is short but wide-ranging, gliding as it does from stone to wood, ivory to horn, clay and finally bronze. The examples under discussion show a similarly impressive range from Chinese jade to Tibetan silver. As one might expect, the book contains some fascinating aperçus culled from the author's own observations and his digging in secondary literature, and the juxtaposition of examples drawn from western and non-western sculpture is often illuminating, as are the numerous photographic details in this attractively designed book.

The Materials of Sculpture is very much a personal view of topics interesting to its author and should be read in tandem with his monumental catalogue of European sculpture in the Ashmolean museum. Indeed, it is difficult to resist the conclusion that this is half a book, for the decision to separate material from technique means that the discussion is fragmentary, sometimes conveying little sense of how sculptures are made. This is especially true of works like marble and bronze statuary, which go through stages of development in several media but are only discussed here according to a given medium. One would have liked a more sustained account of marble carving and bronze casting as well as something on the difficulties of quarrying and transportation of stone in the pre-industrial era. Symptomatic of this emphasis upon materials over technique is the absence of any illustration of the sculptor's tools or abrasive agents.

Ultimately, there is a fault line in Penny's book which undermines its usefulness. While the aim may have been to produce something like the *Penguin Dictionary of Decorative Arts*, the chapters are too long for dictionary entries but too short to be comprehensive, scholarly accounts of their subjects. The book will doubtless be read by students, but they will still have to return to Rudolf Wittkower's *Sculpture: Processes and Principles* to understand how sculptures are made.

<div align="right">

Bruce Boucher
University College London

</div>

The Practice of Theory: Poststructuralism, Cultural Politics, and Art History by *Keith Moxey*, Ithaca and London: Cornell University Press, 1994, 153 pp., 27 b. & w. illus., £26.95 hdbk, £10.95 pbk

Of the three terms that form the subtitle of Keith Moxey's *The Practice of Theory*, it is the term 'cultural politics' that seems most evasive, most elusive. The other two are much easier to put your finger on. Poststructuralism, here, takes the form of that ever-familiar package deal (Derrida, Lacan, Althusser, Foucault, etc.), but added to this staple theoretical diet are some more surprising ingredients: Voloshinov's and Bakhtin's theories of the dialogic nature of utterances, Uspenskii's and Lotman's semiotics and Kaja Silverman's psychoanalysis.

The theoretical architecture that Moxey constructs from all this allows him to make a number of moves in and on the discipline of art history. First off: if the art historian's commerce with the past is conducted under limits and pressures that are resolutely in the historian's present, then any idea of objective or disinterested history has to be

abandoned; moreover, historians might as well come clean about the 'situatedness' (the partiality, the interestedness) of their inquiry and make it the condition for the inquiry. To flesh this point out, Moxey demonstrates how Erwin Panofsky's book on Dürer, which elevates the German artist to an equal footing with the 'major players' of the Renaissance, has everything to do with Panofsky's own relationship to pressing questions of identity, nationhood and 'race'. (Panofsky, a German Jew, started work on Dürer when it was possible to be both German and Jewish; he published the work when such a position had become horrifically untenable.) This is a vivid example of Moxey's, but it also begs the question (the cultural politics question), that if Panofsky was motivated by unresolvable conflicts in his life—world, then what is Moxey motivated by in his account of Panofsky's account of Dürer? On the face of it, it would seem that questions of identity, nationhood and 'race' supply the conditions for such an inquiry and that this is where Moxey's cultural politics make an appearance. However, it might be worth asking that if such concerns have become the *object* of the inquiry, then is it not an unnecessary limitation to maintain the disciplinary boundaries of art history, even if those boundaries have been extended?

This links in with the other major (and necessarily related) move that Moxey makes, namely, that culture is a radically intertextual affair and that cultural objects have no 'proper' context; indeed they can be seen to be cast adrift in a sea of textuality. It becomes irrelevant (or of only academic interest), therefore, to try and look 'behind' such objects for their causal factors or for authorial intention when the more important cultural work that they can be seen to do lies *elsewhere* — at other historical moments, in collision with disparate and non-generic material. Again, what counts for 'important work' is going to have something to do with cultural politics. To give an example: the painting *Virgin in a Rose Arbor* by Martin Schongauer is seen as connected to the Colmar confraternity of the rosary, which is seen as marking a shift in medieval religious practices in that area, a shift that is seen as of particular value to the religious life of women. The fact that the painting was painted in 1473 while the confraternity was founded in 1485 is only damaging to such an account if the inquiry is aimed at giving a causal explanation of the painting, not if the inquiry is interested in the social function of the painting in terms of gendered religious practices after 1485. Such an investigation, again, allows for a massive expansion of art history's disciplinary field (the number of relevant texts becomes enormous), as well as offering large scope for the practice of cultural politics, but it also returns us to questions about the object and field of study (what we start from and the limitations on where we end up) — after all, is not the radical challenge of intertextuality its antagonism to the contingencies of a discipline, its destablizing of the object?

One valuable aspect of Moxey's work is the way in which it points out the limitations of trying to see through the text to the intentions 'behind' it. As such it is worth thinking about the cultural politics *of the book* (rather than of Moxey) and the social function *it* might perform. Produced during a period of intense competition within the institutions of further education, and as each discipline struggles to increase its market share, *The Practice of Theory* offers a souped-up version of art history — expanded and malleable to a variety of interests, but with its market identity still firmly in place. In this context the 'post' of poststructuralism might be worth taking literally — as a stake used to mark out an area, or as a support used to buttress a precarious object.

Ben Highmore
University of the West of England

WOMEN'S ART
MAGAZINE

A WOMEN'S ART LIBRARY PUBLICATION No62 January/February 1995 £2.50/$10

Emulation: Making Artists for Revolutionary France

Thomas Crow

This fascinating and elegantly written book puts the life of the artist at the centre of innovative art history, narrating a biography of five painters who embraced the ideals of Revolutionary France: Jacques Louis David and his pupils Drouais, Girodet, Gérard, and Gros. Thomas Crow reveals how the personal histories and aesthetic choices of these painters were played out in the larger arena in which a whole social order was being overturned and a republic of equal male brotherhood was proclaimed.
288pp. 150 b/w illus. + 50 colour plates £29.95

Architecture in France in the Eighteenth Century

Wend von Kalnein

The eighteenth century was a time of supreme achievement in French architecture. The buildings of the period are distinguished by restraint and proportion, grace and practicality—qualities that influenced architecture across Europe. This handsome book surveys developments from the final years of Louis XIV to the dramatic fantasies of Boullée. Richly illustrated, it provides a lucid account of the styles and their exponents, set in a stimulating historical context. *Yale University Press Pelican History of Art 320pp. 250 b/w illus. + 50 colour plates £50.00*

Wenceslaus Hollar

A Bohemian Artist in England • **Richard T. Godfrey**
Wenceslaus Hollar came to London from Prague in 1636, and became the first great etcher to practice in England. This handsome book reproduces, with full commentary, over 200 of Hollar's most celebrated works as well as some never before published, ranging from views of London to portraits to costume studies of the fashionable classes.
224pp. 200 b/w illus. + 12 colour plates £29.95

Medieval London Houses

John Schofield

This authoritative book is the first comprehensive study of domestic buildings in London from about 1200 to the Great Fire in 1666. John Schofield describes houses and such related buildings as almshouses, taverns, inns, and shops, drawing on evidence from surviving buildings, archaeological excavations, documents, panoramas, drawn surveys and plans, contemporary descriptions, and later engravings and photographs. *Published for the Paul Mellon Centre for Studies in British Art. 288pp. 300 b/w illus. + 10 colour plates £40.00*

Siena, Florence, and Padua

Art, Society, and Religion, 1280-1400
Volume I: Interpretive Essays
Volume II: Case Studies
Edited by Diana Norman

Siena, Florence, and Padua were major centres for the flowering of early Italian Renaissance art and civic culture. The three communities embellished their cities with painting, sculpture, and architecture, though each retained a distinctive and highly individual style. These two volumes, which serve as textbooks for an Open University course, examine the artistic legacy of the cities during the fourteenth century and locate the various works of art within their social, religious, and cultural contexts. *Published in association with the Open University Volume I: 261pp. 189 b/w illus. + 57 colour plates £35.00 cloth £16.95 paper Volume II: 290pp. 255 b/w illus. + 66 colour plates £35.00 cloth £16.95 paper*

Impressionism in Britain

Kenneth McConkey
with a chapter by Anna Gruetzner Robins

Set against the backdrop of late Victorian and Edwardian Britain, this beautiful book describes the activities of the French Impressionist painters during their visits to Britain, and the influence of their work on British and Irish artists. Reproducing many lovely but little known pictures, the book is the catalogue to an exhibition currently on view at London's Barbican Art Gallery. *Published in association with the Barbican Art Gallery. 224pp. 85 b/w illus. + 160 colour plates £35.00 cloth £19.95 paper*

The Spectacular Body

Science, Method, and Meaning in the Work of Degas
Anthea Callen

The Spectacular Body explores the ways in which the human body—especially the female body—was visualised by artists in late nineteenth-century Paris. Focusing on the work of Degas, it deals with issues of sexuality, gender, and visual representation to illuminate the underlying meanings of the famed Impressionist's depictions of women in his series of bathers, dancers, and prostitutes.
256pp. 108 b/w illus. + 25 colour plates £35.00

The Political Theory of Painting from Reynolds to Hazlitt

"The Body of the Public" • **John Barrell**
"I have learned as much from this book as from any work of art history I know"—Thomas Crow, *London Review of Books*

New in paper 376pp. 26 b/w illus. £10.95

National Gallery Publications

Spanish Still Life from Velázquez to Goya

William B. Jordan and Peter Cherry

This beautiful book is the first major study in English of Spanish still-life painting from its origins to Goya. Written by two of the foremost authorities in the field, it provides an overview of two centuries of still life in Spain. Lavishly illustrated, the book also serves as the catalogue to a exhibition on view at the National Gallery from 22 February to 22 May 1995.
224pp. 120 b/w illus. + 100 colour plates £25.00

The National Gallery Complete Illustrated Catalogue

Compiled by Christopher Baker and Tom Henry

The National Gallery's collection of European paintings from the thirteenth to the early twentieth century is one of the richest and most comprehensive in the world. The *Complete Illustrated Catalogue* provides concise information on every work owned by the National Gallery. Containing over 2,000 illustrated entries (most in colour) the *Catalogue* is both a resource for information and images, and the perfect starting point for the study of the history of Western European painting. *April 824pp. 2300 illus. £35.00*

The National Gallery Complete Illustrated Catalogue on CD-ROM

Compiled by Christopher Baker and Tom Henry

The *Catalogue* is also available in a CD-ROM version, sold in a package with the book. The disc contains the complete text and illustrations of the printed version, along with greatly enlarged screen versions of the illustrations. Compatible with both Apple Macintosh and Windows computers, the disc also provides sophisticated index searching facilities and an on-line bibliography. *April book and disc package £80.00 + VAT*

Shadows

The Depiction of Cast Shadows in Western Art

E.H. Gombrich

In this fascinating book, E.H. Gombrich traces how cast shadows have been depicted in Western art through the centuries. He touches on the ambiguous nature of shadows in myth, legend and philosophy, and analyses the factors governing their shape. Given the complexity of shadows, it is not surprising that their correct construction was not fully mastered before the seventeenth century, although this difficulty did not deter earlier painters from exploiting their visual effects. *April 64pp. 20 b/w illus. + 30 colour plates £8.50*

National Gallery Publications, London
Distributed by Yale University Press

Claude Monet

Life and Art • **Paul Hayes Tucker**

Fiercely competitive but immensely sensitive, astonishingly inventive though rarely satisfied, Monet was a far more complicated figure than has been acknowledged. The quintessential Impressionist, he created more than 2,500 paintings, drawings, and pastels, radically altering the way art was made and understood. This beautiful book is a comprehensive and accessible study of Monet's achievement that sets his rich legacy into context of his life and times, revealing him as an individual of vision and virtuosity. *April 256pp. 60 b/w illus. + 200 colour plates £29.95*

Classical Architecture in Britain

The Heroic Age • **Giles Worsley**

This handsome book offers a radical reassessment of the styles, the designers, and the influence of British architecture during the seventeenth and eighteenth centuries. Focusing on the Palladian classical tradition, Worsley argues that architectural styles do not always supersede one another but can co-exist. His study sheds fresh light on British architecture and provides a new outlook on European and American architecture as a whole. *Published for the Paul Mellon Centre for Studies in British Art April 352pp. 285 b/w illus. + 65 colour plates £29.95*

Shadows and Enlightenment

Michael Baxandall

Shadows are holes in light. We see them all the time, and sometimes we notice them, but their part in our visual experience of the world is mysterious. In this book, Michael Baxandall draws on contemporary cognitive science, eighteenth-century theories of visual perception, and art history to discuss shadows and the visual knowledge they can offer. *April 224pp. 40 b/w illus. + 16 colour plates £19.95*

The Making of Rubens

Svetlana Alpers

Rubens has long been considered a remarkably successful and prolific painter, a frequenter of the courts of the great. He is more admired than loved in our time, in contrast to the troubled figure of Rembrandt. This book takes up basic questions about Rubens's art and life, studies two of his bacchic paintings in detail, and discovers him in a less easy and more identifiably modern predicament. *168pp. 66 b/w illus. + 60 colour plates £25.00*

Yale University Press

23 Pond Street
London NW3 2PN

ARLIS Art Libraries
UK & IRELAND Society

with the co-operation of
AVAIL

CONSERVING THE CULTURE:
THE CHALLENGE TO ART, ARCHITECTURE
AND DESIGN LIBRARIANS

Dublin & Belfast, 29 June – 2 July 1995

The programme for this, the 26th annual ARLIS/UK & Ireland conference, addresses issues of strategic importance to everyone working in the visual arts – art historians, librarians, curators, and archivists.

Based at the University of Dublin Trinity College (TCD), within easy reach of many museums, galleries and libraries, the conference begins by posing questions of what we select for preservation and how it is saved for future generations of users, as well as the effect of electronic publishing on what is available to be preserved. This is followed by discussion of the security of research materials and advice on disaster planning, and continues with a look at the use of documentary evidence from libraries and other documentation resources for the conservation and preservation of historic buildings. There will also be a chance to look at practical conservation methods for books and bindings, including the Book of Kells, with Tony Cains of TCD's Conservation Laboratory.

The second day of the conference deals with similar issues, this time cross-border initiatives in Ireland and the European Union in preservation and conservation, including the EU's promotion of the culture of reading in an age of information technology. There is a choice of visits to galleries and documentation collections, as well as to Dublin street sculpture and Georgian architecture and design.

There will also be a day's study visit to see at first hand the rapidly-changing culture of Belfast. This will include visits to the Linen Hall Library (illustrated political ephemera) and the Ulster Museum, with its exhibition of paintings from the Queen's University collections, and the opportunity to see and hear about the political murals of the Falls Road and the HEARTH project, which is conserving and preserving buildings of historic interest in the north of Ireland.

ARLIS/UK & Ireland's 26th annual conference is being organised with the co-operation of the Association for the Visual Arts in Ireland (AVAIL). Full details of the conference, together with costs and booking forms, are available from Louise Tucker at the University of Brighton (tel: +273 571820), Elizabeth Kirwan at the National Library of Ireland (tel: +353 1 661 88 11) or in writing to Sonia French, Administrator ARLIS/UK & Ireland, at 18 College Road, Bromsgrove, Worcs., B60 2NE, UK.

THE VILLAS OF PLINY FROM ANTIQUITY TO POSTERITY

PIERRE DE LA RUFFINIÈRE DU PREY

"A charming and digressive essay that takes the reader on a memorable architectural excursion."—Witold Rybczynski

Cloth £51.95 404 pages 48 color plates, 159 halftones, 29 line drawings

BERNINI

Flights of Love, the Art of Devotion

GIOVANNI CARERI

Translated by Linda Lappin

"Careri shows that by concentrating on the iconology of the various figures sculpted and painted in Bernini's ensembles, traditional art history has entirely missed the sense of the whole and its relationship to the specificity of the program to which the artist was responding."—Yve-Alain Bots, *The Journal of Art*

Paper £13.50 168 pages 41 halftones

AFRICAN VODUN

Art, Psychology, and Power

SUZANNE PRESTON BLIER

"A landmark work in the history of art."—David Freedberg, author of *The Power of Images: Studies in the History and Theory of Response*

Cloth £39.95 488 pages 8 color plates, 161 halftones, 4 maps

DIMENSIONS OF THE AMERICAS

Art and Social Change in Latin America and the United States

SHIFRA M. GOLDMAN

"Essential reading . . . no parallel in the field."—Mari Carmen Ramírez, Curator of Latin American Art, University of Texas at Austin

Paper £23.95 518 pages 95 halftones

SYMBOLIC SPACE

French Enlightenment Architecture and Its Legacy

RICHARD A. ETLIN

Examining a broad range of topics from architecture and urbanism to gardening and funerary monuments, Etlin focuses on the theoretically innovative architects of eighteenth century France.

Cloth £31.95 262 pages 112 halftones

PICTURING TIME

The Work of Etienne-Jules Marey (1830-1904)

MARTA BRAUN

"Beautifully designed and illustrated, Braun's book serves up a rare combination of anecdote and profound insight."—Betty Ann Kevles, *Los Angeles Times*

Paper £27.95 472 pages 270 halftones, 65 line drawings

THE PLACE OF NARRATIVE

Mural Decoration in Italian Churches, 431-1600

MARILYN ARONBERG LAVIN

"Likely to become the most influential recent study of art of this period, *The Place of Narrative* is also a beautiful artifact." —David Carrier, *Leonardo*

Paper £39.95 426 pages 24 color plates, 209 halftones, 58 line drawings

Available from your bookseller.

Trade enquiries to: UPM, 01235-766662 • Distributed by IBD Ltd., 01442-882222

THE UNIVERSITY OF CHICAGO PRESS

5801 SOUTH ELLIS AVENUE, CHICAGO, ILLINOIS 60637

Subscribe to

CIRCA

Ireland's Journal of Contemporary Visual Culture

67 Donegall Pass　　**58 Fitzwilliam Square**
Belfast BT7 1DR　　　　**Dublin 2**
Tel/Fax: 237717　　　**Tel/Fax: 6765035**

Name ..

Address ..

...

...

Postcode ..

Subscription Rates
(4 Issues)

INDIVIDUAL　　　　　INSTITUTIONS
UK £14 stg　　　　　　UK £20 stg
Eire £15.75 IR　　　　Eire £24 IR
Europe £18 stg　　　　Europe £27 stg
Overseas £20 stg　　　Overseas £30 stg

Subscription enquiries and payments to:
ArtServices,
67 Donegall Pass, Belfast BT7 1DR
Tel./Fax: (0232) 237717